MIKE NELSON'S MIND OVER MATTERS

Also by **Michael J. Nelson**

MIKE NELSON'S MOVIE MEGACHEESE

MIKE NELSON'S

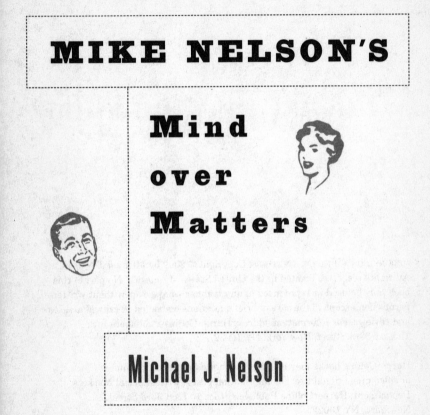

Mind over Matters

Michael J. Nelson

HarperEntertainment
An Imprint of HarperCollins*Publishers*

HarperCollins books may be purchased for educational, business,
or sales promotional use. For information please write: Special Markets
Department, HarperCollins Publishers Inc., 10 East 53rd Street,
New York, NY 10022.

FIRST EDITION

Designed by Adrian Leichter

Library of Congress Cataloging-in-Publication Data has been applied for.

ISBN 0-06-093614-2

02 03 04 05 06 ❖/RRD 10 9 8 7 6 5 4 3 2 1

Contents

PART FIVE: Remembrance of Stings Past

PART SIX: Busy Bodies

PART SEVEN: Food & Stuff

PART EIGHT: Me, Myself & I

PART NINE: The Whole Famn Damily

Acknowledgments

A FEW QUICK THANKS
and then we can move on, no worse off, I hope.

*To my wife, my thanks and love. My children as
well, thank you for staying out of my office when
I asked you, for the most part. Though we'll con-
tinue to work on that, okay?*

*To Peter Cox, my agent, thank you for your hard
work, your humor, and for flying to New York in
my stead a whole lot, because I'm too large to fit
in those seats and I'm not sophisticated enough
to scam first class like you are.*

*Many and hearty thanks to my editor, Tom
Dupree. Without you there to explain me to others,
there would be many people still recovering from
fright and untold trauma. Thanks to Yung Kim
as well.*

*My thanks to Bob. M., Chris B., and Dave H.
Special thanks to Dave O. In fact, why don't I just
go ahead and thank everyone named "Dave."*

MIKE NELSON'S MIND OVER MATTERS

PART
ONE

Coping with It All

DO NOT DISTURB
(I'VE GOT THAT COVERED)

Faced with a choice between two doors, behind one of which is a pack of ravenous tigers and Siegfried—*and* Roy (!)—and behind the other a pleasant stay in a hotel room for several days, I'd have to say, "Bring on the big cats—just please keep those German guys away from me."

My illustration, which started out as a simple device to show my dislike of staying in hotel rooms but ballooned into a complicated and overpunctuated attack on Siegfried and Roy, should not distract from the fact that I don't like to stay in hotel rooms. Not by myself, anyway. And please don't take that to mean that I like spending time in hotel rooms with Siegfried and Roy, because nothing that you could conceive of, ever, could be further from the truth. All right, I could conceive of, I suppose, a room large enough, a suite, with locking doors between all the rooms, where I might be able to spend time with Siegfried and Roy—under duress, mind you! And without their opening act. That guy's the real trouble-maker.

Back to my main point: without the privilege of having my wife and family with me, staying in pleasant hotel rooms is something akin to a sweat-soaked nightmare, a never-ending treadmill of horrors.

It starts the moment you arrive and the person brings your bags up into the room. The door closes behind you both with a vaguely obscene click.

"And sir, where may I put your bags?" he asks, applying pressure immediately. I don't know the layout of the room at all, having only been in it for three seconds, tops, so I gesture vaguely.

"Just put 'em over there, that'll be fine."

"Here, sir?" he asks.

"Yep, that's fine."

"Okay," he says, setting them in the bathtub. "And this small one in the sink, sir?"

"Yes, that's fine." Everything is just fine, as far as I'm concerned.

"Have you stayed with us before, sir?"

"Fine. I mean, yes; yes, I have," I say, though I have not.

"Then you know about our [something unintelligible]."

"Hmm? Oh, yes. Yes, fine," I say.

"Very good, sir. I've marked you down for a one-hour buttocks massage in the main lobby at noon."

"Fine," I say.

"The health club is on floor three, the mezzanine is in the main lobby, the pool is out on the deck, the first floor is accessed through the skyway, and of course you have to dial 38–928–3423 to get out of your room in case of a fire. Is there anything else I can help you with, sir?"

"Fine," I say, and, trying to get rid of him quickly, hand him forty-seven dollars, some loose change, my bike key, and the parking ticket for my car back in Minneapolis.

"Thank you, sir."

"Fine."

And mercifully, he is gone. Now I am free to nose about the room

like a captured ape upon introduction to a new habitat. The first
thing to check on is which side of the "golden barrier" your hotel is
on. That is, does it have a minibar? I seldom take advantage of
them myself, preferring to comparison-shop for my Mr. Salty Pret-
zels. Invariably, I can come up with a better price than $8.50 per
ounce. But the presence of the mini-bar is a good sign, meaning
that the staff is keeping an eye on your room, making periodical
checks to see if they can gouge you for cranapple juice or Mrs.
Dreisen's cheese straws. If there happened to be a skunk in your
room, they'd probably catch it on one of those visits.

Since my tendency is to say yes to business offers to fly places
and then immediately forget everything that was told me by the
offerer, I am somewhat at the mercy of that person. They'll call me
back at some later time to confirm travel arrangements.

"Mike, you've got just the one event on Tuesday evening, and it's
a lot cheaper to get you in there on the previous Wednesday and
then stay over through the Saturday a week and a half after that.
How's that sound?" they'll ask.

"Fine," I say, not listening at all.

"And I've got you staying at the E Terminal Hotel, which is actu-
ally in the airport. You'll be staying at Gate 23A. How does that
sound?"

"Great. And this is New Orleans?" I manage to ask.

"Anchorage."

"And I'm speaking to Elks?" I ask.

"Signing books for Cub Scouts."

"Okay, well, thanks, John," I offer warmly.

"I'm Linda."

"We haven't met. I'm Tom," I say politely.

"You're Mike."

"Right. See you in Omaha," I say, and sign off.

So always, I have too much time in the destination city, which
would not be a problem at all if I weren't by myself. Sightseeing,
theatergoing, and dining out are not half as fun by oneself. Half as

fun would make logical sense, but it turns out to be perhaps one one-hundredth as fun, so I end up taking a walk and nosing around hardware stores (they're never that crowded). I'll tell myself that there's no shame in eating alone and start looking for a good restaurant. Peering into a window, I see a crowd of happy-looking, nonjudgmental people, laughing, having a great time that is obviously not dependent upon their being with a partner, so I open the door and stride confidently in, knocking over a bus tub. Twenty-five minutes later, when the clattering has subsided and the bus tub juice has been sponged up, the hip-looking hostess pulls me aside and announces, "Sir, this is a private party. I'm going to have ask you to go back to your hotel room."

So I do.

I'll arrive with good intentions of getting some reading done, but I quickly become a victim of my own shortsightedness. When I pack, I imagine myself, falsely, to be some paragon of good taste; I eschew trashy magazines and forgo the *GQ* and *Esquire* types, which really have become dirty books with one good article as justification for their having 120 pages of naked actresses. I pack good, fibrous reading material, things that will enrich mind and soul—and I'll have no choice but to read them, there being no alternatives. So there I am in my hotel room deciding between *A Kierkegaard Chrestomathy, The Greatly Expanded and Severely Annotated Complete Works of Dostoyevsky,* and *A Treasury of Slow, Numbing Fiction*.

"Ah, Kierkegaard's the ticket," I think, and begin reading.

Let us consider, I read, but my concentration just isn't there. *Let.* What does *let* mean? I stare it at. It starts to look funny. *Let.* It suddenly becomes devoid of all meaning, and with my grasp of *let* gone, everything else follows. Why am I in Omaha? Who am I? Is knowledge "knowable"? And then all knowledge of self vanishes and I am consumed by a sense of nostalgia for the absolute. I grab for a bag of Mr. Salty's and order is restored.

Kierkegaard goes back in the bag and I turn on the TV. A

"menu" page comes up telling me to press *44 for television, but apparently I hit the wrong command because a page comes up saying *We have received your order for 44 showings of Chris O'Don-nell's* The Bachelor. *A charge of $393.84 cents has been added to your bill. Your 44 showings of* The Bachelor *are loading. Please wait.*

I wrestle with the remote for a minute and get control of the TV. Here's the E![1] network's fifteen-part series on the history of the panty. CBS is counterprogramming with something called *Breast's End*. Fox has *America's Nudest People*. Ah, Comedy Central is showing . . . here we go . . . No! *Encino Man!*

I click off the TV and look at my watch. I've killed exactly one minute and thirty-eight seconds. I'll call my family, I think.

My youngest son answers the phone. "Hi, Daddy, how are you?"

"I'm good. How is everything going with you guys?"

"We're going to make cookies. Good-bye, Daddy." He hangs up.

"Wait!" Oh well. Not much to report anyway.

I decide to order room service and take a shower. I am filled with a towering sense of achievement, having made such a huge decision. Soon I am ordering something chicken-based with aioli on or near it.

After double-checking to make sure I'm unwrapping the correct soap, that I don't use facial soap on my body, causing some sort of explosive chemical interaction, I begin showering, enjoying the seemingly endless supply of hot water. Twenty minutes later I step out soaking wet and quite naked to find a man standing outside my open bathroom door holding a tray with something chicken-based on it. I make a very unmanly screaming sound and begin grabbing towel after towel in an attempt to cover more and more of myself.

"I'm sorry, sir. I knocked, but you were in the shower. I have your chicken and aioli Napoleon. Where shall I put it?" he asks.

1. *E* is really a top quality vowel, and it stands on its own. There is, in my opinion, no need for the exclamation point.

I look away as though that will prevent him from seeing me.

"Just put it over there, anywhere," I say, flustered.

"Here, sir?" he says.

"Fine, fine."

He puts my sandwich under the bed, and then presents me with a bill.

"Fine," I say, writing $100 in the "tip" line so that the addition will be easy.

He leaves, and I stand in the middle of my room wearing a towel, eating a chicken sandwich, and watching *Encino Man*.

Only twelve days left to kill.

PESSIMISM: OVERRATED?

Forgive me, but as a school of thought, I hold little hope for pessimism. Perhaps if its results in real world situations were more encouraging, I would be disinclined to take such a dim view of it. But so far, in actual use, it has been a dismal failure.

I won't pretend that I know a great deal about Schopenhauer, because if I do pretend, you can bet that at some later time someone will come up to me and say, "Hey, you know a lot about Schopenhauer—did he write *The World as Will and Representation*?" I would then be forced to smile slightly and move my head around in the vaguest of motions.

"What does that mean?" the person will say. "Did he write it?"

I will then adopt a strange smug look and say, "Well, it sounds like something he'd write, doesn't it?"

"No, come on, a friend and I were goin' nuts trying to think of it. We really need to know."

"Well, what do you think, knowing what you know about him?" I'll ask him, making sure I have a clear path to the door.

"Hey, look, are you going to help me out or not?" the person will ask.

Then I'll have to raise my eyebrows and get, if possible, even smugger, saying, "I think in this case the patient must minister to himself."

"You don't know anything about him, do you?" he'll say, clearly pretty hot under the collar now. "Hey, Ernie, this guy faked his knowledge of Schopenhauer in that stupid book of his. Can y'imagine anything more lame?"

Ernie, who you can bet looks like Vasily Alexeyev, is bound to join his friend. "Man, I've always wanted a clear shot at someone who simulated knowledge about a philosopher."

And then, only my unique ability to whimper in a sympathetic fashion will save my life.

So, as I said, I don't know much about Schopenhauer, but he is generally credited with shaping pessimism as a school of thought. Now, just skimming over his philosophy, it's clear that he put a lot of thought into it. But one look at his hair will tell you he didn't really have a complete grip on the things going on around him. He wore muttonchops as well, and in my opinion, they are a style of whisker wholly incompatible with the creation of a decent school of systematic thought. If you do not have a Schopenhauer portrait near at hand, think of a joyless Martin Van Buren and you'll come close.

Said Schopenhauer, "Unless *suffering* is the direct and immediate object of life, our existence must entirely fail of its aim." This, then, is the explanation for his hair—he believed in suffering so much that he took it upon himself to use his own grooming habits as a tool to inflict it on others.

Still, a person's hairstyle should not be the sole criterion for judging his philosophy. It should be given great weight, certainly, but a philosophy is without value until it is actually applied to the human condition it attempts to explain. So, let us apply pessimism in several different real-life applications and see how it fares.

SITUATION #1:

Debbie owns a candy shop in a strip mall in Shorewood, Minnesota. Her divinity supplier, Susan, makes frequent visits to check divinity inventory and tell Debbie about some of the exciting changes in divinity. Debbie is friendly with her and decides to ask her to a social event:

> *Debbie:* Say, Susan, my husband and I go boating every Fourth of July. Would you like to join us out on the lake this year?
> *Susan:* (*kills self*)

SITUATION #2:

Jason can't remember the directions to The Gap near his home. So he checks The Gap store locator on-line, but it isn't working, so he calls directory assistance.

> *Jason:* I need the address for The Gap in Crestwood Hills.
> *Directory Assistance Operator:* I'd be happy to help you with that, just one moment, sir. (Ends life.)

SITUATION #3:

Erik is a freelance daredevil. One day he kills himself.

Yes, the only practical application of Schopenhauer's pessimism that makes any sense is suicide, which is why colleges tend to teach about him toward the end of the academic year. Schopenhauer was, not surprisingly, a great proponent of suicide, although he did not apply it to himself (hmm).

Of course it's only natural to ask of someone who invents a philosophy, "How did it work out for you?" It should not come as terribly shocking news that Schopenhauer was a disagreeable loner who never married and in fact hated women. People often said of him, "Wow! I mean, even for a pessimist, that guy's a jerk."

Imagine that you are, say, a nineteenth-century sausage maker whose wife's cousin's brother is a friend of Schopenhauer, so he finagles an invite to a cookout at your place:

> *You:* Say—Arthur, was it? Right. Say, pass that onion dip over here, will you?
>
> *Arthur Schopenhauer:* The best consolation in misfortune or affliction of any kind will be the thought of other people who are in a still worse plight than yourself; and this is a form of consolation open to everyone. But what an awful fate this means for mankind as a whole! We are like lambs in a field, disporting themselves under the eye of the butcher, who chooses out first one and then another for his prey. So it is that in our good days we are all unconscious of the evil Fate may have presently in store for us—sickness, poverty, mutilation, loss of sight or reason.
>
> *You:* Uh-huh. Just give me the damn dip.

Schopenhauer invented his own complicated system of thought involving a universal and ultimately cruel "will" just so he could feel free in his own life to be an obnoxious ass and take no responsibility for his stupid hair!

Most people just dabble in pessimism, of course, choosing to apply it at times when something is required of them. "All right, let's go move that piano," says a friend. "What's the point?" responds the pessimist. "The universe is a cruel joke and we're all going to die." Yet the same person, when handed a really good imported beer, won't say, "No. You keep your delicious porter. Life is never-ending suffering and there is no balm in Gilead."

The entire concept of pessimism crumbles the moment one human being puts aside thoughts of self and reaches out to another to minister to her suffering. The experience of either person can neither be denied nor adequately explained by a negative philosophy.

I hate to be so negative about pessimism, but there it is.

PORTAL TO HELL:
THE RADIOSHACK EXPERIENCE

Ask anyone what a typical electronics store should smell like and you're likely to get an answer like "batteries" or "wire nuts," possibly "capacitors." No one I've ever asked—and that's hundreds of people—has answered by saying "pungent body odor." And yet, you go into your typical RadioShack and that's what you're likely to smell first. As we all know, there can be no pungent body odor without a pungent body, and the most pungent in the Shack is usually that of the clerk.

Most people find the average RS clerk's frequent tentative, reptilelike movements made several feet behind their left shoulder to be somewhat, well, creepy. Add to this the explosive attempts to clear their throats, or the undisguised adjusting of undergarments, and you've got a somewhat unsettling customer experience.

Let's back up a little and take a look at what might cause your average person to have to go to a RadioShack in the first place (it is an a priori assumption that one does not *want* to go to RadioShack). Perhaps you ran the vacuum cleaner over a lamp

cord, chewing it up, and you need some more lamp cord. That's the only reason I can think of.

Every other visitor to RadioShack is either lost or is a very confused guy who thought the sign said CHICKEN SHACK. Yet with only their one slim consumer need, RadioShack has built a network of 7,100 stores, or "shacks," around the world. Their corporate literature makes this claim: *It is estimated that 94 percent of all Americans live or work within five minutes of a RadioShack store or dealer.* That actually sounds like a threat to me. It means that at any moment, they could mobilize their army of more than 7,100 odoriferous men with ill-fitting and stained shirts. Using nothing but lamp cord and cheap Korean-made remote-control cars, they could seize control of the civilian population, toss out our president, and declare one of their own "Ham Radio Operator for Life."

Unlikely, you say? Maybe. Well, yes. And that chilling scenario may possibly be fueled by resentment over being asked, when purchasing eighty-four cents' worth of lamp cord at my local store, "Home phone number?" I don't mean to be rude, but I can't imagine ever wanting to chat with any member of the RadioShack organization about my lamp cord purchase. I can all too readily imagine how that conversation might go:

> **RadioShack Guy** *(gruffly. half-whispered. menacingly):* Mr. Nelson?
>
> **Me:** Yes?
>
> **RadioShack Guy** *(conspiratorially):* How's that lamp cord working out for you? Is it conducting AC power from the wall outlet over to the lamp?
>
> **Me** *(frightened. panicky. half-weepy):* Y-yes. What do you want?
>
> **RadioShack Guy** *(in control now):* You wanna know some other uses for lamp cord? Powerful uses? Uses a mind like yours could never even imagine? If so, wave out your window. I'm in the blue Chevy Corsica parked in your alley.

Because I was certain such a scenario would soon come true, I refused to give out my phone number, and the thin, odd-whiskered fellow got huffy and said they needed it to track their customer base, presumably for the upcoming coup. He produced more body odor and dispensed it in my direction in preparation for attempting to sell me an extended warranty, which I also refused. He then presented the oddest document I'd ever in my life seen, and for whatever reason, I've seen my share of odd documents. It stated that the undersigned had heard the extended warranty pitch and, of his own free will, was refusing to purchase it. He rather firmly demanded that I sign it. Though I was reasonably certain he would intercept and record my phone conversations for the rest of his life, I refused to sign the document.

Our relationship was now at its coolest point ever. He gave me my change and my lamp cord without even offering me a catalog featuring their best-selling RCA-to-mini-plug adapters.

Since RadioShack obviously fills a 7,100-store need for lamp cord, how could the experience be made more friendly for the lamp cord consumer? Well, here's what I'd do if I owned a franchise.

First, I'd despair and wonder what my life had come to. Then I'd panic and try to sell it, but of course, there'd be no takers. I'd start drinking, become sullen, and resent my friends' success. After the intervention, I'd grow to accept my position with a certain tired resignation and come to realize I have to actually start making money.

That's where my full line of Peach Salsas comes in. They have a nice, subtle heat combined with a fruity sweetness that complements so many snacks, as well as making a flavorful coating for roasts and chicken.

I'd sneak them on the shelf alongside the indoor/outdoor speakers, hoping people who hold patio parties might like to try something new in the way of fruit salsas. If I did no more than $700 a month on the fruit salsas, I'd already be doing ten times the gross

of the electronics part of the business. Perhaps then would be the time to strike with the barbecue sauces.

At the same time, I'd lure people into the store by displaying exotic caged animals, obtained illegally through Internet sources. My coatis, capybaras, and Spanish lynxes would be my biggest draws. I'd add bearbaiting and watch the profits rise.

Of course, my success would draw the ire of RadioShack's top brass, because my activities could potentially be seen as being a little off mission. Before long, I'd get an unpleasant visit from RS's acting CEO and top shareholder, Margaret Shack-Hollis (or whatever her name is), and I'd lose the franchise. Time to start drinking again.

Anyway, one of the innovations from my store that RadioShack could take into the focus group stage would be the way I kept a thick blanket of furry grime and dust from settling on the many hundreds of blister packs (I *would* do that—when I wasn't importing rare cats). It's my theory that stores are far more user-friendly if the customer isn't worried about contracting the hantavirus while purchasing a Y-connector.

If RadioShack divests itself of the whole "electronic parts" thing, gets into the salsa game, and cuts back on the offensive BO level, they've got a chance. Otherwise, I give them thirty, forty years, tops.

A VERY UNHEALTHY CLUB

Do you think a representative from the Old Guys Who Like to Hang Around the Health Club Locker Room Wearing Absolutely Nothing for Extended Periods of Time could give me a call and explain your position (and not "splayed out on the chair by the shower" please, because I've already seen that plenty)?

I don't mean to knock anybody's hobbies, but by a very, very large degree, those hobbies where you are not required to display your aged scrotum to the world are favored by ours, and many other cultures. There must be *something* to this, wouldn't you think? I ask you to simply look around the health club locker room—okay, that's long enough—and note just how many people *aren't* sitting naked save for shower shoes, splayed out in chairs and reading the *Wall Street Journal*. Note the care taken by all to keep the amount of time one is displaying one's genitalia to a minimum.

"Oh, lighten up," I hear you saying. "This is man's natural state." I would lighten up, except I can't. I'm very tense because I can see your withered nut sack. And if keeping oneself in man's natural

state is inherently desirable, why do you own clothes at all? Or a house? Is your theoretical "natural man" really allowed to have a health club membership? Shouldn't you and Australopithecus be out leaping around the woods throwing sharpened sticks at an ibex? And how do the shower shoes, the plastic beach chair, and the extraordinary amount of displaying going on fit in with your hastily thrown together "man's natural state" argument?

As to your powdering your lower area with talc over by the sink, leaving great dunes of you-fouled talc, I'm afraid I'm going to have to be firm on this one: stop it. I won't listen to any of your arguments on this point. Nothing, I don't care what it is, that has glanced off your inner thigh, should be allowed to rest on the floor of a "health club." Frankly, and perhaps a touch graphically, I can't imagine any amount of talc, even that Sam's Club promotional size you carry around, is going to improve the situation much.

Why are these same naked men always the ones who want to talk to us, the be-toweled people?

"Hey there, young fella. Get in some tennis today?" they shout (they always shout) despite the fact that the tiled area they prowl magnifies sound a hundredfold.

"Yep, got some tennis in, and now *I'm fully wrapped up in a towel so I don't nauseate the others*!" I want to shout back.

"Good, good. Say, my scrotum is very old and leathery!"

No, they don't say that out loud, but they apparently want it to be clear to everyone.

Often, while dressing myself—as rapidly as possible—I'll hear some poor sap actually engage the shouting naked man.

"Oh, that steam does a body good, huh, young fella?" shouts old tobacco pouch.

Then a reply I can't make out, though I think I detect a note of despair in the low tones, as though the speaker just saw something dusty and gruesome.

"Yup. The old club on this site had just a grand steam bath," comes the old man's ear-rending reply.

Then more tragic mumbling. Then the nude old fellow does something that most every nude old fellow I've ever known does. He brings up the names of absent people the person on the other end of the conversation couldn't possibly know.

"Willard and Bobby used to use that, before they went to Coral Gables."

Silence from the other man as he thinks to himself, "Who are Willard and Bobby? A skating team? People famous enough for using the steam bath that I should know about them? Do *I* know this guy, the naked one? Good Lord, is he one of my wife's relatives and I don't recognize him with his reproductive organs all visible? Where am I?"

And then he becomes unmoored from reality forever.

Why do you think old shouting naked men do this, refer to unknown third parties? Is it because they've been hit by their own pieces of toenail shrapnel too many times to count? Shouting naked old men have a propensity to prop one leg at a time up on the locker-room bench (agghhhh), and go at their twisted, horny yellow toenails with a clipper the size of hedge shears. Pointy, brittle fragments break off the nail and are propelled in any given direction at twice the speed of sound. If just one of them flies straight up and hits him in the head, the brain damage can be permanent. And just think, after all those years of horny, fungus-damaged toenail clipping that guy has done, how many he's taken to the noggin!

What's disturbing about these geezers is how they seem to be teaching the younger health club patrons, and I mean guys in their twenties, thirties, forties, fifties, sixties, and seventies, their bad habits. The younger nude guys don't lounge and splay, as a rule, but they do go about their grooming at the sinks in the altogether. Aren't they cold? Aren't they horrible? I would imagine so and yes, respectively.

When I crouch down to rinse my razor and rise back up, I expect to see only one thing in my mirror: my partially shaved face—

repugnant, yes, but I've grown used to it—not a naked pink, hairy, apelike man. If I want to see that, I'll drop my own towel.

Another request. When we're in the locker room together, men (and remember, we're only there because we have to be. This is no social event), you should absolutely refrain from making any comments that refer to another man's body. Saying, "Hey, you've lost a little weight," though on the surface complimentary, is in fact extremely menacing. It means you've *looked* at me. You've violated the implied code wherein we all agreed that when we're in a locker room, we keep our eyes as high as possible while still allowing for navigation, and we ignore with all our strength of will that any single one of us is naked. We are not naked when we are in there, no matter how naked we are, do you understand?

WE'RE SAVED!
THE TROUBLE TICKET IS IN!

Even in the good old days, I don't imagine it was ever fought over by family members to see who would get the honor of calling to talk to customer service. But things have degraded considerably, and in a recent poll, rather than call a service department, people overwhelmingly preferred "crunching down on a glass capsule of cyanide with my molars."

Part of the problem is that the One Company that now owns everything has a new strategy to try to ensure that you'll never call them. They've begun to instruct their "customer care" people to use their own internal jargon in the hope, I suppose, that you'll be dazzled or maybe confused and just go away.

Because I have a speakerphone, I was once able to wait out the phone queue, keeping busy as I waited, even managing to complete the life-size reproduction of *Kon-Tiki* I had begun right after dialing. If I had doubts that they were actually answering calls in the order they were being received, I didn't let them gnaw at me too much. Finally, just as I was rigging the sails:

"Goodafternoonyou'vereachedtheContekglomcustomerservice linethisisTomhowmayIhelpyou?"

"Hi, Tom," I say, "Say, I tried to add caller ID to my phone, but you people disconnected my line, so now my family and all my friends are getting a message that my phone is disconnected, and I'm sure they're concerned. Oh, and your service guy burned my garage down, too."

"I'dbehappytohelpwiththatsircanyouhangonforoneminuteplease?" and he's gone. Five, six minutes go by. I was certain he'd simply hung up when he came back on.

"I went ahead and did a refresh on that," he said.

"I'm sorry."

"I went ahead and did a refresh on that."

"You . . . did a . . . ?"

"I went ahead and did a refresh on that."

Tom! You maverick. After going away for only five minutes you, on your own, went right ahead and did a refresh?! I can't believe you just "went ahead" and did that! Are you even allowed to go right ahead and do that? *NOW, WHAT IN THE NAME OF MA BELL IS A REFRESH??* Did you run a light steam iron over my bill, or give my phone line a glass of iced tea? Now that I have this cryptic "refresh" information, am I supposed to update my will to reflect a change stating that I bequeath everything I have to the only people who were kind enough to go ahead and "refresh" my phone problems for me? Tom? Tom, you're my eyes and ears on the inside there, help me, Tom! I thought. But of course I did not say it.

It mirrored my experience calling a wireless phone company when I spoke to a woman who was so crabby, I felt she certain she must have just finished calling to get service on *her* phone.

She told me, "I put that ticket in, sir."

"I don't know what that means," I said.

"I put the ticket in."

"Are we going to a show later, you and I?"

"Sir?"

"What does it mean that you put a ticket in?"

"I put a trouble ticket in for you, sir."

Slightly restating things without offering explanation is another defense mechanism of the modern customer-service representative.

"I'm sorry, I don't mean to be dense," I said, "but I don't know what that means."

She spoke louder and more slowly.

"I PUT THAT TROUBLE TICKET IN FOR YOU," she said.

Then I made a very large miscalculation. I tried to get cute.

"Oh. Okay, good, well, I'll finish that Smeelie form and do an eight-nine-over on it."

"Sir?"

"I'll finish that Smeelie form and do an eight-nine-over on it."

"You'll have to say that again, sir."

"The four-oh Smeelie form? I'm going to do an eight-nine-over on it."

"Sir, I will need you to say that one more time."

"THE SMEELIE FORM?! I'M GOING TO DO AN EIGHT-NINE-OVER ON IT."

As soon as they sense you're back-sassing them, they send you into the outer darkness. That's a method they have of putting you on hold but very subtly causing you to doubt whether you're on hold or whether you got cut off. The stakes are very high, of course, and they know that, so they add very faint clicking noises to the line.

"No! Noooo! They cut me off," you think. But then there is the faint click again that convinces you to hang on for a little while longer.

"Please, no! I'm sorry I talked back. I'm very grateful you manipulated my ticket and it was insensitive of me to doubt that it was for any reason other than my own extreme well-being! Please, don't leave me here!" I cry.

Like a scraping noise in a deserted mansion, it's your imagination filling in the void that makes it so horrible.

"It's clicking over to the CEO's line now, he's going to offer an apology and fifty free phones. AH! Another click. I'm cut off! No, one more click. Their parent company has my home loan—they're calling my loan for making trouble about the ticket! No, they're signal-

ing their twenty-four-hour Kill Truck, I've heard about these things! It's headed here now. They're keeping me on the line so the hit will be cleaner! (How come they're so efficient with this kind of thing?)"

And on and on, and of course, eventually you hear, "If you'd like to make a call, please hang up . . ."

Yes, they can and do just hang up on you. It's not as though it's ever going to get back to them. You don't call back and get the woman next to her, who then hits the first woman on the shoulder for passing the buck to her. You call back and get someone three thousand miles away who is even more indifferent to your suffering.

Here's one I got from our phone company:

> *Me:* Say, I waited around all day at my unfurnished office for your service person, and he never showed up. What—
> *Guy:* I know. Can you believe these guys? You write it right on the tickets, "is waiting there," but do you think they care? It's hopeless.
> *Me:* These are your guys, right?
> *Guy:* Yeah. They're terrible. It's unbelievably hard to get good workers.
> *Me:* Perhaps a new and rigorous training program would help?
> *Guy:* Ah, we tried that.
> *Me:* Well, benefits, perhaps, or creating a sense of owner-ship in the company?
> *Guy:* Hmm, not a bad idea. We'll give it a shot.
> *Me:* Great, and you'll call me if there's any problem?
> *Guy:* I sure will.
> *Me:* Okay, I'll follow up in the next couple of days to make sure you got what you needed from my department. Thank you for calling Michael J. Nelson and you have a great day.
> *Guy:* Thanks, bye.

Finally, some good service.

Hey!

Some of the best advice I ever got was, "Start climbing on the shelves." How true it is.

Wait, that needs some context in order to blossom into truly sage advice.

The advice refers to the best way to get service at a Home Depot, or any of the other 4,400 hectare-size stores that spring up one per night around the country.

To keep costs down and choke out the hometown competition, they tend to staff them with one service person per one thousand hectares of store, one competent person per region. This means, of course, that service people are hard to find, and even if you see one, she could be three football fields away. By the time you got to the spot you saw her, she could have punched out and been home in bed for several hours already.

Hence the advice. If you mount their shelving and begin making a break for the ceiling, one of their blue-laser motion detectors will pick you up, and unless there's a software flaw, won't fire the

antipersonnel surface-to-shelving missiles on you immediately, but rather send a service person to see what you're up to, and recommend a course of punishment. But since there is nothing explicitly illegal about climbing on shelving, the law prohibits them from spraying Mace into your eyes and subduing you with plastic cable ties. Now you have a service person to tell you where the butterfly bolts are, and you're clean as far as the courts are concerned. That's the beauty of it.

I can't recommend you do this at Baccarat Crystal Depot, or Baby Mouse Warehouse, because you might damage the goods, and then, I believe, the law allows them to beat you freely with those telescoping billy clubs and invoke RICO laws to take your house.

What happened? How did our stores get so big that we could flood them and re-create sea battles if we wanted to (and who doesn't!)? Back in my day—and I'm still trying to figure out when that was, or if I had a day at all—we used to be able to go into stores and walk clear to the other side of them in one afternoon. Now the cereal aisle alone is longer than the Appian Way.

The reason for all this retail gigantism is that somewhere along the line, the average consumer noted one day that his truck is bigger than any eighteen wheeler and assumed that there was no longer any reason to go to a retailer. If canned mushroom pieces and stems are going for 18.5 cents an ounce for the fifty-pound can at Sam's Club, why should he pay 18.8 cents an ounce for an eight ounce can from the little store owned by his neighbor Arnold, who watched his kids when his third child was being born? That's right, there is no reason, no reason in the world.

The problem is that even people who find Greyhound terminals breathtakingly lovely think the average superstore is an aesthetic scourge on the landscape. And one Cat Litter Warehouse takes up the room of six airports for its parking lot alone. Further, people are routinely found unconscious in their cars, their left turn signal clicking away, dehydrated and in shock, having been waiting for upward of a week for the signal to change.

I have a solution: actual depots. Yes, individual train depots terminating at everybody's house, bringing full freight cars of Cracklin' Oat Bran to every member of the family like clockwork. And people like trains, for the most part, as long as the Woody Guthrie sing-alongs are kept to a minimum.

If we commit some odd billion dollars to infrastructure now, we could easily drive the price of mushroom pieces and stems down to 17.9 cents an ounce for a metric ton.

ONE AT A TIME

As you speed down the freeway in your Range Rover, you sip gently at a steaming breve latte and nibble on a low-fat scone, your Samsung flip phone wedged between shoulder and head as you "drill down" on a couple points with Stevenson on that Citibank account. You smooth back your Pat Riley hair and let the driver in front of you know she should get out of the passing lane by pulling up to within several inches of her bumper. Stevenson raises a dubious point, so you give him a "hell-o?" and "circle back" on the issue, promising to work "twenty-four/seven" if necessary to resolve it. You agree to meet him later for a Macanudo at Club Ashé and sign off. You enter the appointment in your Visor and then attempt to log in to Schwab.com on the wireless Web while taking a corner with one hand on the steering wheel.

During your short trip to work, you have violated no fewer than sixteen laws of the implied contract with your fellowman. The evidence is irrefutable: you are an obnoxious ass.

Perhaps this comes as a shock to you, or more likely, you've

known about it for some time and just haven't got around to doing anything to remedy it. "Yes, I'm an obnoxious ass," you say, "but it's hard for me to do anything about it because I don't care—because I'm an obnoxious ass!" Not being an ass doesn't have to be the sacrifice that you think it does, if you simply pare down the ways in which you plan to be an insufferable jerk.

A few suggestions:

Get rid of the Range Rover. You are not responsible for patrolling Australia's Dingo Barrier Fence, nor do you work the Savannah, capturing and tagging wildebeests. (It's unlikely that you'll get such a job anytime soon, as new hires for either position are seldom former operations finance managers at Pillsbury.) At no time are you in any danger of high-centering on the exposed root of a banyan tree, so you don't need the twenty-four inches of ground clearance a Range Rover provides. The speed bumps at the Ridgedale Mall are formidable, but nothing that can't be competently handled by the suspension and clearance of a Dodge Stratus. Also, the Range Rover's curb weight of 7,500 metric tons[1] allows it to post only forty-eight feet per gallon of gas, which, with its eighty-gallon gas tank, gives it a range of 3,840 feet, or just a few furlongs short of a mile, a fairly limited range for a vehicle with heated headrests.

So what to do with it? Well, you can't sell it because the only potential buyer, the Queensland Australia Department of Natural Resources, just purchased two used diesel pickup trucks, so they're set. If you have children of driving age, you could give it to them, but because of the truck's high center of gravity, there's a 97 percent chance that they'll roll it within fifty seconds of moving the seat forward, so best not do that.

My suggestion is that you use it as a lawn tractor. You can mow, fertilize, and reseed on any grade hill in total comfort while listening to Vonda Shepard on the Bose eight-speaker surround system.

Now, on to the matter of your drinking froufrou coffee drinks while driving. You mustn't. It's unseemly. You don't drive around

1. Fully loaded with gym bag and two (2) *Maxim* magazines.

drinking TGI Friday's Peach Blow Fizzes, or eating large slices of custard-topped trifle, because you instinctively understand that to do so would be to bring shame on yourself and your family. So should it be with macchiatos and café americanos. Oh, they're fine for Italians, but so was Mussolini. Straightforward infusions of coffee and water are a better choice, but neither should they be drunk in the car due to the extreme risk of singeing one's lap.

Don't abandon the coffee drinks and make the lateral move to the gigantic 7-Eleven–style sodas either. In my opinion, one shared by many doctors, you should not be able to take a sitz bath in your drink. If you spill a beverage of that size while driving, it can easily fill the average car up to the level of the rearview mirror, making lane changes difficult, and the sloshing of the soda in the passenger compartment can interfere with first-generation antilock braking systems.

As for your Pat Riley–style, unguent-saturated hair: it's time to launder it. Your hair obviously does not produce enough friction to warrant heavy industrial lubrication, and even if for some reason you use your hair in a manner that might cause it to spark or scorch from heavy wear, the amount of oil emitted by your scalp should be sufficiently unctuous. Deliberately exaggerating natural scalp emissions is a questionable course to begin with. It begs the question: Why the extra oil? Why not pack your hair with fistfuls of man-made dandruff flakes? Or save all your shed hair and mix as much of it as you can back in with your attached hair? Why not? I ask you.

It's important to remember as well that, of the whole of the animal kingdom, Pat Riley most resembles a monitor lizard. How much the hairstyle contributes to this, I cannot say, but I would guess partly—the scaly skin, tapered neck, diet of small mammals, and virulent, often fatal bite being larger contributing factors.

Abstaining from rubbing tallow in the hair does not give you tacit permission to grow a pointy devil beard (also known as a Vandyke, after Jerry), for if you do, you are in danger of being mistaken for a talent agent, or former ace pitcher Jack McDowell, and neither is

desirable. People may approach you with character outlines for sit-coms with monkeys in them, or ask you to take the mound against Cleveland in the first game of a double dipper at the Metrodome.

Another thing you'll need to do to achieve your goal is to take out your cell phone, gently set it on a farrier's anvil, and being careful not to knock it off the anvil and damage it, grasp a good-quality two-pound crosspein hammer and carefully pulverize the thing. When you're done, double-check your work to make sure no single piece is larger than one half inch square. Now put the pieces in a large stone mortar and grind them with the pestle until the phone is completely powdered. Burn the powder, bury the ashes, and never talk on a cell phone ever again.

You'll probably have withdrawal symptoms, including the urge to begin shouting into your hand while standing in line at the deli counter. It's all right, at least for a little while, to give in to the urge. When it's your turn to order say, loudly now, "Yeah, hang on," and then to your hand, "What? Oh, you're kidding me. I sent that invoice weeks ago. Tell Sharon to refax it and—hang on." Then to the deli counter worker, "Yeah, get me a couple pounds of shaved ham and some sliced provolone, could you, sporto?" Then go back to shouting into your hand, ignoring the poignant, pleading look of the counter worker, who's trying to interrupt and find out whether you want baked or Dutch ham. "S-sir? Sir . . . ?" he'll say. Interrupt the shouting with a good deal of disgust. "Yeah, Hal, hang on, some-body's yapping at me here—DO YOU MIND? I AM TALKING TO HAL ABOUT THAT INVOICE HERE!"

Driving, too, will seem strange, what with your newfound aware-ness of the road upon which you travel. During the first few com-mutes you may want to refinish a hutch or do detail painting on an intricate Civil War diorama to recapture the thoroughly distracted feeling of talking on a cell phone. Or you might want to just side-swipe a few Saturns until you get used to it.

If you follow through on these suggestions, will you no longer be an obnoxious ass? You probably still will be. But at least you won't leave greasy head stains on people's easy chairs.

DEAR PERSON
WHO I AM WRITING:

Given the unsettled state of modern business correspondence, is it any wonder that most people prefer to avoid it altogether by quitting the business world and getting into the burgeoning field of sweeping up after parades?

The issues involved in writing even the simplest business letter are myriad and byzantine, and possibly many other words with a *y* in them. Say, for example, you want to write one M. Sarah Yasmine Hamish of the H. Walters Plating Company to check prices on getting some things coated in zinc that you've been meaning to get coated for some time now. A friend gave you her card after she'd had a great experience getting some of her stuff cadmium-plated. Luckily for you, the card indicates that she'll give you a quote by E-mail—*OR IS IT LUCKY FOR YOU?* It's hard to say, but no matter what the results, the situation certainly didn't call for my giant uppercase and italic rhetorical device. For this I am sorry. Anyway, you grab yourself a Mr. Pibb and go to your computer to send out a request for an E-mail quote.

Sitting down, you immediately spill the Mr. Pibb onto your keyboard, and in your haste to pick it up before all of it spills, you accidentally dump half the can directly into the hard drive and another quarter of the can into the floppy drive (don't ask me how that's possible, but it happens every day—just not to the same person).

Three months later, after the computer has come back from being repaired, you send it back again, because they claim they couldn't find anything wrong with it, even though it doesn't work and there are huge brown, sticky stains all over it.

Four months later, you're back in business and you start again, this time *without the Mr. Pibb.* (You've got a tumbler of Sports Shake instead.)

How to begin? You start with *Dear Sarah,* and instantly realize how silly that sounds. She is not dear to you. If she does a decent job of quoting her company's electroplating prices, you will have a generally fond opinion of her, but even then she won't be dear. After all, she's a salesperson in the metallurgy business, not your beloved gingerbread-baking Tanta JoJo. But no salutation at all looks very strange, so you try others. Soon your rejected list grows.

> Hello, M. Sarah!
> Hey, M. Yasmine Hamish.
> What up, Hamish?
> Yo: What in the tarnation is M. Sarah Yasmine Hamish? Anyway,

Might as well just abandon the salutation, no matter how strange the lack of it may look.

You decide to lead with *Sarah Yasmine Hamish* and realize that you have no idea what the *M.* is and if it's appropriate to leave it off. Is it another one of her many names, or is it short for Miss, Missus, Miz, or possibly Mister? Best leave it in there. Yet the whole name printed looks utterly absurd, so you make a try at shortening

it. *M. Hamish,* you type, and then realize that, though there was no hyphen present as a clue, you still may have cut off half of her (or his—there's still that remote chance) name.

Now you are compelled to forgo the name and the salutation and just jump into the body of the letter. *I want to get a quote from you,* you begin. Terrible. Possibly threatening. Better have some kind of salutation. *Hello,* you write, afraid you'll come off like a variety-show MC who has locked up onstage. *Greetings!* you write, leaving open the possibility that this Hamish character will think you're an ESL student trolling for some American woman to marry him.

Frustrated, you begin typing wildly, resolving to send it off without reviewing it further.

```
I jsut ned a q utoe no some pices I want to hve
eclectorpaetd!!!!!! OkAY!?
```

. . . you type and hit "send."

Several hours later, an E-mail comes in:

```
Dear little boy or girl,
Always ask your parents before using the computer,
okay?
Thank you,
M. Sarah Yasmine Hamish
```

You're angry, but your need for electroplating has intensified over the past few months, so you give it another go.

```
M. Sarah Yasmine Hamish,
Sorry, I accidentally hit "send" on my computer
before I reviewed the body text of my correspon-
dence to you.
I was just wondering if I could send you a list of
```

things I needed electroplated so that I might get a
quote from you?
 Yours,
 (Theoretical Electroplating Services Needer)

And you get this back a few hours later:

Dear (Theoretical Electropating Services Needer),
 I am sorry, I thought you were an infant. I would
be happy to provide you with a quote if you will
only include a list of the items.
 Best,
 M. Sarah Yasmine Hamish
 H. Walters Plating Services

Relieved that you've made progress, you write back:

Dear M. Sarah Yasmine Hamish,
 Here is a list of the items that I need electro-
plated (in zinc, please).
 A wrench (I bought it unplated at a substantially
reduced cost!)
 Three (3) roofing nails
 A photo of my aunt Wilma (it's okay that her face
will be covered by the plating)
 Thank you for your time and attention to this,
 Best,
 (Theoretical Provider of Theoretical List)
 P.S. Please don't think me too forward, but may
 I ask the meaning of the *M.* in M. Sarah Yasmine
Hamish? (Very pretty name—just wondering!)

And again, several hours later, you get this:

(Theoretical Provider of Theoretical List):
Your creepy and threatening E-mail to me has been
forwarded to the FBI and a request has been made
that your mail server be impounded as evidence.
Never contact me again.
P.S. You'll have plenty of time to zinc-plate
things—IN PRISON, CREEP!

And I'm sorry, but the Parade Sweepers' Union doesn't admit
people with a criminal record.

PART
TWO

But Is It Art?

OR WE COULD SEE A MOVIE?

If someone ever says to you, "Hey! Let's go see some performance art!" I strongly advise you to handcuff yourself quickly to a railing.

But the odds are that it will more likely go something like this:

"Well. I suppose we ought to go see that Medea ex Machina show at the Bleeding Vein Theater. It got a good review in one of those free newspapers they give away over by the university."

Whether this is true or not, simply respond, "I think that closed already," and I guarantee the matter will be over.

It's usually extenuating circumstances that cause a person to end up seeing performance art. Perhaps someone you don't know very well suggests it, meaning, "We must get together soon," but accidentally saying, "Maybe we should go see *A Showcase of Broken People?*" And you say, "That sounds great," because you don't want to be rude, but you'd really rather insulate an attic with no shirt on.

And you forget about it until the person calls you up the next week and says, "Hey, clear your Friday night!"

"Okay, I will. What are we doing?" you ask excitedly.

"Only seeing *A Showcase of Broken People*," says your friend with mock importance, hoping with all her heart you'll say, "I will throw myself into the wolf exhibit at the zoo before I will see that with you."

Instead, you say, "Oh, great. I can't believe you got tickets," meaning, "I can't #˙&#$ believe you got tickets!"

So come Friday, you find yourself in a rough part of town, having parked near a Dumpster, standing in the lobby of a theater that smells of some exotic mold spore, ordering Milk Duds from a guy dressed as Carol Channing.

"Wow, this is so fun," says your friend, hoping you'll pick up on the subtext, which says, "Can we please go somewhere else, right now? Just drop the stale Milk Duds and run? Please?"

"It is. It's so colorful," you say, looking at the dark stains on the ceiling.

The show starts promisingly enough. A topless woman with the yin/yang symbol painted on her chest leaps around holding a purple ribbon, stopping her leaping every half minute or so to say in a screechy voice, "Which way noooooowwwww?"

This is funny for about five minutes (though you quickly learn it's not supposed to be funny at all, as the majority of the audience turns on you looking as though you'd just belched loudly during Easter mass), but it grows tiring toward the end of the second ten minutes. "Mmm," says the audience when it's over, and they nod soberly.

Next, after an agonizingly long scene change, someone covers the John Cage hit *4´33˝* in which a performer sits at a piano doing nothing for four minutes and thirty-three seconds. Only this person takes it at a pretty slow tempo.

Then a little puppet set is placed on stage and a Punch and Judy routine gets under way. It starts as light, amusing farce but quickly devolves into the most violent and disturbing display you've ever seen. It is a crowd favorite. "That was interesting," whispers your

friend when it's over. You are relieved to see that she, too, is rocked to the core.

Next, a straightforward bit of self-confession in the form of a dull monologue. And then, intermission.

"This is great," says your friend. "I'm so glad you suggested this."

You let it pass and look at your watch. "Wow," you say.

"What?" asks your friend, getting very near the issue at hand.

"Oh, I'm just surprised."

"Oh, why?" asks your friend, and you both realize you are a mere sentence away from liberation.

Suddenly the lights begin flashing and you head back in the theater.

Act II starts listlessly, with a small group of people simply fondling each other, and ends several hours later with thirty-five minutes of ear-damaging guitar feedback. Sandwiched between are all manner of horrors.

When it is over, you and your friend part ways and never speak to each other again.

To avoid such a misunderstanding in the future, it might be helpful to keep a list next to the phone titled *Things I'd Rather Do Than See Performance Art*, detailing a hefty number of various atrocities.

Take a moment and do it now. You just may save a friendship.

UNGAINLY!: MY TRIUMPHS
IN THE MUSICAL THEATER

It is well known that most reasonable people shriek and cry upon seeing a two-hundred-pound man in a sailor suit propelling himself clumsily across the stage while warbling "Anything Goes." Still, the knowledge of that did not stop me from attempting a career in the musical theater, where I might visit all manner of similar horrors on pleasant and unsuspecting folk. I got into it for all the right reasons—to meet and woo a girl—but I didn't really think "musical theater" through to the end, when I would have to go onstage and perform "musical" numbers in an actual "theater" in front of other human beings.

It was my senior year of high school and the musical was Lerner and Loewe's *Brigadoon*. In case you've never seen it, here is a synopsis of the plot: in the eighteenth century, a small Scottish town inhabited entirely by charming people with magnificent voices is plagued by witches who kidnap villagers, brainwash them, and inculcate them into the witch way of life, which includes casting evil spells, making thick, Satan-pleasing communal stews, and

generally becoming quite a bit wartier (and eighteenth-century Scots were a pretty warty bunch to begin with!). Instead of doing the reasonable thing and burning witches by the hundreds without giving them a fair trial, the city fathers settle on a bold plan: they will offer a prayer to God that he cause the town and all the people in it to vanish into thin air. Without consulting the hundreds who will be affected by the proposed vanishing policy, they go ahead with their scheme. God, who on occasion has been known to grant people what they ask for and not what they actually need, does so in this case and the town vanishes, reappearing for one day one hundred years in the future, only to vanish again and reappear another hundred years in the future, and so on.

The originators of the plan were probably relying on bad information and faulty logic. They overlooked the possibility that a hundred years in the future, the witches might have made quite a bit of progress in their own plan to turn the earth into a witch-based society. Or the town might reappear in its spot again only to find that in the intervening century it had become the site of the McGonegal Light Industrial Office Park and the citizens could end up in the commissary standing in someone's cock-a-leekie soup. Or, barring that, that two modern New Yorkers might stumble into the middle of their town and ruin everything.

Two modern New Yorkers, the dim Tommy Albright and Jeff Douglas, who is a professional alcoholic, stumble upon the village on its second century-spanning day after the "miracle." Since Jeff is bombed and Tommy is not the sharpest knife in the drawer, they don't notice that people are acting a little two-hundred-years-out-of-place. Tommy, who is already affianced, goes after the first lassie he sees, the fair Fiona, and falls in love. After asking enough people for the time and hearing, "It's two forty-five and the year is 1746," Tommy becomes suspicious. He is taken to a town elder, Mr. Lundie, who explains what has happened, and incredibly, Tommy believes him. Lundie also tells him of a rider to the miracle (that God allowed because of some vague language in the third paragraph of the

prayer) that an outside person may stay in Brigadoon if he truly loves one of the residents. Fiona gazes at Tommy with doe eyes. Tommy, a typical guy, says he can't imagine that ever being an issue.

The doe eyes eventually do get to Tommy and he decides to stay. Then, realizing that there is no place in Brigadoon to get a decent martini and a nice piece of fish, he changes his mind, explaining to Fiona that even though he's only known her a few hours, he feels like the relationship is suffocating him. Besides, like tourists who go to Mexico and after a few *cervezas* talk seriously about buying property, he's probably just under the spell of the place, what with its no running water, questionable sanitation, bland food, and constant bagpipe music. He and Jeff stay for a wedding, having a quick whiskey and a couple bites of wedding haggis, but then they're off to New York, glad to be heading back to a place with some decent truck fumes.

Tommy is adjusting to life back in New York when he starts to become haunted by visions of Brigadoon. He figures this must be love, so he coerces Jeff (that is, "gives him liquor") into heading back to Scotland with him. They go to the spot where Brigadoon was, a month or several millennia earlier, depending on who you are, and after a bit of whining, Lundie appears, hair on end, wearing a nightshirt, and takes him to Brigadoon, explaining, "If you love someone enough, anything is possible." (Mr. Lundie was deliberately being quaint, of course, for he must have known that no matter how much you love someone, it's still not possible to, say, eat a million crab cakes in one hour or turn rapidly back and forth from a human into a turtle.) Though it is left vague, the assumption is that Tommy's love "called" Brigadoon back from the future long enough for him to hop on before it had to take off again and fly roughly 3,100 years back into the future before morning. Did they make it back in time for morning, or did driving back to pick up Tommy throw off the schedule and send Brigadoon hurling into a black hole? Can Brigadoon handle the extra weight or was the town's capacity figured to the exact pound? We never find out.

In this epic story, I played Jeff, the drinker, while the object of my hopeless desire played Meg, the bawdy comic relief.

Some critics, that is "old ladies" and "my friends' parents," described my performance as "distracted," while others thought I was "different" or "just plain odd." My dancing, such as it was, seemed to particularly unsettle the crowd, and many of the men would leave in the middle of it to "warm up the car," though there were two hours left in the show. (I honestly don't think it was that bad, though I'll admit there may have been something sort of Fred Gwynne-ish about the way I moved.) All who saw me, though, agreed that I had a talent for scaring other human beings.

I believe my lackluster performance may have been due in large part to the fact that while I should have been speaking my lines, I could often be found asking out the poor girl who played Meg, pressing especially hard during crowd scenes.

Several factors worked against me in this regard: first, being comic relief in a bad high school musical does not bring one as much feminine attention as does playing lead guitar in a rock band, being the star quarterback, or even knowing how to spell the word *ham*. Secondly, the director had insisted that I grow a beard to make me look older, which I foolishly did.

I should explain that it was the very early eighties. Everyone in America was making a concerted effort to look shaggy and horrible and, not to brag, but I was better at that than perhaps anyone else. My hair was long and feathered, my clothing cheap, tight, and made entirely from petroleum-based fibers. It was also fashionable (at least among troubled loners like myself) to wear glasses with smoked lenses, and mine were as thick and off-putting as any out there.

So. Take this already horrible package and garnish it with a patchy, adolescent beard and you've got an appearance that causes women to run as quickly as they can to their nearest bulk pepper spray provider. I looked like a cross between Mark David Chapman and Waylon Jennings.

The girl was very sweet in rejecting me, using polite terms like, "You're really nice and all, but we should concentrate on the show," when what she was really thinking was, "Let English pub rock and Monty Python fill your empty spaces—just leave me alone."

I did as she might well have suggested.

It was several years before I performed in a musical again; the people who could have, and most certainly would have, stopped me were committed but disorganized. And they had scattered enough that it was safe to try again.

Wearing pleather boots that sagged around my ankles, cream tights, and shaggy feathered hair inspired by the lead singer of Loverboy, I leaped out on the stage of the University of Wisconsin (at River Falls) as King Arthur in *Camelot*. The audiences, packed mostly with stoic agriculture students, loved it, and they demonstrated their enthusiasm by showering me with silence and slight groans.

Halfway through the show, when the time came to explain to Lancelot what a picnic was, I misspoke my line. "You know, a picnic—you eat girls and chase grapes around trees," I said.

It is hard to win an audience back after saying something like that, and not something that should even be attempted while wearing cream tights.

I probably should have taken a small bow, stepped off the stage, walked down the aisle and out the door, several blocks down Second Street, and gotten a job at Bob's Big Boy, staying under Bob's employ for the rest of my natural life, but I felt a sense of duty to the play and the grape-chasing scene was coming right up.

Because I became an expert on the subject, I should like to offer now a piece of advice for aspiring actors: since you will in the course of your career often be tapped to help both build and strike, or tear down, the sets you act on, here's how to weather it without having to do any work. It is equally effective for both building and striking. First, procure a hammer. Go early or they'll all be gone, snapped up by other actors. Grab a short length of board, any width. Now, with

the hammer in one hand, board in the other, walk very quickly and with purpose in your eyes through the work area and over to the coffee machine. Set the hammer and the board within easy reach. Now drink a cup of coffee while reading the label of the Coffee Mate jar. Repeat. When the tech director approaches, grab the hammer and board and head in the other direction, again walk through the work area, this time out to the candy machine. Set the hammer and board down. Enjoy a bag of Bugles. Look at the bulletin board. Because you are an actor and by nature violently insecure, wish ill will on any actor whose name you see on the board. Buy some Velamints, shaking the machine violently when they fail to drop. When they finally do fall, put all three packages in your pocket, head back to the coffee machine, and repeat the entire process.

If you're more ambitious, you and a fellow actor could certainly take any section of unused scaffolding, lean against it, look up into the lighting rigs, again with purpose and conviction, and point at things, pretending to discuss what you plan on doing to them. Should the tech director walk by, one of you take your hammer (never lose sight of your hammer) and climb up the scaffolding while the other steadies it. When the tech director passes, have the accomplice climb down, move the scaffolding several feet, and start over.

In this way, I have avoided hundreds of hours of real work, while alienating perhaps only a few dozen coworkers.

Anyway, when the King Arthur gig ended, I wrung out my tights, hung up my dance belt, and began to focus on not going to my classes. (A dance belt, by the way, is an article of clothing that offers frontal support to the male tight-wearer while attempting to eliminate the problem of presenting a lumpy, strap-impinged buttock to the world. The smooth look is accomplished by providing only one support strap in the back. It doesn't take a lot of imagination to figure out where that strap might go in order to hide it from the audience. I really am very, very sorry to have to have told you this. For obvious reasons, actors and dancers write their names boldly and many times in permanent marker on the band of their

dance belts and keep very close tabs on them so that there is absolutely no chance of a mix-up come showtime.)

A job in a summer (or "lousy") theater followed, this time the role of Bill Sikes in *Oliver!*, custom designed for me because it involved no dancing and very little singing, just loudness and a sense of physical menace. Obviously *Oliver!*—the story of a child who is tossed out into the street and joins up with a group of other street children who take him back to a larger group of even more children, and those children and the new children all dance and sing—has a lot of roles for children in it. But for some reason, I was surprised to learn that actual *children* would be filling those roles. I assumed that, I don't know, they would be papier-mâché or foam rubber puppets, or that they'd be highly theatrical cardboard representations of children. Unwisely, the director, a talented but severe woman who pronounced the word *okay* very deliberately and like this— "Nnkie"—chose to corral a wild brood of *living children*.

The actor playing the good-hearted Mr. Brownlow was in his own life a bitter, paranoid, hair-trigger psychotic given to fits of unwarranted and intense rage. Salt of the earth, but, wow, the guy could go off! He reacted to the children as though they were sand burrs stuck in his shirt collar, or pans of spitting bacon held inches from his face. He kept his bitterness at a medium simmer most of the time and now and again could be pretty decent to the kids.

"Okay, okay, Brian. Let's remember to come a little farther downstage next time," he'd say, and then he would suddenly remember that he was at heart a walking ball of rage and correct himself. "For the love of GOD, KID, WHY DON'T YOU JUST STAB ME IN THE EYE? RIGHT now! RIGHT here! Just stab my eye out and leave me for dead—'CAUSE THAT'S EXACTLY WHAT IT'S LIKE WHEN YOU DON'T—HIT—YOUR—MARK!" And then he'd storm out. That was the only part of his bit I found a touch clichéd. Other than that, it was top-quality rage.

The children would scatter and wail and the director would do her best to gather them up, touching them on the back of the head with the same hand that held her lit cigarette.

"Nn-kie! Nn-kie! Let's settle down, nn-kie? We'll hit our marks and John will promise not to yell anymore."

John, though, was no more going to stop yelling than he was going to stop sweating through his costumes, as he did every performance. Though I liked him and got on fairly well with him, he did turn on me on occasion. Once, while chatting amiably in the wings, we stumbled on one of his countless rage triggers.

"Yup," he said, "I tried out for your part, you know?"

"Did you?"

"Yup. Really liked the physicality of it. Had some good ideas for it."

"John?"

"Didn't know you were gonna decide not to *act* the part," he said.

"John—"

"But, since kiss-asses like you always get the best roles . . ." He simmered.

"John!"

"For the love of *GOD,* MAN! THAT'S MY PART, MY PART, AND YOU'RE RUINING IT!" he fumed.

"Well—"

"AND YOUR SINGING VOICE—DO YOU HAVE SOMETHING AGAINST THE AUDIENCE? ARE YOU TRYING TO HURT THEM? 'CAUSE IT SOUNDS TO ME LIKE YOU WANT EACH AND EVERY ONE OF THEM TO DIE!"

It was hard to argue his basic point (about my singing, not my wanting the audience to die!). Yes, he was a man sculpted from pure white-hot rage, but he was an astute observer of guys who couldn't sing to save their lives.

On opening night I warbled through my part reasonably well, but when it came time for my ultimate scene, wherein Sikes is shot on a bridge and crashes through the railing to his death, I took the bullet and turned to crash through the railing, but it wouldn't budge. The tech guy had forgotten to remove the bolt that held it in place. I tried to climb through the railing to my death, but with such a bulky costume on there just wasn't enough room to get

through. I decided the only thing left, short of waving politely to the audience and walking away to my death, was to crawl over the top of the railing. To my death. It took me a moment to get my footing, but I eventually got over and did fall to my death, pathetically yelling, "Ahhhhhhhhhhhh" on the way down.

Several performances, if that's the word I want, after that one, the railing gave out just fine, but on the way down I noticed a decided lack of crash pad where there normally was crash pad in abundance. I hit the bottom and screamed, very authentically, as I had just torn all manner of muscles in my lower back. To the audience, Bill Sikes, the evil Cockney thief, who had just been shot and plunged into the river, then moaned and said, "Ow. Son of a . . . My back! Where the hell is the crash pad?"

Critics (that is, some guys I knew) were fairly kind, but they did question certain aspects of my performance. "What the hell was that?" they asked.

You can explain all you want about missing crash pads and bolts not being removed, but in the end, it is the image of your supposedly bullet-riddled body crawling clumsily through a railing that they are, and probably always will be, laughing at.

I was so embarrassed by the incidents in *Oliver!* that I immediately signed on for another tour of duty with the same theater as a singing, dancing, sailor-suit-wearing, extreme-risk-of-humiliation-providing Billy Crocker in *Anything Goes.* The script calls for quite a bit of tap dancing out of Billy Crocker, but as done by our little company, Billy Crocker did quite a bit of leaving the stage while others came out and tap-danced. Anytime there was an obvious set-up to a dance number, it looked as though Billy had just received an urgent call.

The director, hearing me say "I cannot dance," apparently took that to mean that while I couldn't dance *well,* I at least had some voluntary control over my limbs. I perhaps should have impressed more deeply upon him that my brain's long-standing feud with my legs and arms had resulted in them barely being on speaking terms.

The conditions of their détente were that my brain would agree to provide the impulses necessary for walking, but that was it.

At the end of Act I, Billy sings the tender Cole Porter standard "All Through the Night" to his girl, Faith. The melody is largely chromatic, the notes held for some time as it slides slowly down the scale. In the hands of an Ella Fitzgerald or a Shirley Horn, it has a mournful, almost deliberately monotonous sound that makes you want to cry; in the hands of, say, a me, it has a nasally, unsure droning quality that makes you want to rush the stage, grab the lapels of my cheaply made sailor suit, and shake me like a rag doll, screaming "Stop it! Please, stop it! I'll give you anything, money, gold, power, just please stop that horrible sound from coming out of your mouth!" I guess it's all in the interpretation.

No one ever did make the stage, or at least, I never knew about it. I had already hightailed it out of there to make room for the people who were dancing for me.

Billy Crocker was my last turn in a musical (if they still call them that after my having been in some of them). Oh, every now and then I get lost in a reverie where I'm back up there, singing "They Call the Wind Maria" to a packed house. Striding confidently downstage, I belt it out in a powerful baritone. Then I get to the part where I sing "Maria makes the mountains sound like folks are up there dyin' " and something about that word *dyin'* rings a bell in the back of my mind. I glance down at the crowd and notice that every audience member is brandishing some sort of weapon, be it a bar of soap wrapped in a towel or a short length of sawed-off pool cue, and the ushers are calmly instructing them on the fastest way to the stage. I scream and snap out of it before the crowd gets a chance to show their appreciation by clapping their weapons and my body together.

For now, I shall withhold my gifts until such a time as I feel ready.

TELEVISION AND HOW IT'S
SHAPED US...INTO BALLS OF DOUGH

In 1934, when scientist Philo T. Farnsworth first transmitted an image onto a crude picture tube, he had no idea that his invention would spawn a multimillion-dollar industry and, eventually, *The Fall Guy* starring Lee Majors as Colt Seavers. Newly found documents reveal that his own dream for television was that it would exclusively feature a large purple gorilla in a green vest and bow tie riding atop a van driven by a cartoon dog named Beegle Beagle. Sadly, he would not live to see the advent of *The Great Grape Ape Show*, which surely would have made him very happy.

Years after the invention of the television, Farnsworth appeared on *What's My Line?* and was asked by a panelist if his invention was painful when used. His famous reply was, "Yes. Sometimes it's most painful." Here he was probably referring to the often excruciating game show *What's My Line?* starring Bennett Cerf and Dorothy Kilgallen. Although other experts think it may have been a reference to a particularly bad *Make Room for Daddy* in which Gale Gordon played a key role.

Are there even enough adjectives to describe the great cultural

phenomenon we call TV? Shall we begin with *gigantic, influential, culturally significant, flashy, dishonest, possibly destructive*? Shall we continue with *pungent, hoarse, cute-as-a-button, wily, biscuit-like, snide,* and *pig-drunk*? Because paper and ink are fairly cheap, shall we go further with *kittenish, highly seasoned, dreamy, adenoidal,* and *farinaceous*? No, I'm certain we should not.

But *culturally significant* is hard to argue, certainly a lot harder than *biscuit-like,* which wouldn't stand up for long against even an amateurish debater. When future generations think of our culture, three things will come immediately to mind: television; motion pictures; and cargo pants, with the latter being a fairly distant third in significance. Television is so deeply woven into the fabric of what and who we are as a culture that we couldn't launder it out even if we had Cultural Tide with New Cultural Tide Stain Fighter®.

How did television gain this ground? When did it start and what is its future? What time is Walker, Texas Ranger on?

Invention

According to the legend, Farnsworth got the idea for television at age fourteen while out plowing his field. I for one feel a special kinship with Farnsworth, for when I was fourteen out plowing our fields, I got the idea to go get some Oreos. We are brothers in spirit.

Farnsworth secured the patent for his invention, but it became clear that electronic giant RCA, which was working on its own system, would not let it go so easily. Farnsworth began to notice he was constantly being followed by an adorable, curious, and ultimately very menacing fox terrier. He took to carrying old Victrolas with him, which he would throw in front of the dog, and while the distracted pooch was cocking his head and staring, Philo would run as fast as his scientist's legs would carry him.

General Electric also battled him in court, but lost its war to win the patent because the presiding judge insisted that the television system was too specific for a company that clearly wanted to be general. "You go manufacture"—and here the judge made quote signs

with his fingers—*general* electric products like your name says."

With patent in hand, Farnsworth formed the Farnsworth Telephone and Radio Company and unveiled his slogan, "Get Your Farn's Worth," which only confused and annoyed everyone who heard it. He was forced to sell out to ITT.

A depressed Farnsworth retreated to his house in Maine and began drinking heavily, probably after seeing his precious invention being used to transmit images of Jerry Van Dyke. He spent time in the hospital and underwent shock treatment, but no amount of electricity could dislodge the horror of *My Mother the Car*.

He did recover and ended up making many contributions to science before dying in 1971, just as Brian Forster was stepping in for Jeremy Gelbwaks as "Chris" on *The Partridge Family*.

Television: The Early, Grayer Days

September 11, 1928. Schenectady, New York, station WGY broadcasts the first television drama. Entitled *The Queen's Messenger,* it tells the store of a bald Greek detective with a penchant for lollipops and a snappy catchphrase—"Who enjoys you, baby?" It failed, for two reasons: first, the catchphrase was off by just *that* much. Many years later, when a variation on it was taken up by Telly Savalas in *Kojak,* it was a smash hit. Second, not a single person owned a TV back in 1928, a flaw in the system that WGY had foolishly overlooked. If even one person had owned a set, and he was watching, *The Queen's Messenger* would have garnered a 100 share.

In 1939, RCA's National Broadcasting Company broadcast from the World's Fair, with the Kenyan doughnut stand and the guy from the Netherlands who could guess your weight within two pounds being particular highlights.

World War II saw a stop in the development of television, but in 1947, it roared back with *Howdy Doody,* a show that featured the most terrifying grown-man-in-a-cowboy-outfit/marionette/clown

combination the world had yet seen. *Howdy Doody* was purest nightmare fuel and children were too terrified to shut it off for fear that if they took their eyes off of him, *Howdy* might slip out of the studio and hole up under their beds with a boning knife. In comparison to *Howdy Doody,* the 1978 film *Magic,* about a murderous ventriloquist's dummy, looks like *Mary Poppins*. Similarly, *Trilogy of Terror,* a movie which featured a murderous African tribal doll chasing Karen Black with a butcher knife, is like your grandmother's still-warm peanut butter cookies next to a hellish episode of *Howdy*. The puppet's high cheekbones, the subtly menacing cowboy outfits, his siblings, Heidi Doody (who never married) and Double Doody, all contributed brilliantly to its fear-based popularity.

And then there was Clarabell.

In my opinion, there are few things more completely saturated with the stink of fear, death, and hopelessness than a colorful, smiling clown. (Stephen King himself recognized this and once spent an entire day writing an 1,100 page novel about an evil clown titled *It*.) What made Clarabell so frightening was the fact that (s)he was mute. All the evil and horror that (s)he planned to bring into the hearts of children everywhere went unspoken and was therefore limited only by the imagination of those who saw her/him. Clarabell's sexual ambiguity somehow sharpened the terror. Though you couldn't be certain whether Clarabell was a man, a woman, or some twisted circus-ian hermaphrodite, you could be certain its face would be the last thing you ever saw. The crooked, painted-on death grimace left little doubt of that.

Clarabell finally did speak, on the last episode of *Howdy*. It said, "I'll be your escort to hell, kids," though sappy revisionists claim that it said, "Good-bye, kids," with tears in its—I guess you'd call them—eyes.

Another early success was the *Today* show starring chimpanzee J. Fred Muggs. The ape was born Jethro Frederickson Muggs in Sierra Leone to Walter Allingham Muggs and Teresa Blaine Swanson. J. Fred's father mated with his mother some fifteen days into

her menses, as is typical of the "common chimpanzee" as they are known (though they bristle at the implied insult). Muggs joined the *Today* show cast to boost its sagging ratings, and his playful antics and attractive, trim-fitting diaper soon captivated the nation. People seemed to admire Muggs's unselfconsciousness concerning his inability to control his bowels and they were behind him 100 percent when he attacked and bit Martha Raye.

Muggs left the *Today* show in 1954—the pressure cooker that is network news had caused his irritable bowel syndrome to worsen—but no diaperless television show would ever capture the nation's fancy in quite the same way. Baby Huey, a cartoon featuring a diaper-wearing infant duck with gigantism, was an obvious attempt to profit from Muggs's groundbreaking and thoroughly absorbent bottom-wear. It was a hollow mockery and lasted only some twenty years on and off.

Lucille Ball, the Balkie of her time, also saw her glory days in the 1950s with *I Love Lucy*. In the formula I've worked out, Desi is her cousin Larry, the signature "Waaaaah" her "Don't be ridiculous," Ethel and Fred her . . . whoever lived downstairs of Larry and Balkie. It was fresh and new at the time, even if it did grate and make everyone who viewed it feel jumpy and unsettled. But the country must have been in the right mood to enjoy a not-very-bright, scheming woman who couldn't hold down even a simple job at a candy factory.

I Love Lucy stopped production in 1957 while still the top-rated show. Lucille Ball went on to do so much more, not the least of which was becoming the first woman to smoke five packs of Lucky Strikes a day for forty years straight, pausing only to tell husband Gary to get her a Scotch.

The game-show craze came on big in the fifties, and at one time *The $64,000 Question, Can Do, High Finance, Nothing But the Truth*, and *Twenty-One* all got big ratings. Not as fondly remembered was *Touch Arthur Godfrey's Scalp for Dollars* and *Edward R. Murrow's "Smoke-Off."*

Westerns caught on toward the end of the decade, until their

peak, when there were thirty-two of them on the networks. They remained popular until more than a decade later, when people suddenly decided that thirty-two westerns was about thirty-two too many.

The Sixties, Man

The televised debate between John F. Kennedy and Richard Nixon in 1960 is thought by many to have been one of the pivotal moments in the history of shaving. Nixon mistakenly thought viewers would be too impressed by his sweaty brow to notice that he hadn't taken a razor to his Fred Flinstone-y beard. Kennedy, however, was smooth and suave, pointing his bounteous pompadour at the cameras and reassuring all that if he was president, "Everyone in America will be able to PAhk his CAH by the GAHden."

It was in 1961 that FCC chairman Newt Minow made his famous "vast wasteland" speech to the National Association of Broadcasters, who were struck to the core by his remarks. They responded by marshaling their prodigious resources and producing *Mr. Ed,* and at the same time gathered together a fact-finding committee to come up with a plausible explanation as to how a man could come to be named Newt Minow.

About the same time, *The Ed Sullivan Show* was reaching its zenith. An odd stew, it featured singers, comedians, and the occasional person who could swallow and regurgitate different sizes of anvils while playing "Old Folks at Home" on the bouzouki . . . that kind of thing. Sullivan himself is widely thought to have been the oddest, most off-putting man to appear in front of a camera until the invention of Bill Maher some years later. He was so stiff, it turns out, because he was actually a large rod-puppet made out of papier-mâché and controlled by hundreds of cables that were manipulated by stagehands. So complete was the ruse that Sullivan himself was surprised to learn he was a puppet. "Whatd'yanew 'bout that," he said in his nasally, stilted way. "And now let's see what's up with Topo Gigio."

The Ed Sullivan Show ran for twenty-three years, until 1971, when a cynical nation said, in effect, "We are cynical and can no longer be entertained by plate spinners, contortionists, and Spanish men with tiny, custom-made wigs on their hands—give us J. J. Walker!"

The Seventies: Television Gets Down to the Business of Being Really, Really Stupid

To me, the seventies meant one thing: wishing fervently that it were not the seventies. That and trying to convince myself that H. R. Pufnstuf really was my friend when things got rough. Because things really *did* get rough when there was nothing on but H. R. Pufnstuf, and really, seeing a man in a large foam rubber dragon costume speak with the voice of an effeminate Texan was not exactly balm. Watching a small Cockney child with a talking flute be menaced by a campy witch was not as soothing it sounds, either. But it was the seventies, and there wasn't much I or anybody else could do about it. It was the Hudson Brothers decade, and that left little room for sanity.

H. R. Pufnstuf was the product of Sid and Marty Krofft, who produced seventeen shows for Saturday-morning television between 1969 and 1977, including *Bigfoot and Wildboy, The Bugaloos, Lidsville, Far Out Space Nuts,* and *Electra Woman and Dyna-Girl.* Not surprisingly, it is also rumored that they produced many hundreds of gallons of bong water as well. They themselves were fairly forthcoming with that information. Naming a psychedelic show *H.R. Pufnstuf* is a barely coded way of saying, "The producers of this program would like you all to know how very, very much we enjoy smoking rope."

Primetime fare included *Donny and Marie, Barbara Mandrell and the Mandrell Sisters,* and *Pink Lady and Jeff* (which starred two vaguely pink ladies and comedian Jeff Altman). Just this small sampling should serve as ample illustration that madness ruled and campiness prowled, unchained, like a lion.

In 1973, a show premiered that would change the face of idiocy . . . forever. It was called *The Six Million Dollar Man* and it starred Lee Majors as Colonel Steve Austin, "a man barely alive," a fact that became self-evident when you saw him act. The premise was that if you took a man, put him in a rocket and crashed it into the tarmac at twice the speed of sound, you could saw off his mangled legs, hack away his right arm, pluck out his ruined eye, toss them into the Dumpster, and replace them all with noisy robotics before the anesthetic wore off. The cost: $6 million. (Well, actually about $30 million of the taxpayers' money. But when you factor in the kickbacks and payoffs from the private sector, the government was easily able to make it appear that only $6 million had come out of their yearly operating budget.)

The Six Million Dollar Man was a major hit and it was rumored that more than one kid had attempted to cut off his leg in order to get a bionic replacement. (Those were kids who were probably just itching to cut their own legs off anyway and *The Six Million Dollar Man* just provided a convenient excuse.) It spawned a spin-off series, *The Bionic Woman,* in which Steve's former girlfriend crashes into the ground at twice the speed of sound, has her mangled legs sawed off, her right arm hacked away and her right ear removed, tossed into a Dumpster, and replaced with noisy robotics before the anesthetic wears off. The novelty of the show made it a gigantic hit with audiences.

One point that should be made: as with the $6 million man, the operation to the bionic woman was done *without the patient's consent.* And because of the high cost of bionics, both were shanghaied into the service of the top-secret agency OSI to pay back the cost. This is like having your mechanic put a small-block 328, bored out, with dual quads and an Edelbrock tunnel ram into your Chevy Lumina when you bring it in for an oil change, and then force you to sweep the garage floor for the rest of your life as repayment. Now granted, Oscar (head of the OSI—and Colonel Steve Austin's friend!) could argue that both patients would have died without their respective operations. That could be true, but giving them

artificial limbs with Frankensteinian strength was an option that neither patient asked for. They might have opted for limbs having only stock, Chevy Lumina–type strength for far less money, something they could have paid off themselves by taking a weekend job at the Hallmark store.

There was also a bionic dog, Max. Much like cloning, this strikes me as a profoundly stupid idea, the kind of thing that happens when OSI scientists are given too much money and freedom. "What?!" you can almost hear them saying, their voices trembling with rage and condescension. "I suppose you think there's something wrong with making a super-strong killer German shepherd? You know, we can keep test-tube babies' heads alive by transplanting them onto gigantic tadpoles, I suppose you think there's something wrong with *that* now, too!"

Steve Austin would be subjected to further crashing of those close to him in *The Return of the Six Million Dollar Man and the Bionic Woman,* in which his son, Michael, crashes into the ground at twice the speed of sound, has his mangled legs sawed off, etc. Steve, who is not the brightest bulb on the tree, never suspects that Oscar may be deliberately crashing his loved ones into the ground at twice the speed of sound in order to build himself a sizable cadre of bionic OSI thugs with a limited ability to think for themselves.

Fortunately for everyone, the *Bionic* series ended when it just got too unbelievable.

Nerd, Would It Be Too Much Trouble to Ask You to Sit on It?

Perhaps the most legendary and fondly remembered show of the seventies was a bit of fifties nostalgia called *Happy Days*. The title was undoubtedly ironic, because any character in close proximity to either Potsie or Ralph Malph would surely be fighting acute depression and an urge to take his life.

Happy Days cemented into the national consciousness a modern icon, the leather-jacketed hood, with the character of the Fonz, played by Henry Winkler. With all apologies to Mr. Winkler, who I regard as a very fine actor and by all accounts is a very decent man, I never believed that the Fonz could beat up a wood duck, let alone the much larger thugs he often either bested or frightened away with lackluster feints. I would have to question as well the sexual magnetism the show imbued him with. Weren't these women at all put off by the liter of greasy emollients saturating his hair until he looked like a black cotton swab freshly dipped in KY jelly? His method of seducing them involved snapping his fingers, and when he did, every woman within range of the sound would rush to his side, often shoving each other to be first in line to service him. Were all these young ladies really that eager to sacrifice their dignity and self-respect for several minutes of lubricious coitus with a dim-witted thug? I, for one, doubt it (even if I do desire with all my being to be Fonzie for just one night).

Perhaps they were seduced by his signature "Aaaaaa." (That is a long *A,* as in *Aaaaayyy,* not a short *A* as in *Aaaaahhhhhhh,* a sound he might have used were he, say, being lowered into hot broth.) It is not totally conclusive just what "Aaaaa" meant, though having analyzed many instances of it myself, I am prepared to present my theory. I believe "Aaaaaaa" was Fonzie's shorthand for "Aaaaaaa whole bunch of axle grease somehow ended up being stirred into my hair." Others are certain—and though I disagree, I respect their research and thoroughness—that it is a call whose meaning is, "Aaaaa thousand laundry cycles would not rinse the sweat, pomade, and spilled Cherry Coke out of my needlessly stiff blue jeans." No matter the truth, it is an exciting intellectual argument.

Happy Days too fathered a spin-off, *Mork & Mindy,* with Robin Williams as an alien in a red-and-silver jumpsuit that made him look like a cross between Dorothy Hamill and David Bowie. His catchphrase, "Nanu nanu," is even more abstruse and impenetrable than Fonzie's. It may have been a phrase signifying Williams's

desire to someday abandon his wife and marry the nanny, or it could simply have been a kind of backup to the jumpsuit and bad scripts to make absolute sure his character annoyed. Perhaps you disagree. Well, to you I say, "Shazbot."

The MacCorkindale Decade

As the seventies waned, most everyone was overjoyed that they were finally coming to an end. I don't think anyone could have predicted that the seventies would lead directly, with no break at all, into the eighties. Delight turned to horror as we got out of the frying pan of feathered hair and spandex and into the fire of *The Greatest American Hero,* Corey Hart, and leg warmers.

(On a personal note, I believe I was the only man who could wear chartreuse leg warmers with the proper flair and élan. Most guys looked pretty bad in them.)

The show that seemed to define the eighties, with its cool synth soundtrack, its hot crime-fighting duo, and its slick sense of fashion, was, of course *Manimal,* starring Simon MacCorkindale and Melody Anderson. Yes, *that* Melody Anderson. (Note: There is no Melody Anderson other than the Melody Anderson who was in *Manimal,* but I've seen other writers use that device and I've always wanted to try it myself.)

MacCorkindale (whose name means "son of the man who lived in a small town that was famous for its all-natural bottle stoppers") played Professor Chase, an animal science professor who led a secret life. It's my guess that most animal science professors lead some sort of secret life, none of them anything but deeply shameful, but Chase's involved fighting crime by turning himself at will into any animal he wanted. (It was a secret he had learned from his late father, who in turn had learned it from, I don't know, I guess his grandma's neighbor.)

Chase was unembarrassed that his superpowers were of such limited use and often turned into a cat. Although this was no help

in his fight against the powers of evil, it did help attract old widows and women who managed natural food stores. After being forced to eat several cans of Frisky's Buffet to keep the ruse going, Chase began to limit his shape-shifting to the larger cats, hawks, or snakes. He made one attempt to gather facts on an embezzling scheme by turning into a catfish, but that, too, was a complete failure and he was nearly deep-fried and served with hush puppies, a side of slaw, and warm buttermilk biscuits for $4.99.

Another program emblematic of its decade was *Square Pegs,* starring Sarah Jessica Parker and Jami Gertz. Though it was praised by many critics for being an accurate depiction of the high school experience, in my opinion, it fell quite short of doing that. Where were the painful beatings delivered at regular intervals? Where was the cruel math teacher who threw erasers and mocked the student who didn't understand the quadratic equation? Where was the tall, awkward young man who couldn't make friends and so retreated into a world of tortured silence, where he pored over the later Beethoven sonatas and the novels of J.R.R. Tolkien? Where were the regular chants of "Nelson is a loooooser, Nelson is a loooooser!"

Anyway, it had a very catchy theme song that went something like this: "Square pegs, square pegs, square, square pegs. Square pegs, square pegs, square, square pegs" (repeat thirty-eight times).

The year 1984 saw a stunning innovation: though people were familiar with shows that delivered both "blooper" and "practical joke," no one imagined that they might one day be melded into one show, hosted by old guys. But that's just what Dick Clark did with *TV's Bloopers and Practical Jokes.* The practical jokes were elaborate, requiring very complicated setups and many well-trained accomplices. More often than not, the end result would be a mild look of surprise on Connie Sellecca's face. Hosts Ed McMahon and Dick Clark would then laugh, though it was clear that Ed was unsure which of his shows he was hosting and would mistakenly introduce a contestant in the spokes-model competition. Though it

has never been very difficult to fool Connie Sellecca, even she caught on after several years and *Bloopers* was canceled in 1986.

The Nineties: The Reiser Years

The entire decade of the nineties was covered end to end by Fox's *Beverly Hills 90210*. The story of the show's beginnings are legendary: it was 1990 and producer Aaron Spelling needed a hit. He was in the planning stages of a 123-room mansion valued at $37 million and didn't want to be "house-poor" when he was done; he needed a ridiculously successful show to cover the costs and pay his pushy gypsum supplier. The *Fantasy Island* residuals were earmarked for the Formica countertops, and the *Charlie's Angels* haul was used up on the conversion to a hundred-amp fuse box, so he quickly scribbled the words *Hollywood, breasts,* and *high school* on an invoice from his chandelier supplier, handed it to his production company, and they got busy. One week later, *Beverly Hills 90210* was on the air and Spelling was paying his creditors net-30 like clockwork.

It was incredibly well received and became an instant hit. His house, that is. It had a bowling alley, a full-sized ice rink, two rooms for wrapping gifts (in case one wore out?), a rose garden on top of the garage, and a doll museum. Some neighbors complained that the house, which took up as much ground as a football field, was excessive, especially given that Spelling is a thin man and couldn't possibly need all that space, but most visitors or sightseers responded with an enthusiastic "holy shit!"

The show, too, was successful and Spelling toyed with other zip codes. *Fergus Falls 56537* was in the development stage when they discovered that test audiences were not only unfamiliar with the town of Fergus Falls, but also the state of Minnesota as a whole. Those who had heard of it thought it had seceded from the Union many years before, and others angrily insisted that Minnesota was a hamlet in Indiana.

Undaunted, Spelling tried again with *Breast Junction 362436,* about a fictional town that grew up around a thriving swimsuit-top testing facility. Spelling poured his heart into it, paying attention to every aspect of production: from the viscosity of the baby oil to be spread on the actor/models' chests, to the material used for each and every cup. It never got to the air, and he was so despondent that he added on to his house and quickly produced another couple dozen shows, including *Melrose Place, The Heights, Robin's Hoods, Models Inc., Malibu Shores, Sunset Beach,* and *Pacific Palisades.*

In the late nineties, Spelling lost some ground when a new spate of teen shows debuted, led by the strangely named *Dawson's Creek.* My investigations into the origins of the name are not complete, but I can say with some certainty that it is *not* in reference to *Hogan's Heroes* alum and ex-game-show host Richard Dawson. A red herring by the producers, and a clever one at that. Further research reveals that there is a character named Dawson on the show, which might lead one to believe that this person's ancestors put down roots near a small tributary to which they eventually lent their surname name to. This is incorrect. It turns out that, against all known rules of logic and good taste, Dawson is the character's *first name*! It is his creek that is being referred to in the title. Even more puzzling is the fact that Dawson is a young man of about seventeen—how did he come to possess his own creek?

The complications become more labyrinthine: promotional materials for the show all feature the character Dawson lolling about in a rowboat on what appears to be a lake! Is it possible that Dawson is aware that he owns a large body of water, but does not know the difference between a lake and a creek, and that's part of the drama of the program, his inability to distinguish between different bodies of water?

I would not normally have entertained the possibility, but given the title's frustratingly elusive internal logic, I had to wonder

whether *Dawson's*, rather than being possessive, was in fact a contraction? That would change the meaning to *Dawson is Creek*, or *Dawson is a Native American of Creek ancestry*. Or possibly, it refers to his dialect, making *Dawson's* possessive again, but referring to his way of speaking the Muskogean language.

It all makes me wonder how things have changed so much from the days when television shows were given elegant names like *Skag*, the Karl Malden series, or *Tom Smothers' Organic Prime Time Space Ride*.

Hi, Definition Television!

Television has changed considerably since its early days, when it was not so in-color, and people who appeared on it weren't quite so named—"The Fonz." But how much more will it change? Will scientists figure out a way to generate thirty-foot-tall holographic images of David Spade indistinguishable from the actual David Spade except for the fact that they are twenty-six feet taller? It seems almost certain. Virtual reality *will* come to TV and we can look forward to a day when we'll be able to pal around with Joey, Rachel, Phoebe, and the rest of our *Friends* in a fiction created when tiny electrodes are attached to our medulla oblongatas and the show is beamed directly to our nervous systems, with *Friends: Inside Your Own Head* the TV show. You could conceivably take your own friends with you on the optional network hub, but I have a feeling taking your own friends along will feel like dragging a safe when you have such easy access to Joey, Rachel, Phoebe, and the rest of the *Friends*.

Philo T. Farnsworth would be proud of what we've done with his creation. We can only hope that right now scientists are working on a way to resuscitate him, create a bionic Philo T. Farnsworth, and install him as host of *Temptation Island II: The Bionic Philo T. Farnsworth Edition*.

YOUNG MASTER CHILLINGSHEAD

*It can't be that hard to write a huge novel condemning
puritanical moralizing, can it? If it doesn't even have to be
all that condemning or even very big, things probably get a
great deal easier.*

This is how I would do it:

{ I }

The Aged Pritchett, Mister

THE DETAILS SUCH AS I WILL NOW ENDEAVOR TO SET DOWN
are such that the retelling of them will only serve to elucidate
the facts of the situation such as are those that this yarn seeks to
shed light upon, inasmuch as those facts are sought to be made
clear by him who sets them down, in this case, I, who wishes this to
be the eventuality.

Hunchen Pritchett sat on the porch of his crumbling mansion by
the sea in his great granite rocking chair, carving a whale into
some smaller sea mammal.

"Good sir," said I.

"DEVIL!" shouted the old man. "Your foul countenance singes
my white head! You bring lies by the duffel bag, and nothing good
can come of your visit here, Devil!"

Good folk strolling past the Manor Pritchett were eyeing me
suspiciously.

"Let's keep the 'devil' shouting down to that which is only very
necessary, if I'm not being too forward," I whispered.

"Devil! Devil! Big fat devil! Huge red, sharp-tailed, pitchfork-using devil!" he taunted.

"Good sir! Ple—"

"Old Scratch, the Enemy, Author of All Lies!" he continued.

"I entreat yo—"

"Cloven hoof, tossed-from-heaven, horn-headed—"

"All right, that's it," I said, stripping off my waistcoat and preparing to give him great quantities of what for.

Years of being old and grizzled had toughened him, and it was not as easy to subdue him as I might have liked. I was forced to begin hitting him with antique elbow chairs, which I had dashed inside and gathered from his sitting room for just that purpose. But he was no stranger to being hit with antique elbow chairs and was able to rally, pulling an intricately carved oaken buffet from behind his back, hitting me directly upon my head and driving me through the weathered wood of his porch like a nail, until I was stuck fast. Then he began tapping me, checking my progress, and tapping me again, "setting" me in the porch as a master carpenter might do to a peg.

"Prithee sir, ouch. Please stop that," I begged of him.

"Just"—*tap*—"let me"—*tap*—"get you"—*tap*—"just right"—*tap*. "There! Now isn't that better?" he asked.

"No! Sir, as I said before, ouch. Dis-un-enpulleth me from my stuckitude at once," I commanded. He yanked on me with a comedically large pry bar that he apparently kept for such occasions, until I was released.

"Good sir," I began *yet again,* "I have come on a matter of urgent business concerning Manor Pritchett."

"Be you the lawyerman? One they call Pillington Chillings-head?"

" 'Tis me, and none other than me be he."

"Well, why did you withhold this information like it were a great big grape?"[1] he asked warmly, though "bitterly" would

1. The author, me, probably meant "secret." (Note: I did [author].)

probably be closer to the truth and if I added "and with vile hatred," I would not be overstating it.

"Would it be too much trouble to sit with you in your house, away from this sea storm"—there was a great storm threatening to blow us away—"or were manners repealed by President Millard Fillmore and I somehow missed the headline?" I said, and looked at him with a sarcastic "Well, old man?" look, my hands out to my sides, palms up, shoulders shrugged.

"Do come in, Master Chillingshead," he offered expansively, though "resentfully" probably scores a more accurate hit and if "and as though he would rather die than ask me in" were following along behind it, I think I still would come up short in describing his rancorous displeasure with me.

I passed over the threshold of Manor Pritchett and into the drawing room, where Pritchett bade me sit on an overstuffed tiger.

"Can I get you a watermelon shandygaff?" he asked sarcastically, giving a stiff little bow. "Or would you like to smooch my gray, pimply backside?"

"What th—?!"

"Father!" came a sharp cry from the balustrades. "Stop inviting our guests to osculate your unkinder half, at once!" And the heavenly young woman descended slowly, floating down the stairs as if on wings of cloud. Such were, I would later learn, the sophisticated hydraulics of the Liftmaster 3000 installed several years before for the old man.

"Father, will you have Encomium bring our guest a refreshing glass of elm juice?" she commanded, her voice soft, but clearly signaling that it would be entirely her pleasure to dish him out a broom-handle beating if he disobeyed. She was lovely.

Hunchen Pritchett shuffled off to the kitchen, making noises like Poopdeck Pappy as he went.

"I'se don't see wise I'se gots to get the whelp a glass of . . ." I heard him say before rounding the corner.

"Dear sir or madam—" she began.

" 'Sir' covers it quite nicely, and I thank you," I interrupted.

"I do beg your forgiveness for my father's shocking ugliness and his regrettable behavior as well," she said tenderly. "He has not been the same since the unfortunate event of his birth."

"Well, who is? Think nothing of it, I beg you."

I stood up to receive her offered hand and was able to examine her face. It was breathtaking, and indeed, a breath I took and thereby avoided passing out, which admittedly I might have done anyway.

"My name is Pillington Chillingshead," I offered. "Inquiries were made with my office concerning the Pritchett landholdings in England. I came to get the family documents in order." She looked at me unblinkingly. The clock ticked. We stood this way for a quarter of an hour.

"So. I guess I would need those," I said. *Tick. Tick. Tick.* Another quarter hour. "Just the family documents, and I would be out of your hair," I said.

"And what would those look like?" she said, screwing up her face up with the effort of her inquiry.

"Their mien and bearing would suggest to the soul who happened to take in their appearance that they were composed of paper." Then added, "About this big," holding my hands the appropriate distance apart. *Tick. Tick. Tick. Tick.* One half of an hour ticked away.

"Very skinny in this direction," I offered, trying to suggest how thin paper can often be, without meaning to insult her obvious intelligence.

"Do they have legs?" she asked.

"Madame, it would indeed surprise me greatly if the family documents had any such appendages." *Tick. Tick. Tick.* "No legs. Nope." *Tick.*

"What do they sound like?" she asked earnestly.

"Well. Now, that is a not altogether effortless question to answer. They emit no sound unless some action is being performed upon them—"

"Are they in a box?" she asked.

"YES! Yes, often the family documents are put in a box of some sort! Good. Good, very good." The excitement of the moment died. *Tick. Tick.*

"Please know how happy it would make me to retrieve that box for you," I offered.

"I will go and bring it back to you," she said, and floated away.

It would be fair to say that at that moment I felt as though I was connected to Desadora Pritchett by a golden cord of heavenly love that only death or horrible disfigurement could sever.

BRAVO!

The Bravo cable network, though mostly devoted to nightmarish European circuses and short black-and-white films about insane people, occasionally gives airtime to an interview show called Inside the Actors Studio. *On it, the unctuous host, James Lipton, fawns over celebrities, doing everything short of serving them rich paellas and giving them scented oil rubdowns.*

Just in case Mr. Lipton ever calls me, I have my script ready for how I want the show to go.

Lipton (*with immense weight*): Ladies and gentlemen of the acting program, if you would kindly remove your shoes. Our next guest has not acted for some time now, but probably could if he wanted to. Would you please welcome ... Michael ... J ... (thirty-second pause) Nelson.

(*Light applause. Some shouts and groans. An empty milk carton just misses me.*)

Lipton: First of all, let me say how tenderly I love you.
Me: I know.
Lipton: Why don't we start with you repeating the story you told me backstage.

(*I look toward the audience for pleading applause, and hear nothing but a whispered conversation where I can only make out the word* slacks. *A thin woman from the acting school shouts, "Get on with it, hack."*)

Me: Well, as I was telling Jim, I—

Lipton: *Mister Lipton*, please.

Me: Yes, of course. You see, once, early in my career, the director Amelia Frauenschue called me to play Amantillado in *Any Port in a Storm* and told me that Paul Newman would be playing Elzado the Stevedore, who strangely, is actually a wheelwright. Well, I was quite nervous to meet him, but when I got there, it turns out that she had said, "*Roger* Dicken-son." Apparently, I had heard the "son" and thought "man," and, well, I don't know what I was thinking with "Roger" and "Dicken." (*I laugh nervously for several minutes as all stare at me with hostility.*)

Lipton: And as dull as that is, it's not even true, is it?

Me: Yes. (*tiny pause*) No.

Lipton: Then, you landed what would come to be known as the role that would define your career. That, of course, was as Danny Zimmer in Alan Alda's 1981 film *The Four Seasons.* Tell us about that.

Me: Actually, that was portly character actor Jack Weston.

Lipton: So it was. Tell us about him.

Me: Well, I know that he was in *The Four Seasons* and *Gator* with Burt Reynolds and Jerry Reed.

Lipton: Correct. And we have a little surprise for you. Students, please welcome Mister . . . Jerry (*four-minute pause*) Reed.

(*Thunderous applause. Jerry strides onstage chewing on a toothpick, grabs a chair, spins it around backward, and straddles it with his long legs.*)

Lipton: Gerald, tell us what you think of Mr. Nelson.

Jerry: Don't think much of him. Looks to me like they took a pork belly and tried to dress it up as a picnic ham.

As far as I'm concerned, that dog won't hunt.

(*More thunderous applause*)

> **Lipton:** Sir Gerald, will you please . . . sing for us . . . "East
> Bound and Down" from the motion picture *Smokey and the
> Bandit?*
> **Jerry:** You got it, Jimmy Boy.
> **Lipton:** (*blushing*) Oh . . . oh, heavens.

(*Jerry brings down the house with "East Bound and Down"
and goes on to do "When You're Hot, You're Hot" and "She Got
the Gold Mine (I Got the Shaft)" while I look at my watch.
Finally, he finishes, and trades several amusing handshakes
with Lipton.*)

> **Lipton:** Gerald, I thank you for helping shed light on Mr.
> Nelson's work. Do come back next week for Dame Judi
> Dench.
> **Jerry:** You're on, Lipton!

(*Jerry exits. Pause, as Lipton looks after him.*)

> **Lipton** (*thoughtfully whispered.*): Oh, Jerry. Jerry.

(*After several minutes, I lean forward to interrupt his reverie.*)

> **Me:** Mr. Lipton?
> **Lipton:** (*impatiently*) Okay. Okay. Um, after losing the
> Danny Zimmer role to Jack Weston, you hit the inhalants,
> hard, didn't you?
> **Me:** Not that I remember.
> **Lipton:** Ah, but you wouldn't. And now it's time for a list
> of questions, invented by the great Jacques LaPlubierre on

He was so close...

his show *Et Ainsi le Grognement va sur.* What is your favorite bean?

Me: Hmm. Orson.

Lipton: (*ghastly silence*)

Audience: (profound rage)

Me: Or . . . son . . . heh-heh . . . Um, lima?

Lipton: Security!

That's as far as I've gotten, but I'm pretty sure I'll have time to finish it before Lipton calls.

BEHIND MUSIC

We seem to be devouring our own pop culture faster than we can make it, which is pretty darn fast. And so we begin to add to the canon unaged and unexamined bits of recent pop history. The result is VH1 programs mythologizing bands like Creed, which just formed a couple minutes ago, or epic biographies of Drew Barrymore, who was just born a couple of minutes ago.

A side effect of this is the habit of fellow celebrities and journalists of appearing on these programs and, in somber tones, attempting to add to the myth. It might go like this:

> **Narrator:** Janet Jackson may have been down, but she was not out. In the spring of that year, she showed up at the Sisqó Foundation for Abdominal Strength Research Awards Dinner wearing only one strategically placed cotton ball.
> **Journalist:** That was just an amazing moment. That was Janet just saying, "Here I am. I'm coming out. I'm wearing a cotton ball and I just don't care who knows it." After all

she'd been through, with her record label releasing her album a week late, this was her moment to come back and just say, "Hey, I'm here, and I'm wearing a cotton ball."

Henry Rollins: The cotton ball thing—that was genius. I mean if I could capture that kind of ragged energy in my poems, then I don't know what.

Normal people, those of us who don't wear sunglasses indoors and aren't in boy bands, don't have the benefit of our behavior being seen through the forgiving lens of pop culture. We must stand or fall on our actions, which is a shame. Take for instance Jimmy Tremont, a kid in my sixth-grade choir who threw up in front of everyone at an Easter concert. If he had only managed to make something of his life by being famous (instead of just becoming the fire chief in the town I grew up in), the event might be retold in a more positive light:

Narrator: The pain of Jimmy's D-minus in Mr. Riegert's science class weighed heavily on his creative soul. Little did anyone know he would purge that pain in a rush of creative activity. He threw up violently while singing a Handel cantata in front of a crowd of two hundred.

Journalist: (pushing up his glasses, shaking his head meaningfully, and looking off at some distant point) I think Jimmy just felt like he was trapped. He needed to . . . howl! To just say, "Hey, I'm Jimmy Tremont. I'm here, I'm a little sick, these choir outfits are hot, and I've been up here a long time. It's my turn to come out."

Henry Rollins: That vomiting bit, that was genius. You just knew, when you saw it dribbling down the front of that purple choir robe, that he was gonna be huge.

That Guy from Smashmouth Who Looks Like Curly Howard of the Three Stooges: I remember being blown away by the colors, man. I was just like, "Whoa, he had

elbow macaroni, and he had Doritos, and he had something red," and it was just a complete picture. It was brilliant.

Narrator: But Jimmy was not finished yet. Two years later, in an eight-grade geometry class, he would mispronounce the word *circumscribe* as *circumcise,* the boldest move yet of his career.

Paul Stanley: Everyone else laughed when Jimmy Fremont said "circumcise," but I remember being blown away. It was just a really powerful moment.

Rosie O'Donnell: I was a thousand percent behind Jimmy when he did the circumcise thing. Even though I've never met him or seen him or even heard of him before, I really respected the statement he made with that.

Gerardo: (wiping tears from his eyes) Can we do this later, man.

Of course you can guess that Jimmy had his troubles. He got caught with a Miller High Life behind the school bleachers. But he's back now, and he's ready to try his hand at throwing up again.

PART
THREE

This Modern World

VIRTUAL ME

What is an avatar? A very long article on avatars was featured in my newspaper today. Why? Should I be buying an avatar, or investing in one, or possibly sanding one? Or should I be breading one and pan-frying it? I don't know—but by gum, I'm going to find out! I'm going to read that article!

Okay, I've read it now, and I think I have a better understanding of just what an avatar is, though the article was rough going and I'd be lying if I told you I wasn't sneaking peeks at the crossword puzzle between paragraphs.

It was about "Ananova," an avatar designed by a British technology company. To help explain what an avatar is, the article told me that Ananova is a virtual newscaster. This was not of much help to me, because I had been living under the assumption that all newscasters were virtual newscasters. I read on. *"She could go on television tomorrow," said Deborah Lightfoot,[1] press officer for*

1. While being interviewed, she had to shush husband Gordon who was singing "The Wreck of the Edmund Fitzgerald" at the top of his lungs while in the shower.

Ananova Limited in Leeds, England. "Her technology allows that."

I was still confused. She seemed to be implying that most newscasters are not prepared to go on television because their technology does not allow it. But I've seen them! On any given day, any number of newscasters can be seen, their technology freely allowing them to report the news. You can't stop them from using their technology to go on television and report the news, even though you may want to very badly. I was still missing something. What, I did not know. So after finding a four-letter word for *natural balm* I continued reading.

Apparently, this avatar reports the news on-line at ananova.com. I logged on to check her out. In the time it takes for an avatar to load onto my machine, Ananova, the virtual newscaster, was virtually reporting the news on my computer. Because of that, I now know what an avatar is: apparently it is an unintentionally hilarious computer representation of a human being.

But avatar advocates—and I'm not making that up, the article refers to them by that exact name—say that the newscaster role is a tired one. Having seen an avatar reading the news for just under a span of one minute, I am afraid I concur with the prevailing wind now blowing through the avatar advocate industry.

One of their number, a Mr. Tim Child of Televirtual Ltd., is contemptuous of virtual newscasters and insists that avatars' future is on "third-generation cell phones." (That name caused me to pause and tear up a little, thinking about my own Grandpa Cell Phone. He was a wonderful, wonderful communication device and I wish my new Samsung had known him.) Said Child: *"With 3G phones you won't browse the Web in the conventional way—you'll use voice portals. We call them vortals."*

Well, I hate to be rude but it doesn't really matter what you call them. If I call grapes "greenie lumps," that itself isn't enough to change the name of grapes. You high-tech people have committed enough language atrocities as it is what with your "floppy drives" and your "e-tailing." If there is such a thing as voice portals, and I

seriously doubt there is or will be at my house, seeing as my computer regularly locks up while printing an envelope, then we can decide on a name then. But I can guarantee I won't be casting my vote for "vortals." (I shall continue to refer to voice portals as "Sexy Lips," a little pet name I used during our brief but tumultuous relationship of many years ago now.)

I resent his aggressive use of the word *you* as well. "*You* won't browse," "*you'll* use voice portals." It's a violation, and though perhaps not as personal as "you'll be using the newer high-tech bathroom tissues," it still feels creepy. It feels like he's watching me—which only reminds me of the Rockwell song "Somebody's Watching Me," and that's enough to ruin anyone's day.

Child's ultimate vision for avatars is that everyone would have his own, and they would be loaded in phones and on E-mail software so that when you called or wrote someone, your avatar would appear and mouth your words. *Why?!* Are they finding a lot of cases in interpersonal communications where people are throwing up their hands in frustration and saying, "I *kind* of see what you're saying, Paul, and you make a decent point, but until a creepy little hollow-eyed cartoon image of you appears on my screen and mouths it to me, I just can't fully understand it"?

I don't want a smaller version of me running around doing things I don't know about. The real version of me is hard enough to control and I have a rough enough time explaining to people why he did what he did.

Besides, if you give your avatar to people, you know they'll just deface it with funny mustaches and lumpy noses and then laugh at you when you're trying to tell them something serious.

So for me, things will pretty much be the same as they are now.

WHEN A CHAIR IS A CARD

I find myself targeted by designer office chair suppliers who bombard me with their catalogs. This happened suddenly, allowing no opportunity for me to move my family and change my name to something blander (*Mark* Nelson?). Yes, I'm hurt, as anybody would be, over being assumed to be an office chair consumer. Have they seen pictures of me and recognized something weak and lumpy about my bearing that would suggest that I sit around all day playing video solitaire instead of carrying I-beams and tossing hot rivets, or putting on boxing gloves and punching other men? Why am I not sent horse tack or cement mixer replacement-parts catalogs? Or a sales pamphlet featuring one-, two-, or three-liter bottles of leather-scented muscle oils and extra-duty weight-lifting belts?

It seems obvious they took a look at my credit report and said, in effect, "Hmm. Two children. Buys Toyotas. Pours his voluminous backside into a creaky office chair and uses pasty hands to manipulate, with some effort, a mouse and keyboard all day. Probably even uses one of those ergonomic 'track ball' mouses to

avoid hand strain." (Yes, I have one. But I could use a regular mouse if I wanted to. I'm not that soft.)

And though I'm hurt, sure, I look at the catalogs because, who couldn't use a new office chair? But I must say, I'm alarmed and confused by modern design. So, to summarize, after receiving in the mail and glancing at an office chair catalog, I'm hurt, alarmed, and confused.

The catalogs I get feature small pictures of the chair designers themselves—little glamour shots pasted atop a much larger picture of the chair itself. Invariably, the designer is a silver-haired gentleman from the Low Countries. As everyone know, whenever silver-haired gentlemen from the Low Countries get together in numbers greater than two, they leave behind them a trail of minimalist furniture, and that principle is certainly on display in my unwanted catalogs. Feelings of spikiness dominate. If one lived in a house that was very much like a huge piece of broken glass, each chair would be at home in it.

But the ad copy for the chairs is in stark contrast (the "stark" part of it no doubt delighting the designers) to my own impressions. They are described as having *whimsical curves, a charming design,* and very often as being *witty.*

No chair I've ever come across is funny ha-ha, but is it possible for a chair to be witty? What would that look like? I suppose if pages of *Blithe Spirit* were laminated to its cushion or if it had a microchip that allowed it to parrot Dorothy Parker or Alexander Woollcott, it could perhaps be described as dryly witty, but these chairs don't have these features, just aluminum powder-coated frames.

What if your chair *were* genuinely witty—cleverly designed, utilizing classic basal planes and double curves and materials that reference other designs in a nimble and wicked manner? I bet it would get old really fast. "Mm," you'd say with a wry smile as you noted how witty your new chair was. About five days into ownership of it, you'd still be marveling at its fresh invention. Seven days in, you'd be aware of its novel interpretation of classic themes, but you'd begin to be slightly irritated by them. After ten days of noting

the design's wink-and-a-nod attitude toward the modernist school, you'd punch your chair right in its smirking, witty little face and then step on it, bending a leg slightly and damaging its aluminum powder-coating. Even if your chair were designed to be *warmly humorous, down-to-earth,* and *accessibly friendly,* I would have to think even that would grate after a while.

One catalog features a chair referred to as *spunky*. While I'm trying to get my work done, I don't want my chair interrupting me with its pluck and vigor. I want a sturdy thing to sit on, not Mary Lou Retton. *It stacks intelligently, too,* as if trying to prove that it knows when to get serious and allow itself to be stacked without mouthing off. Still, *spunky*'s dark side is all too likely to be *aloof, bitterly acerbic,* or even *cruel.*

What am I supposed to make of those extra-modern chairs that are shaped like huge, elongated butterfly yo-yos or large amorphous white blobs that look like frozen ghosts? Those things run into real money; the white blobby number costs more than six grand. What if you got it home and couldn't make any sense of the directions saying, *Screw leg (B) into blobby white protrusion (C)*? There are an awful lot of blobby white protrusions, and one protrusion looks very much like another. So you throw it together with little confidence, and sit on it for years before seeing a properly assembled version and realizing you were perching on its left side all this time. If you called the customer complaint line for the chair, they'd probably just tell you it was being spunky.

Happily, the great majority of chairs are dull, witless objects that seem quite content in their place as mere tools for supporting human backsides. Mine, a secondhand task chair, has, at best, *plain good looks*. If I was being uncharitable, I might describe it as *unpleasant, not much to look at,* or as *pretty ugly, really*. Regarding its personality and intelligence, *thuggish* comes closest, although *thick* applies, and if you said of it, "What a loser," you wouldn't be far from right.

It is not spunky at all, certainly no more than, say, Salman Rushdie or Jerry Orbach is spunky, and I'm happy with its Rushdie/Orbachian level of spunkiness, thank you.

PASSWORD: YAWN

I am rarely in a position where I find myself desirous of toasting any particular item. A slice of bread, the most obvious candidate for toasting, I enjoy eating in its original state, preferring to trust the baker and his judgment about its doneness. I almost feel it would be second-guessing his talents to recook it, even if I have paid in full for the bread and consequently the license fee to alter it in any way I see fit. Still, my family does not share my leeriness and works the toaster pretty hard, convection-heating several items on an average day. As a typical "toasting" family, we have almost no concerns about our toaster's security, choosing to leave it accessible to all users. When people come to visit, we leave our toaster out as a tacit invitation for all to begin browning the food item of their choice whenever they'd like. If there's one thing I'd like people to take away from a visit to our home, it's a sense that we are a family whose toaster is open to all.

The same goes for my ski machine—if you'd like to use it, by all means do, but be aware that it's extremely loud and its proximity

to the water heater, furnace, washing machine, dryer, and duct work will depress you greatly, and after three minutes, even on the low setting, you'll find yourself wishing you were in a gulag eating a boiled onion instead.

In fact, you may help yourself to all the appliances in my home, save one: my computer. It's not that I am withholding my largesse in this area. The problem is, unlike my toaster, it is protected by some thirteen dozen 128-bit high-encryption passwords. I'd give them to you, but I don't remember them, and it would take me several hours to gather all the wrinkled Post-it notes I've scribbled them on. I would disable them, but I can't: they are forced upon me by the default settings of a plain out-of-the-box computer.

I don't need all the security my computer wants me to have. I did not buy it on eBay from Wen Ho Lee or Oliver North. In fact, I challenge those of you who my passwords allegedly protect me from, to be interested in the contents of my computer. It can't be done. Among the highlights, which some of the most intricate and advanced technology on our planet forbids you from seeing, is an abandoned story about hats, a piece of clip-art photo featuring a Canadian man sitting at a desk, and a PowerPoint presentation about macaroni and cheese that I made to amuse my children. The fact that it didn't amuse them in the least is quite beside the point—which is, if a magnetic bulk eraser salesman accidentally brushed up against my computer with his case of samples, erasing all 107 kilobytes of material on the hard drive, nothing much would change. Oh, the piece on hats would have to be started and abandoned again, but for me, that is nothing.

Against all logic, I am required to protect the very few Internet radio station presets I use with one of my many passwords. If you devoted countless man-hours and thousands of dollars in hacking equipment and managed to access information about my Internet radio presets, you would undoubtedly experience what the one or two people I've shared information about my Internet radio presets have: a boredom so profound your vision will swim.

One of the problems with the password system for me is that I am rarely in a state to do my most clearheaded password thinking at those moments when I'm asked to originate them; the consequences are invariably severe. For instance, I want to buy a three-dollar bottle of bike chain lubricant from "chainlubeforless.com," so I add it to my cart, and when I go to check out, I'm asked to set up an account and provide a password. Figuring I won't need to visit the site for another six to twelve years, I hastily type in the nickname of a kid in my neighborhood growing up who threw a dart at his sister. *Dumpie,* I type, thinking myself very clever. Half an hour later I receive an E-mail confirming my order for thirteen pallets of exotic Teflon bike lubricant and informing me that my credit card limit has been raised by their partner site "autocreditlimitraise.com" and charged in the amount of $38,591.32 and $1,200 for shipping by next-day air.

Alarmed, I check their site for a customer service number, fully prepared to wait thirteen hours on the phone. Of course, there is no phone number of any kind to be found even in the deepest submenus of their improbably large site. There is no indication whether they are based in the United States or on one of those disused offshore oil rigs that crazy millionaires buy and found countries on. My only option is to log in and visit on-line customer service, which immediately demands my user name and password, neither of which I could provide if I were strapped down and beaten. It asks me for my E-mail address, which I give, and it then sends me my password "hint," which I myself typed just under an hour ago. *I like fish,* is the hint I provided myself, which of course is no kind of hint at all. Obviously I was smirking my way through the "hint"-creating process, probably too busy patting myself on the back for saving eleven cents on bike lube and in general being a wiseacre.

I can't be the only one whom this has happened to, forgetting passwords almost immediately after ordering bike chain lubricants, can I?

Perhaps some bright folks could develop software that allowed for the disabling of security measures for people like me, who are protected in a more general sense by the apathy of potential hackers. It's my guess that there are very few people benefiting from the security offered them on their home computers. Those in possession of highly inflammatory top-secret international documents don't scan them into their Compaqs and upload them to their free Hotmail sites anyway. They do the sensible thing and after transferring them to microfiche, eat the original and store the film in their false back molars. They then fly to Marrakesh and are garroted, causing Bond to get into a massive shoot-out on downhill skis.

The point being, you can use my toaster.

A SERIOUS SPEECH
TO BUSINESSPEOPLE

Ladies and Gentlemen, welcome to the Henry VIII Motel here in East Grand Forks [or wherever I happen to make this speech] and many thanks to those of you who helped push away the folding walls to make such a nice space here in the combined Anne Boleyn/Catherine of Aragon room [or whatever two rooms are combined, or not, to make the space for the people to sit in]. As you know, Fishman Enterprises [or whatever enterprise whose employees I'm speaking to] has had a tremendous [passable/unfortunate/ disastrous/Job-like] year and it is all [no] thanks to you [goldbrickers].

Right before I was set to come up here, I was passed a note that I was asked to read, and so I'll do that now. "Could the gentleman with the walnut allergy please raise his hand so we can serve him his chicken breast."

Which reminds me of a story: once, while I was speaking to a group from e-iVieCo, a gentleman with an allergy to walnuts, not unlike that fellow there, told the waitress to make sure there were

absolutely no walnuts in his food. Well, the waitress, an old woman, hard-of-hearing, thought that he had said, "I'd like extra walnuts." Well, this gentleman didn't realize it and soon he'd eaten a good handful of these walnuts and his throat blew up and he fell out of his chair and . . . well . . . he . . . um, was rushed to the emergency room. Ahem. He . . . um . . . he lived. But it was touch and go there ANYWAY, the business climate this past year has been like a chicken breast with an indeterminate sauce: no one was able to predict with any accuracy whether there were walnuts in it or not, and that has led to the current state of the market.

Like many of you, I have felt the pressure put on me, mostly by the ads shown during tennis matches, to invest my money wisely, or else risk spending my "golden years" in a self-storage garage, scraping what I can off discarded banana peels with a slat from a broken venetian blind. So in 1997, I put every penny I had into Monkees memorabilia. Unfortunately, in early 1999 there was a Peter Tork scare and prices began to plummet. I remained calm and put the whole lot of it up for sale on eBay. Unfortunately, I had failed to put a "reserve" price on it and so $400,000 worth of merchandise sold to badmonkeeman11 for $38.75.

I got hit hard, but like every good businessman, I learned. I realized that the Monkees were a volatile band, investmentwise. Research and good instincts led me to take out a second mortgage and put that money into Shaun Cassidy–related goods. His stuff has not matured yet, but there is every indication that it will, and when it does, well, I'll see you on the shuffleboard courts.

One of the most pressing issues your company faces as it moves into the twenty-second century is just what to do about the coffee fund. Seldom does anyone actually put the thirty-five cents per cup, the agreed-upon price, into the pay box; then when Dan the I T guy goes to buy the coffee supplies, he's short of funds and ends up having to pay for a good portion of it with his own money. Understandably resentful now, he buys the generic preground in the big white can. Since this is made up of cheap Mexican robusta and

toasted ground chickpeas, the coffee brewed from it ends up tasting like the runoff from those black rubber bar mats. As a result, no one pays the thirty-five cents per cup and the dysfunctional cycle continues.

Frankly, I don't have the answer. I do know that whatever the answer is, it's going to involve a lot of memos.

And that brings me to the nub of my speech: what in the name of Samuel W. Scratch is "throughput velocity"? And if so, why? To get to the bottom of it, I asked my friend Dave, who works at a company that specializes in "throughput velocity." Here is what he had to say on this issue:

"Thank you for your interest in 'throughput velocity.' My chief concern at the moment centers on how to optimize my revenue mix. I will continue my effort to take this problem, chunk it down to its core elements, and find positive variances to both my top-line and bottom-line metrics.

"Perhaps a VRU is the solution. Either way the CD127 will reflect changes from ACI in CPH, SPH, and thusly, CPO.

"Right now I need to dialogue with some people to see how the monthly growth rates finaled out. Perhaps there still is a solution set that we have yet to dimension. The one thing I do know is that certain people will need to change their headset on this issue or we may be faced with negative growth that we cannot outrun on a top-line basis, even with deferrals outpacing accruals."

Now, Dave has always been a sensitive and intelligent fellow, but clearly, he's gone batshit and needs to be forcibly extracted from that place before he loses more ground to the creeping insanity. I will now make a note in my Palm Pilot to helicopter in with a team and deprogram him. [I then pretend to make a note in my Palm Pilot, which is actually an old box that my blank checks came in.]

And what of business ethics? Will you ever have any? Of course you know I like to kid you. But answer me this, is it okay to steal a bread company to save your own holdings from going chapter thir-

teen? If a colleague has a trash receptacle that is not regulation size and you are the only one who knows it, when you turn him in, is it okay to lie by pretending it was hard having to turn him in? If the company's inhouse Muzak service plays "The Piña Colada Song" three times in an eight-hour period, is it okay to burn down your office building? These questions have plagued business ethicititians for thousands of millennia.

Allow me to pose yet another business question: Why won't the Häagen-Dazs company admit that their name is made up, that it means absolutely nothing? I'll tell you why, because it's disgraceful, that's why. It stinks like Egg Nog Ripple. Their gigantic, totalitarian ice-cream state was founded on a big fat lie and all the Rum Raisin in the world won't change that. All the putting-a-map-of-Denmark-on-the-cartons in the world will not make it *not* be made in giant, used hog troughs. I can't go around opening stores called "Jørgen's Fine Swiss Timepieces" that sell pieces of wood carved to look like Swiss watches all willy-nilly, why should Häagen-Dazs be able to get away with their chicanery?

Well, to put it simply, because as a division of Pillsbury, they could have any one of us put to death and never face a trial. They're that powerful. Make waves for the Pillsbury corporation and one day you'll be waiting for your bus when, seemingly out of nowhere, a chubby white figure with a puffy white hat will appear behind you. A muffled gunshot will be heard, and that'll be it. Even if you saw him and had to time to throw a punch to his midsection, he'd just back up a step, giggle adorably, and then snuff your candle anyway. It's dark stuff, and I'm sorry you had to hear it from me.

[Note: Portions of the above were edited when I spoke at Häagen-Dazs Booster Days, a festival held at Pillsbury's headquarters in Golden Valley, Minnesota. Nice folks.]

It has been said that work should be play with a purpose, and I certainly could not agree more. While at a meeting, try spiking a volleyball with tremendous force directly into the face of your team

leader. Or pull out a game of Hungry, Hungry Hippos at an "all-staff" and begin playing, laughing loudly and shrieking with girl-ish delight. Or simply get out a bat and order that idiot from marketing to start shagging balls for you. I guarantee that your stock in the company will rise.

I'm going to close by giving you a piece of advice my first boss, Larry "Biscuit Head" Flamand gave to me some twenty years ago: Larry said to me, "You! Do the shitters on three first—then vacuum and empty ashtrays. That way you can catch a few Z's on two with-out the old man seeing you." If I could leave you with anything at all, my friends, it would be: work hard and lend a hand to those around you; keep your eyes open and find the joy in human indus-try; and most important: You! Do the shitters on three first—then vacuum and empty ashtrays. That way you can catch a few z's on two without the old man seeing you.

SIR, YOU ARE WEARING A MILK CARTON

What is our country to say in defense of the many television ads featuring guys dressed up as the tooth fairy, a carton of milk, mosquitoes, or any mascot for that matter? "We're deeply sorry," is a good start, but it doesn't begin to address the countless disturbing questions these incidents raise.

First off, why do advertising people feel the need to send concepts at us in great waves, like infantrymen storming a beach? One moment, not a single grown-men-as-mascot ad on the air, the sun is high in the sky, the leaf blowers are momentarily quiet, and everyone's feeling pretty good. The next day, the sky darkens and great columns of grown-men-as-mascot ads attack, numbering in the hundreds of millions, and things are considerably worse than they were the day before. Sales of the product they were advertising plummet, so they lay off everybody who isn't wearing a mascot costume and press harder.

But the problem is that the grown-men-as-mascot ads are supported by the thinnest of concepts: namely, that there is a grown

man in a mascot costume on-screen. I'm not suggesting that this can't be funny. There was probably an eight-second window in early '95 when it was worth a smile. But when it does collapse, there he is, a guy in a mascot costume, giving a bad name to his product, mascots, grown men in general, television, our nation as a whole, and the existence of the human species. (And then someone has to clean his costume, too.)

That's when the advertising people, who had hard focus-group data to back up their decision to go with the mascot concept, decide that it wasn't rolled out properly, that they just need cross-media support and it'll fly. So they send out another wave.

A word on focus groups: Do you really believe the people contributing to a focus group are taking their jobs at all seriously? And if so, are they the kind of people who should be making the final decision on this country's taste? I've seen these focus groups and they tend to go like this:

Host: Okay, how do you all feel about cabbage? Do you like cabbage? Let me see some hands. Okay, so cabbage is not something you'd like to see more of. Okay, what about guys in mascot outfits in a vaguely "ironic" setting? No. No takers on that.

(*Two guys in back, putting him on, raise their hands.*)

Host: Yes. Okay, you'd like to see more mascots. On a scale of one to ten, how strongly do you feel about mascots?
Guy Who Is Putting Him On: Ten.
Host: Wow. Okay, very strong feelings about mascots. Everyone else, how do you feel about mascots? Raise your hand if you agree with those two.

(*Just to have the matter over so they don't have to talk about it anymore, they all raise their hands.*)

Host: Okay, very, very positive feelings about mascots.

And the data comes back suggesting that every able-bodied person in America has extremely positive feelings about ironic mascots.

Perhaps the mascots might even have had a chance if the concept of the grown man hadn't already been trashed by the advertising industry. Has a single adult male ever appeared in a television commercial and not significantly degraded the image of the species as a whole? Men in commercials are whining, pajama-wearing idiots with drippy head colds, who can't cook, find the bathroom, or wash themselves without help. They're an army of Captain Agarns, only without the dignity.

And when will the advertising industry be done with print ads featuring high-angle shots of young people thrusting their arms toward the camera in an aggressive manner and making a "mad face"? I see these and think, "Go ahead and buy your MP3 player, I'm not stopping you—you don't have to threaten me." Or, "Yes, you can have the new Dream CD, I won't fight you for it."

These ads are irresponsible, as they play into a fear, shared by most adults, of being harmed by teenagers in colorful pants wielding Sony memory sticks.

There was a short-lived fad for print ads that feature shouting young men wearing some sort of dark goggle-type eyewear. In the absence of any information to the contrary (actually, any information at all), I will have to conclude that these goggles are a part of the rave lifestyle that the kids today seem to enjoy. And good for them for wearing eye protection! All that preaching by shop teachers has obviously not gone entirely to waste. My only caution would be, if your rave features any arc welding, DO NOT rely on those oxyacetylene goggles to block the harmful light. You may think you're being protected, but you can get severe retinal damage that no amount of shoe-gazing music can repair.

Focus groups and market research must be suggesting that

teens today are more "aggressive" than they were several years ago. Did we begin breeding a new kind of "plains teenager" that is a more aggressive beast in need of its own brand of advertising? Yes, somehow we did. Wait, no, of course we didn't.

More likely, the advertising industry is trying to grab hold of the elusive Riot Grrl subculture. And what are Riot Grrls? How would I know? Are they a loosely affiliated group of women who believe strongly in front-loading vowels into the first words of titles and omitting them entirely from the second? Probably not. But it is unlikely that I will ever be able to go deep enough undercover to find out. I do not believe that the Riot Grrl culture has so far produced any significant riots, but again, could there be a less qualified individual to have up-to-date Riot Grrl information? Here is a short list of people that I am marginally more qualified than, in the area of Riot Grrl culture:

- Ed Asner
- Strom Thurmond
- Ed Begley Jr.
- Yo-Yo Ma

Everyone not included on that list knows vastly more about Riot Grrls than I, so I encourage you to go to anyone but them and myself as resources.

WACKY MORNING
MISREPRESENTATION

My car has fifteen-inch tires.

I'm just kidding, it really has sixteen-inch tires.

Funny? Because the term *I'm just kidding* would seem to imply that that was the intention. And yet, it's absolutely and unquestionably as far away from funny as you could possibly get. The space between that remark and actual humor is vast and unending. Humor is east and those two sentences are west.

So why are prank phone calls ever considered funny? Unless I'm missing some key element, they are as a whole kith and kin with my little tire-size misdirection.

When I hear them being performed by morning radio DJs from shows with names like Fuzzy and the Buttmonster, Up-Chuck and the Bean, or the Chickenman and Ed, I physically squirm with discomfort for the few seconds before I can snap the radio off. Is that what they're going for?

If I may take a moment to address those wacky morning names. What is the theory behind them? Even the cleverest among them

were done being amusing by the time sound waves had dissipated the very first time they were ever uttered. Upon repeated hearing they elicit in the listener the identical reaction to being sprayed by a light mist of vinegar: it goes mostly unnoticed, though there is an awareness that *something* unpleasant is happening. Upon extreme repetition, it's as though the vinegar bottle's nozzle was set to "stream" and directed into the eyes of the listener.

I realize the idea is to be a little more rambunctious in the morning, get people moving, get the blood flowing. But no one wakes up to a skating chimp in the kitchen, a skiffle band in the closet, Russian tumblers in the bathroom, and Gallagher in the car. (Well, Mrs. Gallagher does—all of those things, in fact, in an attempt to drown out the sound of her husband.)

"Hey, it's Bugster and Filth here in the morning and it's time for our Whack-a-licious Anger Call," they'll say. "Today we're gonna call Ted from Martek Consulting. A coworker set up him up. Says he doesn't like to get sales calls at work—so I'm gonna call him and pretend to be a salesman calling him at work." They titter. Then they do call him and get through, Bugster lowering his voice slightly, and making it "funnier" so he won't be recognized.

"Ted?"

"Yes," says Ted, about as cheerfully as anyone at Martek Consulting.

"Yeah, I'm wondering if you wanna buy some lightbulbs?"

"What? No. No, and I'd appreciate it if you wouldn't call me at work," he says. There is tittering in the radio booth.

"But don't you want to buy some lightbulbs?" says the Bugster, becoming slightly Southern now.

"No. Now I told you, I don't appreciate sales calls at work."

"But, Ted, these are really nice lightbulbs!"

"Look, I'm hanging up and don't call me ever again!" Now huge laughter breaks out in the booth.

"Wait, wait, Ted. This is Bugster from the AM Morning Nut Log! Boy, oh boy, you were hot, Ted. What's the matter, don't you like

sales calls at work?! Woooooooooooooo, boy, howdy, I'm tellin' you! YEAH!"

"Ted, this is Filth here. Did you ever think in a million years it might be us?"

"I certainly did not, as I don't live my life on guard against people named Bugster and Filth calling to lie to me."

"I *guess* not! Woooooo!" says Bugster.

"How did you feel when he asked you *again* about the lightbulbs?" Filth asks excitedly.

"As you no doubt heard, I was a touch irritated, because as many of my friends and coworkers are aware, I do not like to be bothered at work."

"Boy, we're sorry to make you feel so foolish, but it was just too good to pass up!" Bugster laughs.

"Are you gonna be a little more careful now when you answer the phone?" Filth prods.

"No. This shall not alter my attitude and presuppositions about incoming calls whatsoever."

"Uh-huh. Yeah, right. WHATEVER! You're gonna be thinking about this twenty-four/seven, Ted."

"Now, Ted, you tune in tomorrow, 'cause we're gonna get some other poor dope, and you'll want to hear that, kind make yourself feel better. So tune in, 'kay?"

"I'll do nothing of the sort."

"Great!"

Then there is a full segment of celebration in the booth. They retell the tale, analyzing it and re-creating select bits, giving the full schedule of times it will be replayed throughout the day and the coming weeks, and details on where you can buy the tapes and transcripts.

I say stick to playing Ray Stevens's "The Streak" and sounding off horns, and that should be plenty funny.

THINK YOU'RE WRONG?
THINK AGAIN!

Please stop scolding and shaming me, syndicated human interest stories.

For instance, in setting up your premise for a piece titled "Someone's in the (Smaller) Kitchen," you lead off with this question, which I am only too happy to mull over: *In order to be efficient, kitchens must have large, high-output ranges and commercial-size refrigerators, right?*

"Well, let me see," I think. "I guess it would depend on the amount of—"

WRONG! For a growing segment of busy professionals, a smaller, more efficient kitchen is the way to maximize available space!

"Ahhh," I cry out, recoiling with no small amount of shame. Then I gather myself. "But I never said that in order to be efficient, kitchens must have large, high-output ranges and commercial-size refrigerators! *You* said that!" Then I reread the story's response.

WRONG!

I guess I'm just wrong.

There's a variation on it that is no less shaming:

Think bolero jackets have gone the way of leg warmers and maxi-skirts? my syndicated human interest story will ask.

Here I have even less to offer, and so abstain from answering.

THINK AGAIN! it demands of me. In this case, I might stand my ground a little more.

"No. I don't want to," I'll say to my morning paper.

But the syndicated human interest story is firm. *Listen, you sorry little punk*, it seems to be saying, *I know exactly what you think in respect to bolero jackets and their popularity relative to leg warmers and maxi-skirts, and I'm tellin' you, right now!, not thirty seconds or two days from now, to THINK AGAIN!*

My wife is concerned because I cry a lot while reading the Variety section of the *Minneapolis Star Tribune*.

Often, these stories will make firm pronouncements backed up with what looks like solid confirmation from the experts. Here's how they might handle a potential, say, pimiento uptrend.

The nation seems to be undergoing a pimiento renaissance, and at many upscale parties, the serving of unadorned pimiento is a flat-out trend.

"*Pimiento is the small piece of Spanish sweet pepper this season,*" *says Esa-Pekka Twartham, visiting hors d'oeuvre scholar at Bob Hoskins University (Sydney). "People love it because it's red and it's soft and you can just put it out without a lot of fuss. This is the year that pimiento is announcing to the world, 'Hey, take me out of the olive. It's my turn to shine.'*"

Then they'd start with the accusations.

Yep. And you thought that pimiento was just a mushy parasite—

"Now hold on," I would object. "I thought no such thing. I admit I haven't been the biggest pimiento booster around, but I've never spoken ill of it, never defamed its good name!" But it's too late. I've been found guilty.

Well, you'd better think again. And it might as well add, *You worthless, pimiento-underestimating moron!*

The syndicated human interest story always features a person who exemplifies the whole issue, whatever it might be.

Like many Americans, Roger Farkle was skeptical of manure therapy.

"*I thought it sounded weird and gross,*" he confessed. "*But now I'm sold on it. I have more energy and I don't gnash my teeth in my sleep anymore.*"

These people usually are awarded the stinger—the final, punchy sentence:

"*When I see that manure spreader backing up to my bedroom window,*" he says with a wide smile, "*I'm as happy as a man can be.*"

Now, I think I understand that the purpose of the syndicated human interest story is to fill paper. But really, when you see one like the following, you have to ask yourself, "Couldn't we just fill paper by printing the words *bobcat* or *Jason Patric* over and over again?"

Shopping carts are rolling into some surprising stores.

Wrestle your way through the pointless wordplay to get to the actual meaning and you might be left wondering, "If I cared for even a second to think about it, what store would it surprise me to learn had purchased shopping carts? Tiffany's, maybe? Tom's Fill Dirt and Gravel? Amazon.com? Smith Brothers Motor Home Sales?"

It turns out to be a story on Sears's new fleet of shopping carts. Perhaps they've killed my enthusiasm with all their shaming, but the most surprise I can manage upon hearing this news is, "Uh-huh."

Undaunted, the story goes on to press the issue that shopping carts are really, really showing up in some incredibly shocking places. *Truly, you would absolutely soil yourself,* it seems to be saying, *if you learned just a few of the amazing, jaw-dropping places that shopping carts are rolling into!* Unfortunately, Sears is the only example they can come up with, so they consult an expert for some outside corroboration that the shopping cart thing is a phenomenon bigger than the kitchen downsizing trend.

"*... Even stores that once looked down their noses at shopping carts are beginning to say. 'There's some value here,'*" said Britt Beemer of America's Research Group in Charleston, SC. "Carts are very powerful."

"Britt, honey," the men with the restraining devices will say reassuringly as they surround him. "You've been consulting too hard, honey. Come with us."

"Carts are VERY POWERFUL!"

"Carts can't be powerful, Britt. You used to know that."

"They rolled into Sears stores! They used to look down their noses at them—now they're saying, 'There's some value here.' OF COURSE there's value! CARTS are VERY POW—"

And then he's tackled and restrained.

Think Britt Beemer of America's Research Group in Charleston, SC, will be back contributing quotes to syndicated human interest stories anytime soon?

THINK AG—oh, what am I saying? Of course he will be.

NOT TERRIBLY WEIRD

If you called up one of those guys from Peru who always show up in the "Weird News of the World" columns and found him at home, you could get to the truth of the matter pretty quickly.

"Altabejo Tejas of Arequipa, Peru?" you ask.

"Yes, this is Mr. Altabejo Tejas of Arequipa, Peru."

"I wonder if I might ask you about the story about you that appeared in my newspaper, right under 'Dear Abby' and that other woman who has squeezed into the picture with her?"

"That is her daughter," he says.

"Thank you. Anyway, did you in fact graft a live llama onto your amputated arm?" you ask.

"No, sir, I have never grafted any beast of burden onto any part of my body," he says earnestly.

"I see."

"Your news syndicates insist on calling me and my friends looking for corroboration of very odd events that never took place," he says with a touch of pique.

"So you did not attempt to marry Volcan Misti mountain either?"

"I have a wife already."

"And you did not try to sell four hundred thousand dead condors to Kentucky Fried Chicken," you push.

"I would tell if you did that."

"And just for the sake of thoroughness, you're not a half-man/half-wolf creature who kills livestock by night, are you?"

"No. I'm a photographer," he says.

"Thank you, Mr. Tejas."

"My pleasure. How'd the Cubs do today?" he adds.

"They lost."

"What else is new?" he says, and hangs up, the issue quite settled.

I am unimpressed by the "weird" stories in these columns, because I'm quite certain most of them aren't true. The stories that are true, mostly small-time criminals doing dumb things, I don't find very weird at all.

File this under the how-stupid-can-you-be heading:

Amarillo, TX: A small-time criminal, who goes by the unlikely name of Thomas Johnson, was arrested trying to hold up the Oh-Pen-Lait convenience store at 11:30 P.M. Said the arresting officer, Sam Billard, "He produced a gun, asked for all the money in the cash register, and the clerk pressed the silent alarm. We showed up and arrested him." Johnson (if that's what he wants to call himself!) had this to say about the arrest: "I'm a criminal, that's what I do. I tried to rob a store, as I have often done in the past, only this time I got caught."

I guess you did get caught, "Thomas"! You got caught by Weird Stuff's "Dumb Criminal of the Week" staff doing something pretty darn dumb!

Doing stupid things, it seems to me, is the stock-in-trade of small-time criminals, which is what keeps them in their positions as "small-time criminals." If they were "really top-notch criminals," we would not be informed of their comings and goings and their botched jobs.

A subgenre of that is the "drunk people acting foolish" type of stories.

> Fort Lauderdale, FL: A man who police described as "feeling no pain" was trying to help a soda machine give birth when his hand got caught. Said the man, a Mr. Todd "Toddmonster" Parks, "I was not trying to 'help it give birth.' I was reaching up to steal a soda." Okay, Todd. Whatever! Mr. Parks, again: "Look, it's true. Now stop bugging me. I'm still drunk and I might get violent."

Which would lead, hopefully, to the headline EDITOR OF WEIRD NEWS ITEMS STUFFED UP SODA MACHINE.

PART
FOUR

The Great Outdoors

ANIMALS: WORTH SAVING?

People seem to have generally favorable attitudes toward animals, especially the furrier ones, and the bigger the eyes the better. It seems to be a truism that we should try to be kind to animals and protect them, to give them land to roam on, pat their heads, provide seed bells and pieces of pricey romaine lettuce. But does this make sense? Are animals as fondly disposed toward us as we try to be toward them? What I'm saying is, What have animals ever done for us?

Just as an example, do you think spitting cobras give a tinker's damn whether we live or die? Do you think they're concerned about preserving our habitat and making sure we're not exploited? Oh, you could try asking one, but I'm fairly sure his answer would involve deadly neurotoxins being directed at your eyes.

What are animals up to? Will they ever organize like the Planet of the Apes, requiring us to send a representative in a loincloth?

For the answer, let's start at the bottom with one-celled animals, so called only because *one-celled things* was deemed too vague. If

you look closely, and you have to, amoebas are not really animals at all. Any animal worth his salt will at least snap at you or try to get you with his powerful hind legs when you attempt to capture him. Not the amoeba. The most it will do is to extend some of its cytoplasm outward, forming what are called pseudopodia or false feet, and even that term is extremely generous.

You will note that extremist animal liberation organizations are largely unconcerned with the unethical treatment of amoebas, and rarely do they break into laboratories to free them. None of their chants contain the word *paramecium,* despite it being such a natural for a slogan like, "Let's go and free some, jailed paramecium! By twos-ah and a threes-ah, free some amoeba!" I think it's because they have looked as affectionately as they could into an amoeba's beady little nucleus and not gotten a whole lot back. One can't really blame them.

The same is true of the invertebrates, but you can sometimes see a tiny spark of life in their eyes, though often it's simply a fleck of slime. The sea sponge, for instance, is emotionally distant, and if it offers you a wave of its flagellum, you can count yourself lucky for having seen such an ostentatious display of affection. Likewise the flatworm, although it will be more than happy to give you dysentery if it has half a chance. The loriciferan is a small invertebrate that is so dull, scientists decided not to even discover it until 1974 and then ignored it until 1983 when someone standing in a lab with his hands in his pockets was given an assignment to classify it, just to keep him busy.

The largest of the invertebrates is the giant squid, and its behavior is pretty much what you'd expect. To mate, the male places a packet of sperm of in the female's oviduct, or in a vesicle below her mouth. "Thanks, lover," she says sarcastically in reply, but the male is too dense to realize he didn't exactly rock her world. He jets off in a cloud of ink and brags to his friends, who have to frisk him for his packet of sperm before they'll believe him.

With birds, we get closer to "animals" as we know them. They have a spine (though they seem to lose it when being chased by a

lousy cat), a brain, and a crude sense of humor. What is disturbing, however, is that at least one of their species, the ostrich, can reach weights of more than three hundred pounds. Meaning, I think, that when push comes to shove, that ostrich could clean my clock, and I'm not comfortable with that. I want to know in advance of any fight with a bird that I have a better-than-average chance of winning, even if I haven't trained that hard for it. I'm not saying there's anything we can or should do about it, I just want to say to all the ostriches out there, "We're cool, right?"

Of all the hundreds of species of birds, the unluckiest is perhaps the chicken, a flightless bird that has the extreme bad fortune to be flavorful. It is also a powerfully stupid animal, even as animals go, and if the other animals feel any measure of sympathy toward the chicken, they don't let on. For they know that the presence of a chicken takes the heat off of them and lessens their chances of ending up dead, wearing a tight jacket of oil, crumbs, and seventeen herbs and spices.

One bird that simply has to stop calling itself a bird is the hummingbird, which is really a moth. If it won't eat the seeds I set out for it, but rather, requires a special syrup prepared in just the right proportion of water to sugar, colored red, and served in a special container all its own, it cannot expect to be called a bird. I do not take special orders from my own children, and I certainly won't from anything weighing less than an ounce.

Not until we get to mammals are we truly talking about animals. Live birth is extremely difficult and complicated, and not just for the father. Until birds and other beasts can commit to the sacrifice of live birth, they're just not on the team and we'll continue to eat their eggs or throw them on Halloween. One animal that has tried to make an effort is the duck-billed platypus. It has taken steps and shown a willingness to advance by adopting breast-feeding. However. It has doggedly stuck to its egg-laying ways and should therefore never have been put on the mammalhood voting ballot.

The big hitters are really your dogs, your beavers, lions, horses, capybaras: these are all great, great mammals, and a credit to their

spines. But there are some mammals who quite frankly give us a bad name. Kitti's Hog-Nosed Bat, for instance, is only an inch long and weighs less than a tenth of an ounce. Worst of all, it's called Kitti's Hog-Nosed Bat. (It's not Candy Jo Reese's Great Horned Owl, or William "Billy Ray" Trent's Bengal Tiger, so why is Kitti, who sounds like she might be a drugstore clerk, allowed to have her name attached to tiny bats?) Anyway, to be worth anything at all, mammals should be able to roar or mew or at least give off a decent-sounding panicked squeak, but Kitti went ahead and named a bat that is too small to do anything remotely that robust. I think it's time to call Snyder's Drug, ask for cosmetics, and when Kitti picks up, break the news to her that her bat has been downgraded to a fungus.

Rats as well, should have their mammalhood revoked, not because they don't qualify genetically, but on charges of moral turpitude. There are only so many great plagues that you can cause before you have to take responsibility. In the trial against them, their bald tails (so horrible and unmammal-ly) should be admissible as evidence against them.

Bravo, though, to those mammals that represent the class with distinction and style. Camels, thank you all. You are strange and interesting, yet as comfortable as an old shoe. Elephants, take a bow—unless it's hard on your knees. Walruses, drop some weight and catch a shave, you'll be up there with the best of us.

Yes, animals perhaps are worth saving, as long as they get the rules straight: stop poisoning us and lashing us with stinging tails (scorpions, stingrays, you hear that?) or swallowing us whole. Keep the loud cries down a little and make them less hair-raising in general. Watch the stampeding and never fly in and decimate entire crops.

Finally, animals, clean up after yourselves, like the common bigfoot. They stay out of the way and don't leave their scat or their decaying bodies lying around. They're the perfect animal. Take a page out of their book and you'll get more respect from us.

COUNTRY BOB'S
EXTRA-DARK CABIN

The first thing you notice when you wake up in the middle of the night at my friend Bob's cabin is the shocking lack of light. Really, there is none at all. At other places in the middle of the night, you can usually find some small portion of light bouncing around here and there, but not at Bob's.

Let me back up a little. Actually, the *first* thing you notice when you wake up at my friend Bob's cabin is that you have no idea where you are—or even really who you are—but you suspect strongly that you may be deceased.

Your first task, then, is to establish the state of your mortality— which isn't as easy as it sounds. Oh, it would be nice to lean back into "I think, therefore I am." But in the middle of the night at Bob's cabin, "I think, therefore I'm dead" sounds every bit as plausible.

You'll want to take a little litmus test then and try to remember if you ate at Mark's Backwood Saloon. Because if you did, chances are you gave in, again, to the dare to try Mark's deep-fried mini-

tacos, and if you did that, well . . . You can only roll those bones so many times before they come up snake eyes. And you remember, and . . . Yes! You did eat at Mark's Backwood Saloon. You can conclude now, with reasonable certitude, that you ate the deep-fried mini-tacos, and consequently, you are stone dead.

"Well," you think, "nothing to be done." You are just about to get up and stroll around the hereafter, seeing if perhaps you can't find a tunnel of light or maybe some kind voices calling out to you, when you hear something very unlike a kind voice. It is a snuffing, snorting sound that could be either one of the other guests or a large dromedary camel. Since it is in character very similar to the hellacious snoring that kept you up so late, you assume it is another guest.

"Ah, good," you think, "this means I'm not dead," and if it is with less enthusiasm than might seem appropriate, it is because you know you now have to somehow make your way to the bathroom.

Going to sleep at Bob's cabin is very much like parking at the airport. Often one forgets to look up and see which row one has parked in. Therefore, when one returns several days later, one spends three hours in a very dispiriting search, actually contemplating catching a taxi home and just waiting until airport security calls several months later, telling one that one's car is still there and one owes them $11,000 in fees, offering helpfully to sell the car to cover the costs.

At Bob's cabin, as you retire, you'll do well to glance around and notice: Are you parking in the tiger lot, that is the basement; the bobcat lot, the main floor; or the eagle lot, up in the loft? Because as I said, in the middle of the night it is darker, as the expression goes, than the inside of a deacon's hat. If you don't believe me, I urge you to take hold of a sturdy black top hat such as a deacon might wear, and peer into it. Take note of its darkness. Now go to Bob's cabin in the middle of the night and look around. What do you see? That's right, you see Bob's face in the halo of a flashlight, and then as your eyes adjust, Bob, wielding a T square or whatever

tool he happened to grab, holding you at bay and demanding to know who you are and why you've come to his cabin in the middle of the night. Explain about the deacon's hat and I'm sure there won't be any problem.

If you've only ever lived in a city, you can't quite believe how dark it can get, and just how many stars there really are. If you're lucky enough to live on a lake, go down on the dock when the stars are out and there is no wind, and the lake will act like a perfect mirror. Look up, you'll see stars. Look down, stars. It's breathtaking, and if you're not careful, you can get vertigo. You feel as though you're lost in the stars. How many seventies rock albums were inspired by the phenomenon I do not know, but I would guess at least three by Styx.

So in this darkness, if you fail to take note of where you lay down to sleep, you could take a few tentative steps, flip over a railing, and plunge out of the loft, landing at the head of the stairs that lead into the basement. Then, as you begin taking inventory of your injuries, odds are you'll pitch down the basement steps, waking the whole place and causing further inconvenience when you ask someone to drive you to the hospital so you can get the necessary pins put in your leg.

And you didn't notice, so now you have to go to plan B, which is to probe the area around you with your hands. You touch something. "Ah, a whiskery face," you think.

"Probably male . . ." And you ask yourself, "Why is it I'm lying in such close proximity to a man who isn't my wife?" That is, why are you lying so near a man and *not* lying near your wife. They are two separate concepts, but it is late and you should be forgiven your mistake. You probe the stubbled area a little more, and note that it has the character of a Murph, perhaps a Smitty.

Then you remember. Golf weekend. Bob's cabin. Lots of guys. Many hundreds of pounds of guy, in fact. Guys on every available surface. And, you remember, you are upstairs in the loft. So you make your way down, stepping directly on the heads of at least

thirteen people, several of the owners waking up to ask you nicely not to—at least as nicely as you could expect from a person who has woken up to discover a man standing on his head.

You make it to the bathroom, and as you shut the door (before turning the light on, thank you) discover that the hinge has oxidized severely since you last used it four hours ago. The wooden door acts as a perfect sounding board, and as it closes, produces 113 decibels of a noise that sounds as though someone were dragging a piece of chalk across the bottom of a very large aluminum cookie sheet. You close it as quickly as possible and turn on the light, noting how extraordinarily different light is in character compared to darkness. They are as different as, well, as could be.

Completing that leg of your mission, you shut off the light and yank the door open quickly so as to shorten the duration of the noise, hitting yourself efficiently in the head with it.

Coming back out into utter darkness, you are reminded of your eighth-grade science class, where you learned about visual purple, the pigment that helps the rods in your retina to see in low light. You remember how it bleaches upon exposure to bright light and loses its effectiveness, taking a while to darken and become helpful again. You figure it will be about six weeks till your visual purple is up to the task, and you think about all the heads you have to negotiate on the way back to your spot next to the snoring whiskery person.

You lie down on the kitchen floor, pull the dog over yourself, and go to sleep.

TENNIS TIPS

Dressed in crisp whites and sneakers, you stand on the cool, red clay, the tightly strung racket in hand, a trio of freshly unsealed balls in your left pocket. The worst has happened: someone has talked you into playing tennis, and made you buy the balls. But soft—there is no reason to panic. Unless you feel uncomfortable looking like an uncoordinated moron. Then there is every reason in the world to panic.

More bad news: since you're standing on *red* clay, it probably means that you are on the center court at Roland Garros in Paris, and that Yannick Noah is somewhere nearby, just about to yell at you. It also means that after a tough match, you must go off to some Parisian bistro and have cockscombs sautéed in duck fat and capon marrow, served with a reduction of goat bladder stock and lamb hoof shavings.

But that is later, and you can always spit everything into your napkin, provided it's big enough to hold an entire six-course meal. For now, you've got to quickly learn to play clay court tennis. Later you can figure out how you ended up in Paris.

Service

The serve, or more formally "service," or yet more formally "Robert Millington Service III," is the stroke that starts out each point. It is usually an overhand stroke, but you can do it underhand, if you're more comfortable looking like an original drafter of the Hawley-Smoot Tariff. If you are an elderly gentleman who wears a wool one-piece, red-striped bathing suit, this is probably the serve style for you. May I also suggest that you purchase pants that rise to a level well above your navel, use a monocle while reading documents related to establishment of the Tennessee Valley Authority, and tell young workers under your charge, "I like the cut of your jib, young man."

For everyone else, the overhand serve is the way to go. For your first serve, toss the ball up and out in front of you, and try to think of yourself as going up to get the ball. Reach for it, and swing freely with a loose wrist. After doing this, most of you will find that all the muscles of your rotator cuff have torn like wet tissue paper, and you cannot raise your arm above the level of your waist. This is normal and nothing at all to worry about. Simply switch arms and start again.

You'll notice that after many attempts, you still cannot get your first serve in. Statistically, no amateur player has ever gotten his first serve in. The wise ones use it as a way to probe the net for weaknesses.

For your second serve, it is advised that you adopt a topspin, or American Twist, or Doritos TacoBaconCheez Twist Crunch with Bac*Os® Brand Imitation Bacon Bits. To do this, you will need to toss the ball much farther back in your stance than with your first serve—though not far enough where you'd have to scramble over the fence behind you to get at it. To impart a topspin to the ball, brush up the back of it with your racket. I don't know if this is to

remove crumbs or what, that's just what I was taught. When you're finished doing that, answer your opponent, who has asked, "What in the hell are you about over there?" Tell him about the brushing, then wait for him to say, "You know, I didn't want to play you anyway. It was Joyce's idea," and then, finally, serve the ball with topspin. It has a much higher chance of going in—about 15 percent compared with the first serve's dismal 0 percent chance—and "kicks" up at your opponent, which is supposed to be harder to handle. But seeing as your opponent has never seen a first service, he's well equipped to handle your little kick serve, and with almost no effort, flicks it crosscourt and charges the net like Xerxes at Thermopylae.

There are a number of ways to handle this: I like to utter a little involuntary yelp and run into the adjacent court. Sometimes your opponent's eyes will follow you in amazement and he won't even notice if his return was in, though, of course, it was. Since he can't prove it, yell "Out" and announce the score with another point in your favor. Then get off the court of the people next to you. Go back to the service line, fault, then serve up the topspin second serve again. When your opponent drives it deep down the line and runs to net like a Pamplona bull, get somewhere close to the ball if you can (within ten feet should be fine for this tactic), take a swing, and let go of the racket, making sure that his head in is the path of its trajectory. Don't be intimidated when he comes over the net and threatens you. Stand your ground by sniveling and produce a clammy hand as evidence that the racket throw was accidental.

Announce the score, including that last point as your win, only do this once your toss is up in the air. He will interrupt you by saying, "Hey, hey, hey, now. That was my point. I gave you the first one, but that was mine." Put your hands on your hips, a condescending smile on your face, shake your head slowly for a while before answering. "Okay, Ron. If you're going to take that one. Could you just wait until after my serve to cheat next time?" And then immediately toss the ball up again and fault. Sigh heavily and look at

Ron, hands on hips. Then spin in your ineffective second serve. When he absolutely crushes the ball for a winner, give a little salute with your racket and say, "Nice lob."

Announce the score as you begin your ball toss, but catch it again before serving and say to Ron, "Does that square with your thinking?" and then gaze at him with a look of theatrical, almost vaudevillian expectancy.

Fault, of course, then when he crushes your second serve again, get to the ball and take a huge, uncontrolled swing at it, connecting only with the frame. The ball will shoot up in the air, over the fence, and begin bouncing around the parking lot. At this point, go ahead and unleash a string of the foulest, filthiest, most darkly scatological profanity ever heard. Curses of byzantine construction, utilizing slang, medical jargon, nautical terms, references to animism, structural tolerances, surveying records, and, most importantly, the names of people known to Ron, getting specific about them, and ending with a primal scream of rage.

From then on, surround the announcement of the score with a truncated, lower-energy version of the cursing, like this:

"Filth filth curse filthing fifteen cursing filthing four-filthing-tee."

Also, line-call announcements should be similarly embellished.

"That cursing filthing piece of filthing curse was filthing out, for your filthing cursing information."

And as you switch sides, it should sound like this to Ron as he passes by you:

". . . mumble mumble filthing son-of-a-cursing filthy FILTHING HORRIBLE CURSING filth filth filthy-filthing curse mumble mumble . . ."

When receiving serve, stand inside the baseline to take the ball early, before it has a chance to "kick" or "bend." In fact, go ahead and stand inside the actual service box, the area where the ball is required to take its first bounce. In fact move all the way up to the

net, where it's relatively easy to put away a quick volley and end the point early. Your opponent will object, of course, citing the rule that requires the ball to bounce once before you are allowed to strike it. Ask him nicely if he'll overlook that rule. Ron being Ron, he won't let you.

Because of that, you'll lose badly, of course, and you'll look bad doing it. Perhaps I should have given you some instruction on the forehand. Or the backhand.

I gave you the cursing thing, right?

Ah well, enjoy Paris, anyway.

THEY REALLY, REALLY BLOW

Autumn is one of our best seasons here in Minnesota. Truly, it's right up there with spring and summer, and better by a long chalk than winter. Winter is not nearly so nice. A winter in Minnesota is comparable to being hit by a frozen train. Winter is, frankly, like hell, or death. Or cold, skinny rats gnawing their way . . . well, I overstate my case. The point is, autumn is strikingly beautiful and my favorite season. But recently, the elysian calm of our warm autumnal afternoons has been terrorized by a sound that I can best describe like this:

*Rrrrrrrrrrrreeeeeeeeeeeeeeeeeeeeeeeeeeeeeeeeeeeeeee
ee
ee
ee
ee
eee
eee*

ee
ee
ee
ee
ee
ee
ee
ee
ee
ee
ee
ee
ee
ee
ee
ee
ee
ee
ee
eeeeeeeeeeeeeeeeeeeeeeeeeeeeeee ...

And it will go on like that, wavering only slightly in pitch, for thirty-eight solid days. (If I tried to duplicate its duration, the *eeee*s would go on for 4,500 pages, so I spared my publisher and you.) Though it starts as a single voice, it is soon joined by others, and they all come together in shrill chorus, every now and again a voice dropping out, only to be picked up by others. It is never silent.

The source is, of course, the leaf blower, or "power rake," or "world ruiner." The sound it makes again, is this:

Rrrrrrrrrrrrreee
ee
ee
ee

ee
ee . . .

I would ask you to compare that sound with this, the sound of a rake.

Swisssh. Swissh. Swissh. (Sound of children laughing.) *Swissh. Swissh.* (Mournful sound of whippoorwill in the distance.) *Swissh. Swissh.* (Soft sound of approaching footfalls.) *Swi—*

"Well, howdy, neighbor!"

"Howdy-do to you, friend. How's every little thing?"

"Oh, Martha's busy putting up"—*swissh*—"that boysenberry jam of"—*swissh*—"hers. I'll drop some by later, if you'll"—*swissh*—"be around."

"Sure will. And if you'd sit a spell with me and have a sarsaparilla, I'd be much obliged."

Fall used to sound like that. Not exactly like that every time, certainly. Not everyone has a person named Martha in his home cooking up boysenberry jam. Still, I think my point is clear.

Leaf blowers have taken a world which was, on the whole, a decent place to live, in spite of talk radio, and turned it into a noisy and unpleasant vale filled with atomized bits of vegetal detritus.

Leaf blowers are cunning. They operate only when earth is offering her best face, when paradise is within reach, and just when it is inches from your grasp, the leaf blower snatches it away. The phenomenon might be described like this:

ParaRRRRRrrrrrrrrreeeeeeeeeeeeeeeeeeeeeeeeeeeeeeee
eeeeeeeeeeeeeeeeeeeeeeeeee
 ee
eeeeeeeeeeeeeeeeeeeeeeee
 ee

eeeeeeeeeeeeeeeeeeeeeediseeeeeeeeeeeeeee
eeeeeeeeeeeeeee . . .

There is nothing sadder or more frustrating than watching a man chasing half an ounce of lawn clippings down his sidewalk for an hour trying to get them to make it over the hump where yard meets concrete.

If the broom had been invented after the leaf blower, it would be hailed as a marvel, a triumph of twenty-first-century technology. Here is what a broom sounds like as it dispenses with half an ounce of lawn clippings.

FWuwish. FWuwish. (Sound of gentle breeze.) *FWish.* (Sound of voices as two children glide by on bikes. Sound of woman who has just finished dispensing with half an ounce of lawn clippings sitting on incline in yard. Sound of woman sipping coffee as she watches the sun slip behind the oak and elm trees on the horizon. Sound of a gentle sniffle as a tear rolls down her wise face because she is overcome with joy over God's goodness.)

See above for refresher on the sound of a leaf blower.

The leaf blower is a coconspirator in one of the greatest crimes against humanity ever perpetrated: blow-raking. I've seen it, witnessed blow-raking firsthand. It's horrible. Be subjected to it yourself and it will change you in some fundamental way.

Blow-raking is the act of using one's leaf blower to gather all the leaves in one's yard together, as opposed to the common practice of using it to blow leaves out of hedges, landscaping rocks, and the like. As you might imagine, it's monstrously inefficient. The blow-raker will start at one corner of the lawn on, say, a Tuesday and begin blowing the leaves toward the center. On Friday, he will have four of the leaves where he needs them. The rest will be on the opposite corner of the lawn. He will restart the process over there, and a week later will have eight leaves where he needs them. However, the original four leaves will be back in the corner where he began.

I used to believe that blow-raking was done by misguided people who had interpreted the leaf blower's power as an increase in efficiency. I can no longer delude myself. Blow-rakers must be judged by their fruit. And that is the black rotted fruit of noise, fumes, destruction, ruin, and hate.

I didn't want to have to raise this point, but with blow-raking on the rise, the stakes have gotten higher and I'm willing to take it to this level: overwhelmingly, it is men who operate the leaf blower. Yes, men who grasp that big, waist-level nozzle, with its large, powerful motor, point it at anything in their path, and vanquish it— waving their powerwand over all they survey. Nothing can stand before it. It's easier to operate than an electric guitar and much cheaper than a muscle car. Certain men can't resist grabbing on to it, revving it up, showing everyone in the neighborhood how big and powerful is their . . . leaf blower.

Perhaps there is nothing to it. I simply ask you to take a good, hard look at yourself and your motivations.

And while you're doing that, I'll be breaking into your garage to smash your leaf blower.

PART

FIVE

Remembrance of Stings Past

TIPS ON GETTING STUNG
BY WASPS

Much like paddling a canoe past angry hippopotomi, catching poison arrow frogs, or eating discount blowfish, getting stung by hundreds of wasps is not something you should attempt without solid counsel first.

I believe I can help.

First, it is important to identify the differences between bees and wasps. Bees are your basic striped nectar-gathering fellows, and I've never met a bad one. They're very social, to the point that you get the feeling they'd talk your ear off if they could. They work hard and they play hard, enjoy dancing and drinking nectar, and their motto seems to be "Live and Let Live," even it does just sound like "Bzzz bz buzzzz buzz." Yes, they will sting, if you step on them or slap them or attempt to drink them with a swallow of Tahitian Treat, but it brings them no pleasure. In fact, they're so committed to their peaceful ways, they have an if-I-sting-you-I-die-too policy.

Wasps, on the other hand, are a dark bunch. Their legs hang sullenly down as they fly about seemingly without purpose, perhaps

here-and-there randomly killing a viceroy larva or stinging a woolly bear caterpillar. The females, instead of giving birth in any decent, nurturing way, jam a giant, drill-like ovipositor into whatever object is most convenient and let loose with a stream of equally hideous spawn. Others of their crowd simply slouch around an existing nest waiting for an opportunity to sneak in and dump off some larvae.

It gets worse. The spider wasp hops nervously around the underbrush like a junkie drifter until it surprises a spider contentedly sipping dew from a curled willow leaf. Then it grabs and stings the arachnid, paralyzing but not killing it, and begins to drag it off to one of its many nests that dot the forest floor like tiny flophouses. Incidentally, if the spider's legs cause the slightest inconvenience while lugging it back through the brush, the wasp simply bites them off and drinks whatever blood flows out of the wounds. Once inside the nest, it lays its eggs on the spider's body *while it's still alive*! When the larvae are born, they immediately feed on Charlotte's still-trembling body. This is pretty grim, serial-killer stuff.

And their housing! Many wasps make their homes by chewing wood and plant fiber, mixing it with their saliva, and spitting it with utter contempt on the underside of your eaves, or on a door lintel. The paper is perfectly illustrative of their impermanent, live-for-today attitude. Others make their homes from mud, spit out in a similar fashion. It is as though their souls can't help revealing their very justified self-loathing.

Wasps can sting, many times if need be. And you just know they'd sting you a thousand times, until they were soaked with sweat and nearly dead from fatigue, if you didn't stop them.

Fortunately, I was able to stop them that day, the day I ran afoul of a hundred or more of these vicious killers.

Let's not get into who stepped on whom, or who parked a running tractor above whose nest in the earth. I think I could reasonably ask of any wasp, "What the hell are you doing putting your home in the ground? What are you, a hobbit?"

And it wasn't as if I was rototilling their home, I was just stand-

ing there above it. What kind of world would it be if, every time a wasp flew near my home I came running out and directed a thick stream of DDT directly at it?

That's essentially how they treated me, by flying up my pant legs by the hundreds, stinging and stinging with homicidal rage.

One moment, I'm loading wood into a trailer, humming something pleasant and wondering what kind of homey stew I'll have that evening. The next moment, I'm screaming and wondering if there's any simple way to detach my own legs. Since the pain seemed to have no source or context, I concluded, perhaps a tad melodramatically, that there must be a sniper firing at me from somewhere in the woods. I hit the dirt.

What happened next just proves what lazy, shiftless creatures wasps are. Though moments before they had been perfectly content to sting my legs, it became clear that they were doing so only because my legs were so accessible to them. Now that my face was placed conveniently near the door of their nest, they began to sting that. It was eerie to look right into their cold eyes and see only hate. Hate segmented into many smaller bits of hate, of course.

I quickly formulated a plan that involved running clumsily, pinwheeling my arms, and shrieking like a frightened toddler. This did the trick and I was soon wasp-free. However, I realized I had left the tractor and its trailer back on their nest, still running.

The smart thing would have been to regroup, subscribe to a beekeeping journal, seek out one of the mail-order beekeeping supply outlets listed in the back, and purchase myself a full suit, hat, bonnet, and smoke canister. Then, fully suited up, the wasps woozy from the smoke, I could have driven out of there laughing and taunting them as I went. Blame their histamines, many ounces of which were at that moment destroying blood cells that were needed in the reasoning center of my brain, but I figured I could just hop onto the tractor and get out before they even noticed.

Those of you who own 1949 Ford 9N tractors can attest to the fact that they have a top speed of one mile per day, unencumbered by a trailer and using high-octane fuel. Mine was nearly fifty years

old and had some miles on it, so it didn't have quite the pep it once had. I jumped on it, popped the clutch, and gunned it. Within moments, I was a foot away from the nest entrance, but the wasps sent their best troops, who caught up with me easily and had a field day. I felt it best at that point to resume my hollering and slapping and then to overturn the tractor by steering it sideways over a large pile of earth.

Luckily, I survived. But what about those who park Ford 9N tractors on top of wasp nests who aren't so lucky? There are no official figures available, but I would have to imagine there are hundreds of deaths every year, more in Iowa. Surely there are natural enemies of wasps (besides myself and anyone who has ever been stung)? Can't they be bred by the thousands in deserted airplane hangars and let loose to kill every wasp on the face of the earth? Isn't there some low-cost way to capture all wasps in the spring, bring them to a lab, and sting them so they know how it feels? Or better yet, just kind of hover around their faces while they're trying to eat, threatening to sting them for hours on end?

There will be those who defend wasps, saying, "They are beneficial in that they control larvae and caterpillars that are harmful to crops." That may be, but what would you rather be attacked by, a few dozen pudgy caterpillars or a terrifying swarm of bald-faced Africanized wasps (I assume at least of few of them have been Africanized, knowing how they get around)? You'll never hear anyone screaming, "Arrrgghhhh! Help! Please help me! I'm being attacked by a silkworm!"

If you're at a party and one of these wasp defenders starts in with the typical propaganda, tell her my story, how they stung me, again and again without remorse. Tell her about the horrible buzzing, the cold eyes, the welts, the painful recovery. Let it sink in for a moment, then walk away. Unless there's really nowhere else to go. Then stand where you are but change the subject as quickly as you can, or drop a crab puff as a distraction.

That's how the war against wasps is going to be won.

INEFFECTUAL WOO

I have no more idea than the next guy what the best way to approach a young lady is. But things can't be so different from when I was still in the game that it's gone out of fashion to drive near her home, get panicky and flushed, give up, and go home to read Conan Doyle.

My technique was always a bit more *reactive* and not as proactive as that of my more "popular" or "healthy" friends. I liked to repeatedly position myself in the vicinity of women I was fond of and hope that this alone would cause them to begin dating me. It rarely worked (that is, "never"), but if it ever it had, look out!

(If the reader will forgive me this shameful indulgence, I send this little secret message out to Sarah R., Teresa T., Susie Y., Margaret U., Wilma H., and Rhonda W.: we've never officially met, but I just wanted to say thank you for not condemning me quite as harshly as some of the others.)

What I'm saying is, though I'm no expert on pitching woo, I

know a bad job of it when I see it, because that's all I've ever managed.

Here's one I recently witnessed:

> **Guy** (*nineteen years old. In the latest Jimmy Hililflfilfirer fashions. Baseball hat, brim rolled severely, nearly into a tube. Approaches group of five young women on a walk.*): Hello, ladies.

And the girls walk on, ignoring his advances.

What went wrong? Well, at first I thought, "Oh no—he's attempting to use Eddie Rabbit's 'Step by Step' instructions to winning her love!" The first step, as you'll recall, was to "ask her out and treat her like a *lady*." The second step, if memory serves, has something to do with windshield wipers slapping out a tempo, keeping perfect rhythm with the song on the radio, and that's where most romances fall apart.

No, what most likely happened was he temporarily suffered under the delusion, brought on by the stress of meeting women (a stress more severe, mind you, than getting a divorce and losing your job while on a jetliner that is currently plunging, uncontrolled, out of the sky), that caused him to believe he was strolling through Hyde Park, circa 1851, and that he had just doffed his silk derby, tugged at his tartan waistcoat, smoothed his mustache, and taken some snuff when he happened upon Lady Windemere's coterie. "Isn't that Miss M. Meunch, daughter of the Bohemian financier of some note?" he no doubt thought to himself. "And lands! It's Miss duFrothier, back from the mineral spas, prescribed to her by Dr. Stoppenham for her nervous condition. If I have not missed my guess, accompanying her is none other than Elizabeth Ullingsmith, daughter of that coarse American interloper, allowed into the finer circles only because of his recently gained fortunes in the copper mines! Soft, hereby they pass," he thinks and then says, of course, "Hello, ladies." And a perfectly appropriate greeting it is

to his own fevered mind. But unless the exact scenario he imagined is actually occurring, it is perhaps wiser to forgo that particular lead-in.

Another frequent mistake of the modern guy is to oversell himself, intellectually speaking, in the copy of his personal ad:

> Single man, 35, seeks smart, funny female to share belly laughs over Aristophanes (*Thesmorphoriazusae* in particular), titter wickedly over Pynchon, gasp at Borges, read passages of Joyce to each other in bed, rework Bach's rougher fugal passages, annotate the First Folio, exchange knowing *Mmmm*s with each other while critiquing Van Der Goes, give huge volumes of Goethe as Christmas gifts . . .

Yes, you want to distinguish yourself from the guys who write, *Hey. Want some of this sweet meat? Give me a shout,* but this is no way to do it. Any woman who reads that copy conjures a mental picture of a guy in stained pants with a broken zipper who's been working at the hobby store for eight years while preparing for his GREs. That is not necessarily a bad thing, unless you ever want to have a woman touch you again (shoving doesn't count).

I think I side with many cardigan-wearing fathers from 1957 when I denounce the practice of driving up and honking for your date. She is, one would hope, not a Rapid Oil Change. (Is she? If so, make sure she puts the appliqué on your windshield telling you when you're due for another.) I suggest going all the way up to the door, and once there, sounding off one of those pressurized air horns. Or you could walk in and start making a sandwich until she's ready, or even *if* she's ready. Make sure to talk to her father. Again, I have no special knowledge in this, or any, area, but you could open with something like, "What are you all about?" or "You got any cotto salami in this joint?"

If the object of your desire has children, don't press too hard trying to ingratiate yourself to them like this:

> *You*: Hi, buddy. You look like a sweepy boy. Just get up from a nap? I brought you something. (You produce a twelve-foot stuffed Pikachu from behind your back.) You like that?
> *Child:* Um, I'm eighteen. And I'm a girl. You could give it to my brother.
> *You* (*to brother*): How's about you, little cowboy? You like Pikachu?
> *Brother:* I'm twenty-three. I picked you up and brought you here 'cause you didn't have a car, remember?
> *You:* That's right. Say, could you drive me to the florist and lend me a twenty?

Another dependable mistake is the mentioning of old girlfriends on the first date.

> *You:* Why did you have to get me talking about her? Betsy! (*Falling on your knees, crying in anguish.*) Betsy!!! Oh, God—O heaven, how my heart beats at the passing of that heavenly name across my cursed lips. I release it again to its proper place in the firmament of heaven . . . *Beeetttttttttttttsssssssssssssssyyyyyyyyyyy!!!!!!* Why do you dredge from my wretched soul my haunted past with that blessed angel?
> *Her:* I just asked how long you'd been with Damark.

Most importantly, no matter what stage the relationship is in, brand-new, affianced, newly married, long divorced, take special care never to call her by the wrong name. The name of an old girlfriend is bad enough, but if her name is, say, June and you slip up and call her Herbert H. Friar, you can expect serious setbacks to the relationship.

So far I've focused on *don't*s, so allow me to conclude with some positive advice: during courtship, women, we're told (by women), like to feel special. So on your very first date, give her an ambassadorship. It doesn't have to be a huge country, or even a very good one—Monaco would be a nice, romantic choice. Better still, pick her up in a gigantic parade float adorned with thousands of fresh-cut flowers. Hand her a tiara, opera gloves, and a scepter, and show her to her seat while you climb below and drive around for a few hours. Then show her the huge Macy's balloon you had made in her image, and I guarantee she's yours.

LITTLE DID WE KNOW

A whole lot of work went into my education, a tiny bit of it even mine. But from the period covering first grade up to and including eighth, I learned only this: a little addition, a little subtraction, some multiplication and division, a couple things about the Pilgrims—but mostly, I learned that Eli Whitney invented the cotton gin.

Back then, there just wasn't all that much to know.

I learned about Eli Whitney for seven years straight. It's as though the teachers had been given only that to teach us, and so they made a very thin gruel of it and just kept adding water to it.

"Today, children, we're going to learn about Eli Whitney, who—"

"Invented the cotton gin," came the chorus of voices.

"Yes, but did you know how—"

"Great an impact it had on the economy of the South?" said my class in unison.

"Aha—*but*—"

"Whitney did not make much money from his patent on it and ended up building muskets instead," we said.

"Hmm. Yup. So we went over that, huh? What else can I tell you . . . ? Well, why don't we just hit the multiplication tables?"

Obviously, there was a lot to be learned, there just wasn't nearly as much knowledge in the accepted canon yet.

I would imagine the kids going to school in 1543 were living on easy street. You just know the teacher sat with his feet up on the desk with a newspaper, a drawing of an inclined plane on the blackboard, in the same spot it had been for a couple hundred years. Then one day all the kids file in, prepared to goof off and maybe answer a question about inclined planes, when they notice something is very different. The teacher is standing up at the front of the class with a panicky look on his face.

"Um, class, we're going to have to postpone our work on the inclined plane because we have some new information. Apparently the earth revolves around the sun. It's not the other way around, as I told you that one time . . . Okay, that's about it. Go back to your work on inclined planes."

As the years went on, they'd add a tidbit of information here or there, but it was all pretty low pressure, and anyway, a war would usually come along and stop things from getting too complicated.

My classmates and I had it pretty easy, too, until my junior high years when some younger teachers started futzing with the cur-riculum, trying to add in some of the groovy things they'd been learning in college.

"When your 'message' isn't being 'decoded' properly by the 'receiver,' that means there is some 'noise' in the communication process," they told us.

"What does this have to do with Eli Whitney?" someone would ask.

"Well, Eli Whitney filed for a patent. That was his 'message,' and the patent office was the 'receiver,' so . . ."

Now we were back on solid ground.

But then we were hit hard with Ecology, with a special focus on light pollution. Light pollution became the cotton gin of my junior

high years. "Do you realize if we don't do something now our sky will be completely polluted with light within five years?" they warned us. We did what we could, but the ability of thirteen-year-olds to enact sound policy changes that could effect a reasonable and long-term shift to shielded outdoor lighting sources was understandably limited.

Noise pollution was a concern as well, and was dealt with by showing us scratchy films of construction workers using jackhammers as people nearby winced. The efficacy of this approach is still being debated, but I can say that since then I have never knowingly noise-polluted.

After junior high, everything just mushroomed as human knowledge, mostly surrounding technology, doubled every year (see, that was just one of the new things I was expected to learn). Now, if you want to know just one tenth of all that is known about, say, the human scapula, you have to focus on that to the exclusion of everything else or you'll be considered a scapula naïf in the competitive world of scapula research. And because of all the so-called "advances" in "technology," Eli Whitney research suffers.

I'd like to remind our knowledge-crazy society that if we allow ourselves to become ignorant of our history, we are doomed to repeat it. Are we prepared for yet another Yale-educated inventor to create a machine that cleans the seeds from the once-worthless "green-seed" cotton, turning it into a tremendous cash crop?

I didn't think so. Let's put Eli Whitney learning back in its rightful place as the only thing kids know.

L.A. DIARY

*Since 1991, I've made infrequent trips from Minneapolis out
to Los Angeles, for various television pitches, award shows,
or simply to get away from image-conscious Minneapolis
for a little while, man. The following are some of my
completely unreliable memories.*

1992: My first trip to L.A. for an awards ceremony, no less.
It is a packed flight and I get an aisle seat next to a man who I'm
convinced was bathed by nurses shortly after birth, and that was
it. He has since then simply added layers of Speed Stick in a losing
battle to cover up his odor. He is wearing a sweater made from
Orlon, a man-made fiber ideal for wicking away freshness and pro-
moting the growth of bacteria. I immediately become queasy and
find I have to hang almost fully out in the aisle in order to avoid
passing out. I am hit by the drink cart so hard it nearly dislocates
my shoulder. The man takes off his Orlon sweater, and entire
galaxies of stink are sent directly into my sinuses. The meal choices
are announced. Either breaded chicken breast with rice pilaf or
sun-dried opossum with aged sweetbreads. When it gets to me
they're out of the chicken, so I pass on the meal, but the guy next to
me eats mine as well as his and his wife's. (Incidentally, since then,
I have never once received the meal choice on any of the nearly
fifty flights I've taken. I am simply handed whatever dregs are

scraped off the bottom of the serving cart. I don't say this to elicit sympathy; I would merely like to point out the extraordinary odds against it.)

In L.A., I stay in a busy high-rise hotel along with roughly forty-eight million Mary Kay ladies there for a convention. Every trip either to or from my room takes over an hour as the women embark and disembark. I take one pointy Mary Kay lady elbow to the ribs for every floor.

At one point, after stepping out of the shower, I hear a stern voice from an unseen source saying alarming phrases, but the voice comes in and out, so all I make out is, ". . . Smoke and some . . . on floor twelve . . . evacuation . . . leave your belongings . . . flames are licking the . . . hair on fire . . ." I dress hurriedly and head to the lobby, arriving one hour later with forty-eight million Mary Kay ladies. It is pandemonium in the lobby, and when I ask an employee what the trouble is, he says that he thinks someone pulled the fire alarm by mistake. I ask him if he's sure, and he says, "Uh, yeah, I think so."

We lose the award. There is a big party after the show, in a big tent with a big band, bars everywhere, and the largest pile of soft-shell crabs I have ever seen (I've seen about four piles), but there is almost no one in attendance. When I ask a bartender why, he says, "Everyone's at parties sponsored by the networks. This party, this is for losers," and looks me up and down. I am about to tell him in very strong terms that I'm not a loser when I realize that, technically, I am.

1992: Another awards show. This one is produced by Dick Clark, and the man is quite simply producing the hell out of it. He is instructing all the thousands of people jammed into the lobby, appearing first from one side, then from the other. I see him leave and suddenly he appears right behind, gently guiding me into the theater, taking a drink from my wife's hand (a drink bought for her by Wolf Blitzer. The bounder. His name is Wolf, after all). As soon as

we enter the theater, he is up on the stage doing mike checks. Dick Clark, it turns out, can bi-locate.

My wife chats with Faye Dunaway in the bathroom, helps Kim Alexis with her dress. Later she talks with James Garner's wife, and on the way out exchanges pleasant words with Peter Coyote. Me, I saw Super Dave Osborne, but didn't talk to him.

1994: My compadres on *Mystery Science Theater 3000* and I score a meeting with DreamWorks. Steven Spielberg may be there. Just before I leave for L.A., my neurologist prescribes the latest in a string of hundreds of drugs for my severe headaches. Or rather "headache," as I have had one continuous headache since 1989. It is a kind of drug that steadies my heart rate, making it beat once every twenty minutes.

We arrive at the Universal Studios lot for our meeting with the DreamWorks people and are given directions to their place, which is deep inside the lot. We walk for nearly a day in the 107-degree heat. My heart beats once every twenty minutes. People's voices start to sound distant and dreamy, and I begin panicking because I have a sense that things that just happened haven't really happened and are just about to happen again. It is unnerving. When we arrive at their beautiful bungalows, I discover to my horror that they are open, hacienda-style buildings with no air-conditioning. It's probably only seventy-eight degrees in their lobby, but it feels to me like I'm working the line-cook position for a brunch shift at the Denny's in Death Valley. The receptionist asks me if I'd like something to drink, and when I ask for water, he goes into the bathroom and gets me a two-ounce Dixie cup of lukewarm tap water, explaining apologetically that they're in the process of moving their offices. His voice sounds to me like it is being run through Peter Frampton's guitar processor.

For our meeting with the DreamWorks people, we'd all had our tasks assigned, but whatever mine was supposed to have been, I now take on the position of the official perspirer. I cannot stop

sweating, and my linen shirt does nothing to disguise this fact. My coworkers try to pick up the slack, but there is little they can do about the large, sweaty Midwesterner soaking through his shirt while sitting in Steven Spielberg's tasteful offices.

The woman who signs us out looks me over and notices blankly that I am dying. As we walk out, she asks if I'm all right, and the timbre of her voice wavers between that of James Earl Jones and Gracie Allen. Halfway through our day's walk back out of the Universal lot, a van stops to pick us up, sent by the woman, no doubt to haul away my corpse. I climb in the back, to the one spot where no air-conditioning has ever touched. The speaker system on the van is broken and only the bass can be heard. But only by the person sitting in the back. No one else notices. It throbs and crackles, and the trebleless voice of the singer sounds every bit as though Satan is trying to hold a conversation with me. I can't respond with my voice, so I simply sweat.

The next day we have a full slate of meetings and I am still sweating. The whole load of us cram into our rental car and begin driving around Los Angeles. I am in the back again sweating and so ask the driver if he could turn up the air. He turns it up to an absurdly high level, but I continue to sweat. The person in the passenger seat finds that his shins are beginning to freeze, but I can't stop sweating and ask them to turn it up. The passenger begins wrapping items borrowed from the other passengers around his legs, and ends up looking like a visitor to Byrd's Little America. Probably because our core temperatures are lowering, we cannot navigate well and miss most of our meetings.

We do make one of our meetings in Century City, which was the setting for *Conquest of the Planet of the Apes*. I consider making a mental comparison between the apes enslaved by their cruel human owners and the workers in Century City enslaved by their corporate owners, but then I remember that *Conquest of the Planet of the Apes* is a really bad movie, and that unless I was reading it wrong, it had already made that comparison. Apparently I'm off my

game. I decide to go to one of the many L.A. juice shops that will, for a sawbuck, throw an entire produce section into a juicer for you and give you the extract in a large paper cup. Gigantic blended juice drinks made from entire produce sections are double-edged swords, and this one cuts the wrong way. I feel woozy and redouble my sweating efforts. We have our meeting with some very pleasant women who stop us in the middle of every pitch to tell us they have something very much like it already in production. I come very near to unloading thirty-five ounces of juice on their conference table, something I feel certain they did not have in production already.

1995: Another awards ceremony. This time I sorely disappoint a "seat filler," one of the people who dress up in formal clothes and come to the theater where they stand in line and wait for those in attendance to leave their seats. Then, when an attendee sneaks into the lobby during a commercial to take a quick meeting about *Joe Dirt II,* they go sit in his place so that the camera doesn't see any empty seats. The ultimate dream of a seat filler, I would think, would be to sit next to Jerry Seinfeld or Madeleine Stowe, though "not sitting next to me" would have to be pretty high on their list of desirables as well. Unfortunately for one young woman, her darkest nightmare becomes terrifying reality. "Howdy!" I say as she buries her head in her hands and weeps. "I know—I wanted *Murphy Brown* to win, too."

We decide to hang in the lobby for a segment, as the shows are extraordinarily long and even more boring in person than they are on TV. Stephen King is also in the lobby, and while talking we say something that makes him laugh. A moment later, we decide to engage him, but when we look up, he is gone. Is that the spookiest thing you've ever heard? Well, as it turns out, we see him a little later at the after party eating roast beef and chatting with the others at his table. He doesn't seem nearly as macabre once I see him buttering a roll.

1997: At a big old network and sales extravaganza, I am seated very near John McEnroe. I sit pondering methods of introducing myself, including complimenting him on his remark to a bald French line judge—"Grow some hair!"—but I realize that may come off sounding like I want *him* to grow some hair, which is entirely up to him. I almost get up enough nerve to say hello, but he is called up onstage, where he waves to the crowd, which is standing in ovation, and then is flown away by helicopter. I realize grimly that the only way I could be flown from the event by helicopter is to sustain a massive head injury.

I will be back, you beautiful, nasty town! Do you hear me? I'll be back once I've conquered this little burg I call Minneapolis! Which I expect to have done by the fall of 2008, at the very latest! I'll keep you up-to-date as I know more!

ODD JOB

My high school guidance counselor, bless him, never suggested that I was most well suited to being a telephone collection agent. Oddly, he came instead to the conclusion that I should be a nurse. The only evidence he offered was that I was good in science, so I pointed out to him some of the negatives, most prominent among them that I really didn't want to be a nurse.

"These are very good scores in science!" he told me, in a tone that said, "Come on—just be a nurse."

So perhaps it was my pique over being accused of being prime nurse material that pushed me into telephone debt collection.

Like most people, though, I couldn't just waltz in and take my seat at the phone bank. I had to fail at every other attempt to secure any other half-decent job first. Then I found myself, at nineteen, seated across from a very sinister-looking man, his menace undercut only slightly by his brush-cut, powder-blue dress shirt with white collar and gold-tone collar pin.

"Do you have any experience in Debt Recovery?" he asked flatly, his eyes hooded.

"No."

"Any phone-bank experience at all?" he pressed.

"No." *Man, these interviews are rough*, I thought.

"What kind of office experience do you have?"

"None," I said.

"What was your last job?"

"I was in *Oliver!* I was Bill Sikes," I told him. I thought better of trying to impress him with the fact that Bill Sikes kidnapped Oliver and sang the number "My Name."

"How much you want to make?" he asked.

I'd never been asked this question. I just assumed a person automatically got minimum wage up until the point when they got a real job.

"Um, whatever's good for you," I said amiably.

" 'Cause I'll tell you right now, you take a look out in that parking lot and what do you see?"

The collection agency was in a windowless building, but I turned my head over my shoulder in the direction of the parking lot anyway.

"Um, it's pretty full," I guessed.

"Yeah, it's full of Camaros and Trans Ams, and Lasers. These are not cheap cars—our people do well. Some of them make six figures, easy." We sat there for a moment while I figured out what six figures was.

"We pay draw on commission," he said.

"Sounds good." I was just glad they paid something on something.

I went to orientation with a dozen other people a few weeks later.

"Hang your heart on the rack with your coat" was the advice pounded into our heads by the woman running it. She had apparently hung her mildly pleasant face out on the hook with her coat and went with her severely pinched, joyless, raisin-y face for this particular day. She looked like my mental picture of Gollum about halfway through his transition from Hobbit to full Gollum-ness.

A few days into it, she introduced a credit manager for Citibank, who gave them a lot of business. Hands in pockets, jingling his change, he explained, "We gave out millions of credit cards a couple years ago, basically to anyone who could fog a mirror."

A woman in the orientation raised her hand. "Why?" she asked quite reasonably, and everyone laughed.

He stalked over to her. "Hey, it is not your concern why we do what we do at Citibank. You just collect the money! We want you to use Level-A collection techniques." Just be aware, next time you use your Citibank credit card, that if you get sick or something and miss a payment, a nineteen-year-old with a Plymouth Laser could soon be contacting you *using Level-A collection techniques!*

One day of our orientation was spent learning about shame—obviously necessary, seeing as we had all taken jobs there.

"Shame is what motivates our behavior as human beings," said the instructor, hinting at a very strange worldview. ("I'm ashamed to be hungry, so I'm going to make an omelette." "My son being born just staved off my shame for a moment, so I'm going to act happy." Is that really how people work?)

We did plenty of mock calls.

"Sir, do you enjoy not paying your bills? Do you do this in other areas of your life, make promises and not keep them? How can you live with yourself?"

"No," "No," and "I'm sorry," were the correct mock-call responses.

"And you'll be going to the bank today for that consolidation loan and you'll be sending me payment in full, registered mail, and calling me back with that receipt number." You were supposed to be commanding and speak with action, leaving little room for negation.

The orientation lady delivered the killer blow as a question: "'And what can I expect if you don't call me back today?' What would you say to that?" she said, with narrow-eyed gravitas.

And everyone in class is thinking something along the lines of, "Um . . . 'That I've been stranded on an ice floe, chased there by a

wild moose?' I don't know. 'That I've gone about my business, ignoring the obnoxious lady from Allied Interstate?' "

Finally she announces, "There is no answer, other than 'You'll hear back from me.' And that's exactly the response you want."

In actual practice, it went something like this. (Excerpted from "My First Day on the Job.")

Trembly-Voiced Nineteen-Year-Old: And what can I expect if I don't hear back from you today?

Older Guy: What?

TVNYO: I said, "And what can I expect if I don't hear back from you?"

Older Guy: I don't know what that means.

TVNYO: I mean, you're going to call me back today, right?

Older Guy: Yeah. I said I would. Yeah.

TVNYO: Okay, thank you. Have a great day.

And then I hung up the phone and a voice came on my headset, "You should have pressed harder."

TVNYO: Ahhh! What?

Voice: You let him off too easy.

TVNYO: Who are you?

Voice: Up here.

I looked up at the windows of the office that sat half a story above the work floor and saw the sinister man who had given me the job. I learned that he could listen in at random to any of the phone calls. I quickly became adept at hearing the nearly imperceptible change in tone that signaled he was on with me.

Friends would call the toll-free number pretending to be debtors, which they often were—they just weren't mine. "Anyway, you swing by here and get me, we'll stop for beer, and then drive up to see Tim by the time the party"—nearly imperceptible change in tone—"the party who in good faith—*good faith!*—gave you this money trusting that you would give it back! Sir, I repeat, Have you no sense of decency?"

Transgressions were punished by a visit to his office, where

you'd sit in a specially positioned chair that would allow all the workers to see your expressions as you were berated by him. Occasionally, through sheer persistence, he'd get someone to cry, but for the most part, everyone was quite inured to his technique, which was really warmed over Level-A collection procedure.

"Are you trying to make me look bad, is that it? Do you do this in other areas of your life, make promises and then let people down?" Now and then, he'd tell workers that they were the "worst collectors I've ever had the displeasure to work with!"—the logical response being, "Thank you."

One day, after acquiring a little skill in Level A, I riled up a debtor who, uncharacteristically, lived right in the area, and he made a very specific death threat against me, which I reported immediately.

"Well, I wouldn't worry about it," said the supervisor.

"No, *you* wouldn't worry about it because it's not your death threat," I thought.

"We'll keep the back door locked," he promised, the erroneous implication being, "People never follow through on highly specific promises to kill other human beings through the front door." The back door was always locked anyway, I noted. People knocked and someone always opened it, never saying, "Are you here on the death threat? Then you'll have to wait outside."

"Shouldn't we call the police?" I asked.

"He hasn't shot you yet. We can't," he said.

"I hear someone's gonna pop you today," said the huge, white-haired older man who sat next to me, laughing. He took care to make sure that every single inhalation he ever made was done through a lit cigarette. He and his smoking apostles created a great omnipresent fog of stinky blue generic cigarette smoke, and thanks to their efforts, every flat surface was covered with a thin film of sticky tar. I figured if I wasn't gunned down, it was only a matter of days before secondhand smoke took me anyway.

Unfortunately, the gunman did not follow through on his threat

and end my suffering, so I had to return to work there the next day.

I was a miserable collection agent, one month even managing to do something no one else had ever done by failing to make enough to cover my draw on commission. Therefore, on one particular payday, I actually owed the company money for my having worked there the past month. This is a business model that works out poorly for someone used to living paycheck to paycheck.

Reviewing the job in my head yielded something like this: "minus column—I breathe in 1,200 milligrams of tar a day. I work six days a week with some of the numbest individuals I've ever met. If I do my job correctly, people are worse off than when I started, and all this so that the change-jingling guy from Citibank can buy more suits to put change in and jingle. My ulcer has returned. I have eaten nothing but SuperValu brand dill dip and Chicken in a Biskit crackers for more than a month. My supervisor thinks I'm weird, and has made it his task to see to it that my hours spent here are an endless nightmare of suffering. And finally, it costs me money out of my own pocket to work here. Plus column—I was not gunned down by a killer." (I put that in the plus column just so it wouldn't be empty.)

My conclusion: stick with it, it's bound to get better.

And so I did, though it did not. I quit after a year, a wiser man. Soon after, I went to work for a company that did debt *counseling*. This time it was in a cigarette-smoke-filled office with people who hated me, doing work I loathed, eating snack-cracker-and-dip lunches for days on end, but—BUT—I was calling credit card companies instead of debtors!

I am crazy like a fox.

HOW NICE TO SEE YOU,
PIECE OF ASPARAGUS

It's happened to us all before, this singular breach of etiquette: we are walking down the street, thinking of nothing in particular, perhaps recalling how mediocre our tuna sandwich at lunch was, how it was in large part the fault of the Pepperidge Farm bread, which was far too thin to support the sandwich in any meaningful way, even though it was toasted for more structural strength. All right, that is something in particular, granted. Then suddenly we see a face from our past we recognize, but we can't recall the name, perhaps not even how we know the person. So instead of greeting that person and admitting our fault, we hide behind a tree, and as they come closer we attempt to keep the tree between us and them, but as we make it nearly all the way around, we trip on a passing stroller, turn, and pitch into the large plate-glass window of a trendy bistro, crashing through it, where we bounce off a plate of cold smoked salmon and land in the lap of a dowager.

Go ahead. Deny that this has happened to you.

To avoid such embarrassments, what can we do? Well, there are

a number of things. We could buy one of those Harry Lorayne memory books (I had clean forgotten his name), study his systems, practice them until we're good—but what would happen if we started to remember too much? Our memories are not like VCRs, nor should they be, simply recording the things that have happened to us. That's something I'm thankful for, because I'm starting to forget many hurtful details about an old roommate of mine who ate nothing but fish sticks. Anyway, you don't want to end up having conversations like this:

> **Friend** (*who is cracking up everyone at your table with a hilarious story*): Anyway, we started hightailing it out of there in that pickup truck like we were the A-Team.
> (*Much laughter, cut short by you.*)
> **You:** They didn't drive a pickup truck.
> **Friend:** Huh?
> **You:** The A-Team didn't drive a pickup truck.
> **Friend:** Oh. Really?
> **You:** No. They drove a van. A black 1983 GMC "G series" van with a red stripe and license number L83000, or 2E14859, depending on the episode.
> **Friend:** Okay, anyway we hightailed it out of there, and this was that horrible winter in eighty-seven, so we—
> **You:** The winter of eighty-seven was statistically the most temperate in more than a hundred years and snowfall was extremely light. Perhaps you are confusing it with the winter of eighty-five, which was indeed extreme—
> (*Friend picks up ramekin of artichoke dip and throws it at you.*)

This is the danger of becoming one of those memory guys.

Another solution would be to take a moment the first time you meet someone, snap a Polaroid, ask them if they have any distinguishing marks or scars, and on the spot, give them a nickname

that is tied to their physical appearance. "Puffyhead," or "Booze Nose," or "Bad Pants." But this would do nothing to reduce the number of ramekins being hurled at you.

The best course, I think, is to realize up front that there isn't much we can do about forgetting someone's name, and as painful as it is, we have to deal with it in a straightforward fashion.

"Hello," you could say to the mystery person. "I have to tell you right up front that I was hit by a truck shortly after I got to know you at the bun shop."

"I never worked at a bun shop," she'll say.

"Curse that truck driver! Why don't they just pull over and get some sleep? Well, anyway, it's good to see you, Piece of Asparagus."

"Wow, that truck really messed you up, didn't it?"

"Sadly, no. I meant yes, of course, but affirmatives have become difficult for me."

"That's so sad," she says sympathetically.

"No. No, it is. May I ask you, please—and I hope you're not offended—who you are?"

"I'm your partner at work. You're still driving the carpool tomorrow, aren't you?"

It works. I have used it many times.

However, it doesn't work in the reverse. There are those people, not versed in this technique, who are simply honest about it when they don't remember you. Ouch! You might have met one of these people hundreds of times, yet they still insist they don't know you.

"Julie, you know Mike, of course," my friend will say.

"No. Nice to meet you—Mike, was it?" says Julie.

"We've met actually. Three hundred and fifty-seven times," I say.

"Hmm? No. Well, anyway . . ." And it is forgotten by everyone but me.

The very next evening, I run into her again.

"Julie, this is Mike, of course," another friend will say.

"Mike? It's nice to—" says Julie.

"I've met you, Julie. I've now met you 358 times! Here are some

pictures I was able to uncover of meetings 134, 178, 205, 206, and 312. Here are affidavits from dozens of people who have either introduced us personally or witnessed our introduction. Here I have a tape and a transcript of meeting 288. If you could just take a second—"

"Wow, your friend Mike is rude."

"He was hit by a truck," my friend whispers.

There will be times you yourself will simply have to resort to a cheap, shopworn device nowhere near as sophisticated as the truck accident ruse.

When you see a particular person whose name you should know as well as your own, but of course don't, greet them with a warm smile and say, "There he is!" (Note: This DOES NOT work on women, for some reason.)

It is a stopgap measure only, and if the person sticks around long enough, you're going to need to come up with some generic nicknames.

"So how are you, there, pal?"

"Well, actually, I had my arthroscopic surgery and [long description of badly botched arthroscopic surgery, which you don't listen to because you're trying to think of his name]."

"Well, hey, that sounds great, Slim." (He's actually kind of chunky—let's wake up!)

"And then what with the thing that happened with Nancy . . ."

"How is she? Give her a kiss for me," you say sincerely.

"Um, okay. You know that she gave the whole family salmonella," he says.

"Wow. And how does a marriage survive something like that?" you ask, very concerned.

"Nancy is our box turtle. Anyway . . ." (He rambles on about the family's lengthy recovery from the salmonella while you think to yourself, "Who names a turtle Nancy?" and then go about trying to remember his name.)

He continues, "So that's the story with Suzie."

"Well, I hope you flushed her right down the toilet, there, Sporto," you say, forgetting that Suzie is his daughter. Nancy is the turtle.

"I don't think that's very funny," he says gravely. "Anyway, with tax time coming up . . ."

Since this guy obviously isn't going away anytime soon, you'll need to work your way through Buddy, Bub, Pal, Partner, and if you have to, the less plausible ones like Dude, Mate, Comrade, Ol' Buddy Ol' Pal and then onto fictional names that sound chummy, like Barney Rubble, Watson, Archie Bunker, Teddy Ruxpin, Ahab the Arab, Maynard G. Krebs, and finally, out of exhaustion and desperation, Anne of Green Gables.

Use up all of those and it's endgame. Time to deal with the situation in an open and frank manner.

You know how to fake a heart attack, don't you?

DID HE SAY "MEEP"?

Part of the appeal of going to a small, not-so-good college is that a certain percentage of the professors are quite insane, and therefore colorful. It's my opinion, having attended one of these colleges myself, that of those professors who were insane, the demographics broke down something like this: one third had always been insane; one third had been professors at other, better colleges, where they went insane and were sent down to the minors; and the final third were just insane people faking their professor-ness.

My freshman-level English teacher was in this final grouping.

Of all the puppets he resembled—and I'm certain no one would ever have claimed he resembled anything other than a puppet—he looked most like "Beaker," the oft-mutilated Muppet Labs assistant. His hair was a shade less orange and his head was somewhat thicker, though similarly tube-shaped. Like Beaker, his shoulders were nonexistent, mouth turned severely down at the corners. He wore thick glasses, but they only made his eyes look larger and more Beaker-like.

On the first day of class he led off with what would come to be his signature bit—ending questions in a tone of voice that gave

absolutely no clue as to whether they were rhetorical or required an answer from one of us.

"But of course, that's why William Dean Howells's work tends to be classified as—as—as—as—as what kind of writing?" When the sentence began, its tone was vague but did give small clues as to which way it was going to tip. But then any commitment was wiped clean by the last word, which was a masterwork of vagueness. He would halt, his hands working slightly in an extremely opaque gesture—is he waiting for us, or is this a dramatic pause? It was agonizing. Usually, someone would give in.

"Realis—" they'd begin, only to be cut off. It was rhetorical, the bastard!

"Well, as realism, of course, and he was responsible for championing the work of what author, famous for *The Red Badge of Courage*?" Everyone relaxed, waiting for him to answer his own question.

"Well, come on, come on, he's a famous author, one of you must know!" he barked impatiently.

Within ten minutes, his whole class was suffering from stress disorder.

He also displayed an alarming habit that was shared by more than one instructor at my small, not-so-good school. He would allow his sentences to flow smoothly from lecturing tone to shockingly loud, moist, and violent throat clearing.

"Which is why we try to avoid the passive tone when TTTCCCH-HH-CHHHH-HHHHAAAAAAAAAWWWWKKKKKKKKK, SCC-CHKKK, HHHHNNNKKK, *CCCCCCHHHHHHKKK, HMMMK HMMMMK* we're trying to convey a call to action."

During the fits, which lasted up to thirty seconds and seemed certain to be causing massive tissue damage in his sinuses and lungs, people would look around the room at each other in confusion and alarm, unsure whether to take notes or begin pounding on his chest at regular intervals.

One could not ascertain why the throat clearing was necessary

at all. There were no aural or visual signs that his windpipe had suddenly become obstructed. Obviously, he was not in the middle of a steak dinner. He had not ingested feathers, or just shaken out a dust mop. The windows were closed—it seemed unlikely that a dragonfly had lit on his uvula. He appeared no better or worse off after completing these displays either. They were mysterious and disgusting, and everyone felt ashamed and saddened when they were over.

Which is not to say that he didn't sometimes sustain lecture-related injuries that required dressing and/or hospitalization. He did.

Once, while dishing out one of his psychosis-inducing rhetorical/direct question bits, he gestured a little too violently and tried to kill two birds with one stone and push up his drooping glasses. Unfortunately, the questioning, nostril-flaring grimace he often adopted left his nose vulnerable to attack by his fingernails. He knocked his glasses off, sliced open the inside of his left nostril, and began to bleed on himself.

"Oh, dear," he said, testing his nose and getting an unacceptable amount of blood on his hand. "Oh, for . . ." He shook his head in a vague "can you believe this?" manner, and for a moment it looked as if he would ignore the wound and push on. But the blood loss was beginning to look fairly graphic. "Oh, all right," he said, and left the room.

He popped back in. "We'll pick it up on Thursday," he said. "If I live," he might have added.

I was not there to see him self-inflict another, grander injury, but instead had to rely on eyewitnesses from another of his classes. "Beaker slammed his own arm on his desk and broke it," one agent reported. "He was doin' something goofy and cracked his ulna," another corroborated.

I was present at the following bit of strangeness. While lecturing on James Agee, he suddenly became curious about the hole in the countertop of his lecture table, which was really a large cabinet

with storage space beneath it, accessed by sliding doors. Without halting his lecture, he began to probe the hole—squarish, about the size of a small book—sticking his whole arm into it, tentatively at first and then up to the shoulder. Soon, and without stopping his talk on *A Death in the Family,* he was fully inside the cabinet. He hesitated for a moment during the exertion of closing the sliding door behind him, but then continued his lecture. After a moment, he stopped again as his arm came up through the hole, then withdrew the arm and continued the lecture. Then another pause during the exertion of trying to get the cabinet door open again, which he was unable to do.

"Could someone come up here and free me?" came his muffled voice.

The class laughed uneasily, still not sure if this was a joke.

"Well, well, well," he said, his tone thoroughly elusive. There was the sound of a minor struggle. "This is what I get," he said, still without humor or embarrassment or panic or any sign as to whether he was asphyxiating.

After a moment, two similarly dressed jock guys got up, walked toward the front and out the door of the classroom.

"What time is it?" he asked, and no one answered. He had never managed to connect on any identifiably human level with any member of the class, so direct communications from him (not that this was terribly direct) usually went unanswered.

More people got up and left, then more, till there was only a handful of people remaining. Finally two young women looked at each other questioningly and then walked up to his cabinet. Figuring he was in capable hands, I left.

Sometime later, I went to see him during his office hours to get a makeup test. His door was open a crack and I could see him hunched over his desk. I knocked lightly. Immediately, he exploded in activity, shooting out of his chair and yanking the door shut.

"Yes, yes," he said in a panicky voice. "Okay," he shouted, not making it at all clear whether that was "Okay, you can come in," or

"Okay, you must leave right now," or even the beginning of "Okay, I am ready to show you this picture of a clown I drew."

"Please," he said vaguely, and I then heard the sounds of furniture being moved, followed by the sound of a walnut being cracked slowly by one of those screw-type nutcrackers.

The suspicious activity was puzzling, as I had seen him clearly a moment before and he appeared to be up to nothing more nefarious than grading papers. Even if he had been making detailed plans for poisoning the department head, surely his method of secreting it away could be streamlined somewhat.

"Yes," he said, conveying even less meaning than his "okay" of moments before. "Yes," as in "Yes, you may come in," or "Yes, you can smoke in my office," or "Yes, I will marry you, no matter what Mother says"?

I was not, under any circumstances, going to open the door, so I stood outside, hearing the sound of metal cabinets opening and closing, his chair sliding across the floor, some books being stacked, a bust of Socrates being upended, nautical maps falling off a high shelf, shoes being polished, and a three-button suit being steam-cleaned.

I was turning to leave when the door opened and he looked at me without saying anything.

"That makeup test? I need that," I said.

"The makeup test," he said, and ducked back inside his office, did something horrible (I presume), and reappeared with the test.

As he apparently taught only 100-level classes, I never had him as a teacher again. Though I do wonder, what happened to you, Beaker? Did you fully metamorphose into whatever being you were in the process of becoming when I knew you? Did you quit teaching to become a puppet? Are you still locked in your lecture table?

And what were you doing in your office?

Please, even if through some extraordinary circumstance you come to read this and recognize yourself, please don't contact me with the answer to that last question. It was purely rhetorical.

PART
SIX

Busy Bodies

MOIST AS I WANNA BE

Only because I was absolutely certain she wouldn't mind, I recently waited until she was gone, dug through the bathroom cabinets, and took out all the moisturizers, creams, unguents, lotions, salves, humectants, ointments, cerates, oils, cosmetics, epithems, embrocations, liniments, and depilatories of a woman who lives in my house (who may or may not be my wife—I shall not disclose her identity). There were approximately thirty-six pounds of "4-in-1 moisturizing cleansers with hydrospheres" alone. Land sakes, how moist does this woman who lives in my house want to be? Is there a point at which you can soften yourself to death? To get to the bottom of that question, let's look briefly at how skin functions, and then quickly look away, disgusted.

Skin is the largest component of the human body, except in the case of singer/songwriter Paul Williams. With his diminutive size, it was necessary to provide him with custom-made skin far smaller than normal. His other organs are of the standard size, to keep costs down.

Your skin is covered with sebaceous glands, small ducts usually connected to a hair follicle that emits sebum, a mixture of fats including triglycerides, wax esters, squalene, and cholesterol. (As I said, *your* skin is covered with this thoroughly revolting stuff—my own skin would never slick itself down with a mixture of fats like that.) Sebum regulates the skin's moisture and keeps it flexible. If your skin had only chosen a name like "Rainwater Emollient Hydroxy Compound, with Rose Ester and Aloe," or anything besides "sebum," then there would be no moisturizer market.

What I am trying to ultimately get to the bottom of is why, upon using half a bottle of Jil Jordan French Hand and Body Massage Lotion with sweet almond oil, awapuhi, aloe vera, and seaweed, did this woman who lives with me suddenly abandon it in favor of the H_2O Mint Ice Massage and Body Lotion? Was it the awapuhi that drove her away? Or did the sweet almond oil put her too much in mind of nougat? We'll never know. At least, she's not here right now, so we can't ask her. And what caused her to lose interest in that and purchase a half pallet of something called ADVANCED WITH HYDROSPHERES® Continuous Moisture® SPF 8? Advanced *what,* exactly? Advanced stages of hydrophobia? Probably not, but a person earns his little bit of pique when faced with such a pointlessly enigmatic name for expensive glycerin suspensions.

The name *Principal Secret* ADVANCED WITH HYDROSPHERES® Continuous Moisture® SPF 8 seems to imply that upon rubbing it on, tiny automated balls will begin hosing down your face with sunscreen and never stop. This terrifies me, and seems to terrify the lotion's namesake, former *Dallas* star Victoria Principal, if her picture on the packaging is any indication. Though in the picture she is so softly focused that she appears to be emerging from a primordial mist, you can make out what appears to be a rictus of terror on her face. I think that's terror—it's definitely a rictus, I know that. Whatever her look, the artwork seems to promise that regular use of the product will result in nothing less than full mummification.

Which is perhaps why the woman who bought it moved on to

something new, Origins Ginger Soufflé™ Whipped Body Cream, a name that suggests it is to be used only by those who recently visited a dominatrix. Among its ingredients; ginger, of course; orange; lemon; coriander; clove; and olive oil. It sounds like a delicious marinade: I don't see any reason why you couldn't lie in it with salmon fillets strapped to your legs. Even if you're not doing any marinading at all, I still don't see why you couldn't strap some salmon fillets to your legs. They have to be at least marginally hydrating.

Though Z. Bigatti's Restoration Cashmere Body Lotion appears slightly used, I don't recall the woman who lives in my house ever being encircled with scaffolding, sanded, tuck-pointed, and fully restored by the Z. Bigatti company. And Bigatti's going to have a harder time explaining exactly what is meant by this name: Restoration Eye Return. A prepaid envelope for mailing in any eye damaged in the restoration process? If there are any rules to language at all, that explanation is the only one that makes any sense.

I found also the remains of something called a DDF Multizyme Resurfacing Treatment Kit, which is curiously devoid of any hot asphalt. I quote now its description, which is rather abstruse, and will then walk you through an explanation of its thornier terms:

> A natural enzyme[1] kit with everything needed to do an at-home professional treatment, using the best of marine[2] natural enzymes and AHA.[3] This freshly mixed[4] kit will help minimize pores[5] and clarify skin texture.[6] May be used by all skin types for a fresher, more refined skin texture.[7]

1. Probably pepsin, an enzyme responsible for the digestion of meat.
2. The marines of the 7th Marine Regiment are noted for their high-quality pepsin.
3. This probably refers to the eighties band A-HA, famous for its hit "Take on Me." Lyrics from their later albums include countless references to their desire to "move into the production of DDF Multizyme Resurfacing Treatment Kits."
4. Meaning "mixed sometime after the company was formed."
5. Meaning it will dismiss your pores as insignificant.
6. The kit will very patiently explain and answer any question you might have about just what is meant by "skin texture."
7. Another way of saying, "A skin texture that always knows which fork to use."

I would have to think that, given the claims of extreme hydrating ability of the above products, if two or more unguents were applied to the skin, it would become sodden and possibly drown the incautious moisturizer. To get to the bottom of it, I sent an E-mail to a noted dermatologist asking for her expert opinion. It was returned by something called a "mailer-daemon" with a note saying that it "could not be delivered," followed by four pages of numbers and indecipherable code. I gave up and instead E-mailed my friend Bob, a financial planner, with this note:

> Bob,
> Say, do you think it's possible to moisturize oneself to death? I don't think so, but I don't want to prejudice your answer. Could you get back to me this afternoon? I'm writing a piece about it and don't want it hanging around on my desk forever.
> Your friend,
> Mad Dog

It was several days before I got the following, conclusive reply:

> This is an autoresponse. Someone from our office will contact you as soon as possible. Thank you for your interest in our services!
> Please take the time to fill out the following form so that we might serve you better.

Indeed, Bob had hit on an interesting point: perhaps under all those heavy lubricants, women are scaly, repellent harridans. It is thanks only to copious applications of petroleum jelly,

glycerin, shea butter, waxes, and oleo derivatives that we can touch them without rasping off entire patches of our skin and flesh. While presenting a supple, freshly scrubbed, dewy glow to the world, are they actually concealing a rugged hide like a saddle made from the skin of a Komodo dragon? It seemed likely.

I waited until the woman who owned all the moisturizers returned and posed the question to her.

So far I've gotten no response. Obviously I've hit on something.

BAD HAIR PERSON

A recent study done by a Yale University professor of psychology and of women's and gender studies concluded that people do indeed judge new acquaintances by their hairstyles. This study proves what has long been suspected: if you style your hair with swine offal and adorn it with tufts of fiberglass insulation, people will, rightly or wrongly, judge you as smelly and odd.

The researcher who led the study, Marianne LaFrance (known by her colleagues as "The Grant Money Furnace"), said, "We found that different hairstyles quickly lead others to 'see' different kinds of people." She certainly is onto something. Namely, things that seem incredibly obvious often are. One hopes she funds a study testing the ability of raisins to lend a "raisiny" taste to foods, or one that gets closer to finding out whether our assumptions about items that look, walk, and quack like ducks are as airtight as they seem.

Apparently, the 183 men and women who participated in the study sat in front of a computer screen as faces with different hair-

styles flashed before their eyes. They had less than four seconds to look at each photo. Then they were told to record an impression of that person in ten categories, including confidence, socioeconomic status, and sexiness. This was similar to a study done a few years before where people were shown the video game Mario Brothers and told to use that solely to judge all Italian painters. The conclusions were shocking: people overwhelmingly concluded that Italian painters were short with bushy mustaches and wore goofy clothes and brightly colored hats. Researchers were particularly disturbed by the participants' conclusion that "all Italian painters pull outsized vegetables from the ground and hurl them at creatures named Hoopster and Trouter."

Some of the conclusions from the hair study: long, straight, blond hair is perceived as sexy and belonging to affluent and narrow-minded women. Medium length and a side part are seen as signs of an intelligent and affluent man, but they also signal narrow-mindedness. Women wearing short, highlighted hairstyles are seen as the most confident and outgoing but the least sexy. Bushy, blond-highlighted hair on a man is seen as a sign that he's in the L.A. guitar band Whitesnake, while extra-curly brown hair and mustache is seen as a sign that the person in question is Avery Schreiber. Soft, shaggy, red-orange hair covering the entire body gave participants the impression that the wearer was a South American mammal, and "probably a vicuna."

Concluded LaFrance, "Something clearly is driving these impressions because the ethnicity, age, and gender of the judges didn't really make a difference." LaFrance forced people to make snap judgments and was then utterly amazed when people made snap judgments.

I bet she's got long blond hair.

RETHINKING THE BACKSIDE

Female theater patrons of a certain age have a unique method for applying perfume: they begin dousing themselves with White Shoulders using a lawn sprinkler until anyone entering a four-mile perimeter (centered at their pulse points) will have the sensation that lavender petals are actually being pressed into his mucous membranes—then they sprinkle on six more British pints. Why they do this is unclear, as anyone close enough to ask has died immediately from "gardenia inhalation."

I made this discovery at a recent production of *Who's Afraid of Virginia Woolf?* along with another: if a play's running time goes over three hours, the viewer can become restless and distracted, even deluding himself into thinking he might be able to pull down a supporting beam or collapse the lighting grid if he just concentrates hard enough. He may even point his head, flare his nostrils, and arch an eyebrow ominously, which only serves to draw more White Shoulders gas into the sinuses, causing blindness. Unfortunately, it is only temporary, and one must go back to watching

something, usually the play. Try getting something out of a good stare at the lights and you'll soon discover that they mostly just sit there, on. Oh, occasionally they go off, but that's not much to look at either. You can try gazing at the side of the face of the person several rows in front and to either side of you, but that is, altogether, an even duller affair than the lights.

At just over two hours of sitting, blood loss to the buttock-ular region causes tissue to break down and be replaced with pain molecules. Blood pools uselessly in the feet, and all the buttocks can do is look down at them enviously. They sip nervously at bitter lactic acid. At the 150-minute point of sitting in a standard theater chair, the human buttocks die; once dead, they cannot be revived. They cease to function, whatever that function may have been, and must be carried around like a sack, or two, of flour.

The human backside, a complicated collection of bone, muscle, and gross things, was designed and built with a sitting tolerance of only ninety-eight minutes. The "gluteus maximus" muscles (named after the famous large-rumped Roman gladiator), though the largest in the human body, are also the most cowardly and pampered. Even more than the lowly frontalis, the gluteus maximus are looked down upon by the other muscles.

And what do GMs do, really? Like other popular muscles, can they lift things? Certainly not for any but the most talented people, and even then it is merely a novelty. You wouldn't want your furniture moved by a person who has trained himself to lift things with his buttocks, and you'd certainly want him to stay miles away from your torchère lamps. Like the famous biceps, do they look nice flexed and oiled up? Good grief no! This deviation from the standard nonoiled glutes is a lateral move at best (at least I'd imagine it would be—I've never actually seen . . . look, never mind). Can you display them in contests and win prizes? Not in any contest that I'm aware of. In fact, in traditional oiled muscle contests, the buttocks are deliberately covered, and is there any wonder why?

So what exactly do they do? According to the encyclopedia, glu-

teus maximus's "major action is extension of the thigh, as in rising from a sitting position, running, or climbing. It also rotates the thigh outward." But ask the thigh about it and it says, "Hey, I've got it covered."

It seems the gluteus maximus's major function is to get tired at plays and make airplane flights seem longer than they actually are. I suggest that we could do without them. We already have plenty of other annoyances at plays. Often the play itself is maddening enough, especially if it has one of those "theater people" in anything but a walk-on role, or was written by a Swede. And on commercial airplane flights, we have already contracted thick-legged businessmen to muscle us off our shared armrests, and shrill children to kick the back of our seats in a subdued enough manner that their parents are able to convince themselves they don't have to stop them.

We don't need buttocks. It's time for them to go.

THE SORRY STATE
OF MEN'S FASHION

Horror

In the summer, I see him at least once a week. From thirty to fifty feet away, he looks just like any other Joe who walks around my neighborhood with his family or pushes his kid on the swings. Get inside that perimeter and you notice a striking difference—unlike many of the people you run into, you can clearly see his penis in stark relief as it lies in horrifying repose, squashed and slightly bent just atoms behind the blessed opacity of his bike shorts. The *glans*, the *coronal ridge, foreskin, scrotum,* all are plainly visible in remarkable detail.

Now clearly, the male genitalia even in their proper context are a horror beyond human understanding. But an unwelcome peek at this fellow's batch outdoes any real or imagined human or supernatural evil from the beginning of time until the end of the age.

How has this been allowed to happen, and who's to blame?

The Italians? Yes, but only partly. They did indeed invent those accursed black biking shorts, but they do not explicitly promote their use as street wear. Besides, Italian men seem more concerned

with wearing cutaway loafers that display a good portion of sock, or pocketless trousers for a smooth, uninterrupted view of buttock.

What about this guy's wife? Where is she when he's preparing to leave the house in those shorts? Why doesn't she spare the world a view of his underdeveloped Middle European unit by saying something along the lines of "Honey, I love you very, very much. But I will not let you leave the house wearing shorts so tight I can make out your urethral opening." Hundreds of wives say this very same thing every day, and the world is a better place for it. She then could forcefully suggest that he wear the thickest, roomiest jeans available, a pair with reinforced seams. At the very least, she could point and laugh.

Unfortunately, we can't blame her either. She could very well be suffering all manner of stress disorders after years of living in such close proximity to his shrink-wrapped mess. We must assign some portion of blame to the guy himself. It is, after all, his crotch on display. Yet even that is too simple. It would be easy, then, to posit that he had been kidnapped by Italians who implanted a microchip in this brainpan, but if I did that, I'm told I would need some evidence, and I don't have that. Yet.

Like so many things—war, pollution, leaf blowers—we must blame the society that allows it. Since there is no way to punch society in the nose for such a stupid lapse, we'll have to examine more closely the events that have led to the current, and lax, state of men's fashion.

This is fairly difficult because fashion is such an ephemeral thing. One moment it is ludicrous and ugly, the next shameful and idiotic. From the codpiece to the Speedo, men's fashion is a trail of tears. It's not surprising, however, given what designers throughout the ages have had to work with. Whereas women curve gracefully here and there with style and purpose, the obvious work of an intelligent designer, the body of an adult male meanders, and even the finest among them are lumpy and misshapen, slapped together without much thought and no courtesy given to the end user. I

mean no disrespect. I am a man, after all, no matter what my father says. And I do think the male body does some things well. Take calves. Compact, they fit nicely in the space allotted and have a decent strength-to-weight ration. Nicely done. Ears, when young, do a fine job, especially considering how many parts are involved. Beyond that, the male body must be considered a complete failure.

The Male Body: Why?

Think of the challenge the male body presents to clothes. Without hips upon which to hang and drape over, clothes must cling for dear life to a shapeless midsection, often failing. The result is the tragic "plumber's butt" or "bike rack" in which some small percentage of the cheekular trench is displayed, usually inadvertently. (The condition seems most acute with those whose initial meetings with others elicits a prayer on their part that usually goes like this: "Dear Lord, please make it so that I never have to see any portion, no matter how small, of this person's butt crack.")

The fact that the shirt won out as the predominant fashion for the upper body provides a poignant example of just how lacking that area is. Whereas women can chose from countless myriad textiles, weaves, shapes, patterns, and styles in millions of different hues, men must grab either their white or blue shirt, poke their arms through it, and go.

It wasn't always this way. In olden days, there was a good deal of experimentation in the area of men's fashion. In Elizabethan times, for instance, men were often seen wearing peascod doublets, paned hose, a jerkin, perhaps a thrummed cap, galligaskins, short Dutch cloaks, or knee breeches. Since I don't have the foggiest idea what any one of these items is, I'll look them up and be right back with you.

It turns out a peascod doublet is one of those tight vest things with the little skirt attached. Yes, I read it three times, *men* used to wear these. A jerkin is a kind of collarless jacket that goes over

that, presumably because there was still a chance of dignity without it. A thrummed cap is kind of a small version of one of those Beefeater hats. Silly looking, but if it helps those fellows make gin, I can grudgingly side with it. Paned hose is pretty much what it sounds like, which is sheer horror and degradation. It's a pair of pumpkin-shaped shorts made up of strips of fabric laid over a lining that shows through. The wise man took care not to wear this around bigger men, or "a pumpkyn smashynge" could be the result.

Galligaskins is essentially a fancy, or stupid, way of saying knee shorts. These would be worn by sailors of the time, which should come as no surprise to anyone. A Dutch cloak is, as near as I can tell, a cloak . . . from the Netherlands. I have no more information on it.

The overall impression one gave when combining all these different items as an ensemble was one of a mincing idiot. And this Mincing Idiot look prevailed for many years. The only alternative to it at the time was the tights-and-codpiece look favored by the peasants. Personally, I want nothing to do with having something named after a large, rough fish anywhere near my nether regions, but the codpiece actually served a purpose.

It seems that, on warm days, peasants often took off their thick waistcoats and tunics, exposing their hose. Which isn't such a bad thing until you realize that their hose was simply two stockings sewn together, leaving a triangular gap in front and in the back. Back then, there were a lot of peasants, and a lot of warm days. That's a lot of exposed peasant flesh, which can only mean that most people were unhappy most of the time.

The codpiece filled the gap. But it had its own problems, not the least of which was its resemblance to an even bigger, more grotesque version of the very thing it was purported to cover. This is a little like having your bathroom door painted to look like a larger, dirtier bathroom than that behind it. If the codpiece had grown (in popularity), might it perhaps not have spawned the invention of flesh-colored underwear with large, false buttocks on

the outside? Or false armpits with great mounds of bushy hair to be worn at fashionable gatherings?

Fortunately for all of man, the codpiece fashion died and has not reared its . . . Never mind.

Pant and Shirts

Pants. Thank goodness for pants. Before the invention of pants, all was darkness, pain, and confusion. After pants, goodness, grace, and mercy. Mostly.

There is still the troubling issue of the name—"pants"—referring to one item of clothing. What exactly is a single unit of pant? It would be most convenient to simply observe that each "leg unit" is a pant. But then what would we call the upper common area that binds the two pant units together? It will not do to say, "Hand me my pants and their upper binding area, will you?" Shirts have as much claim as pants to be two identical units of "shirt," and it is this disparity that can cause the most confusion. "Hand me my shirt and my pants, please," you might say, and the person fetching them might reasonably hand you one shirt and every pair of pants that you own. A different take might be, "Hand me my shirt and one of my pants, okay?" and the person fetching them, now a bit confused, might begin hacking a pair of your pants down the middle in an attempt to hand you one pant. "Hand me my shirt and a pair of pants, all right?!" you might try saying. And the person, now a bit obstinate, will key on the word *pair* and get you two of your pants, or four units of pant. Once it's all sorted out and the wounds to the relationship are just beginning to heal, you might need to ask for your glasses. I can't help you there.

Looking at the origin of the word *pants,* it appears to have derived from the word *pantaloni,* which referred to citizens of Venice, whose patron saint is Pantaleon. It was taken as the name of a stock character of the commedia dell'arte, a miserly Venetian known as Pantalone. Then, during the French Revolution . . . oh,

look, it's something all confusing and Europe-y. It doesn't help us at all. Pants are, or a pant is, good, and that's all we need concern ourselves with.

Returning to the shirt, there is little to get excited about. Like an anvil or a 1986 gray Jeep Wagoneer, it displays no flair or élan but simply gets the job done. Even when hand-painted or made from exotic materials, it's still simply an efficient way to cover up man-flesh. After all, sinus pills are made from exotic materials and even garages are hand-painted.

The staid nature of the shirt caused our ancestors to raise the question, "Isn't there a way we can choke a man and make him look like a moron at the same time?" Enter the cravat.

The cravat was a far more comfortable alternative to the heavily starched ruffled collar popular during Shakespeare's time. The ruff style has by now almost completely disappeared, and its only champion appears to be actor Bozo T. Clown, who says of it, "It's versatile. I can wear it with my blue rayon jumper or my other blue rayon jumper. And it's firm enough not to get crushed by Cookie the Cook during the car routine. Plus, Ringmaster Ned would kill me if I didn't wear it."

The cravat gets its name from the Croatian soldiers who wore them to intimidate the enemy, not through fear, but by being natty and foppish. Louis XIV employed some of the soldiers and was impressed with their neckwear. Thinking it would look good with his towering black Quiet Riot–like wig, giant fake mole, and bow-adorned shoes, he wore it back to Paris. Everyone who saw it immediately wished they hadn't. They scrambled quickly to invent the guillotine and behead him, but he escaped, and handed his cravat and the reins of the country over to Louis XV, who saw the mob advancing and in turn handed all over to Louis XVI, who they caught and beheaded. Somehow, the cravat escaped and was soon seen on the necks of other men who should have known better.

One of those men was George "Beau" Brummel, self-described "dandy," a term which should give you a pretty good idea of what

he was all about. Dandies were known all over early 1800s England for their stylish manner of dress and their wit—though it should be pointed out that regents were known for being easy laughs. Brummel's influence helped the cravat, or necktie, to become the very height of fashion, and no self-respecting English gentleman would be seen eating bland sausages or feeling vastly superior to the working classes without one.

A more recent tie development, which is really an unconscious homage to the Croatians, is the "power tie." Worn by savvy businessmen, the power tie is a solid-colored, often bright yellow or bloodred tie meant to intimidate "the enemy." "The enemy" in this case being the pasty-white, puffy fellow, likely named Tom or J. T., sitting across the desk from the wearer in his gray, prefabricated cubicle. At its height in the mid-eighties, the power tie *could* be effective, but failed completely if worn with suspenders, due to their unfortunate association with bad Michael J. Fox movies.

And what of the modern tie? Will its width remain constant or will it widen until all men resemble Roger Mudd circa 1978? Will it go back to being poofy and ruffled? If Adam Ant has his way, yes. However, Adam Ant will never have his way on anything, ever, so rest easy.

Men's fashion marches feebly on, wearing black socks with big white tennis shoes and belted plaid shorts. We can't know what innovations are to come, but we can say with some confidence that there aren't going to be any. Oh, some designer or other will parade his male models down the runway wearing camouflage dresses or colorful muumuus and big army boots, but as nice as that sounds, it won't help. We are limited by the medium.

However, there are some things we can all do right now that will help. First, put some pants on. Secondly, and just as importantly, leave them on. At all times. It will be inconvenient at first, mostly while showering or having any kind of leg surgery, but you'll get used to it and even come to enjoy it as much as everyone's enjoying not seeing your privates. Thirdly, take off that Greek fisherman's

hat, unless you're a Greek fisherman or Pete Seeger. And then take it off anyway.

Please remember, too, you're not a cowboy. You don't ride a horse, so there's very little danger your feet will slip through any kind of stirrup anytime soon. (If you don't ride horses but you regularly have your feet in stirrups, then you have your own problems and this doesn't apply.) Take off those cowboy boots. And the hat. It makes as much sense for you to dress as a pirate or a Spartan soldier as it does to wear the cowboy getup. If you're really bent on wearing it, may I suggest you rotate a tricornered hat into your wardrobe so that people will think you're a little loony and not just some guy who wants to be a cowboy?

MY SHORTS ARE SILENT
NO MORE

"Understand a man's shorts and you understand the man."
—Michael J. Nelson in
"My Shorts Are Silent No More"

On a cold gray day in March of 2001, my hundred-dollar linen shorts finally sat down with an interviewer and told his side of the story. It is a story that, if you are either my wife or one or maybe two very good friends, is quite familiar to you, so it does not bear repeating here in these pages.

My shorts handpicked "his" interviewer and his name is not known to me. For the purpose of clarity, I shall refer to him here as Karl.

> *Karl:* Shorts, thank you for speaking with me.
> *Shorts:* Well, set the record straight and all, you know. (*laughs nervously*)
> *Karl:* Why don't you just give us your name and we'll use it to level-check my microphone.
> *Shorts:* One. Hundred. Dollar. Linen. Shorts.
> *Karl:* Thank you. Tell us about yourself, One Hundred Dollar—is that how you'd like to be referred to?

Shorts: "Shorts" is fine.

Karl: Give us some background, Shorts.

Shorts: Well, I can't really say when I was woven and sewn, my first memory is of being inspected. Number 14 signed off on me—

Karl: Marking you with a small orange sticker?

Shorts: Yeah, yeah. Right. And I made my way from somewhere in the East to a warehouse and was eventually routed to the Dayton's department store in downtown Minneapolis.

Karl: How long did you hang there?

Shorts: (*clears throat*) Awhile. I'd say a month. Oh, I was pawed over by all manner of man. It was horrible.

Karl: Where did they touch you?

Shorts: Everywhere. Everywhere.

Karl: I'm sorry. And when did Mike come in?

Shorts: Later. I had been marked down.

Karl: Marked down to one hundred dollars?

Shorts: Marked down *from* a hundred dollars.

Karl: Forgive me, I thought Mike always referred to you as his "hundred-dollar linen shorts"?

Shorts: Oh, he did. But that wasn't how much he paid, that was an old price that was crossed out!

Karl: And how much did he purchase you for?

Shorts: Twenty-eight dollars.

Karl: Twenty-eight dollars?

Shorts: Yes.

Karl: And he called you his Hundred Dollar Linen Shorts?

Shorts: Yes.

Karl: Tell me how he bought you.

Shorts: It was on a Monday, I think. But I don't know, there are no days of the week when you're a marked-down pair of shorts.

Karl: Of course.

Shorts: He came stumbling in, wild-eyed, coarse, and raw-boned. Hair matted, growling, pushing clerks, firing off some sort of sidearm—I'm sorry, I'm unfamiliar with small-bore weapons, I don't know what it was. Anyway, he was drunk and howling—

Karl: Shorts? I'm sorry to have to stop you, but according to an earlier interview with Mr. Nelson, he said, and I quote, "I walked in with my friend Kurt and purchased the shorts. We left." Can you explain why your version is so different?

Shorts: What are you saying? That I'm lying? That I'm making it up? I think this interview is over.

(*At this point One-Hundred-Dollar Linen Shorts walks out of the room. An hour later he returns and agrees to continue the interview.*)

Shorts: I may have exaggerated. He came in and bought me, yes.

Karl: Did he try you on first?

Shorts: (*lip trembling*) Y-yes. (*Long pause as Shorts struggles to compose himself.*)

Karl: You don't have—

Shorts: No, it's all right. He tried me on in the dressing room. Apparently I *fit*. (*He snarls this last word, and brushes a tear away roughly.*)

Karl: And he brought you home?

Shorts: Yes, he brought me home, but he didn't wear me that day.

Karl: When did he?

Shorts: Only several weeks later. To work and then after work at the State Fair, I think. I heard carnival music and lots of voices, but I couldn't bear to look, because I was on . . . him.

Karl: Was he with friends?

Shorts: Yeah, I think so. He chattered away like an idiot, ordering things, (*harsh mocking tone*) "A bag of popcorn and a 7UP please. You want anything?" he says, strutting around like he was somebody. Disgraceful. Well, that was it. He never wore me again, which I guess I should get on my knees and thank the Almighty for.

Karl: So what happened to you?

Shorts: Into the closet. Months pass by. Horrible, dark months. I'm on the floor next to a Coca-Cola sweater—remember those?

Karl: Yes. Yes, I've seen those.

Shorts: And some blasted denim jeans. Dank, horrible days. Every now and then the closet would be opened and something pulled out. Pulled out, looked over, thrown down again. What kind of person lives like that? What kind of person?

Karl: I don't know.

Shorts: Well, then he moved. Into a Ruffy's garbage bag I go and I'm thrown in the back of his '81 Mustang.

Karl: To be unpacked when?

Shorts: Never.

Karl: I'm sorry, never?

Shorts: Never. I stayed in the back of that '81 Mustang for I don't know how long.

Karl: Days? Months?

Shorts: Months. The brakes went out on his way to work. I spent a week in the parking lot of a TGI Friday's by a bank somewhere. Then he drove home with no brakes.

Karl: That's impossible.

Shorts: Not for an idiot, apparently. He made it back to his smelly apartment, and I stayed there in the parking lot for many more months.

Karl: Until?

Shorts: He moved, abandoned the car, abandoned me. I got

towed into a city impound lot and stayed there for a few more months.

Karl: What would you like to say to Mike if he were here?

Shorts: (*long pause*) I'm still here. One-Hundred-Dollar Linen Shorts is still here.

Karl: Thank you.

[Note: My shorts called me not long after this interview, wondering if I would meet him. I did, at a fashionable bistro in uptown Minneapolis. We talked for hours. It was rough going at first, but soon we were talking and laughing. I even made a joke about pulling him on and he laughed. When it came time to leave, I shook his hand, grabbed him, and threw him in the back of my RAV4, where he remains to this day.]

THOSE THINGS ARE,
I'M AFRAID, MY FEET

Stand in the corner and don't think of an elephant," goes the old saw. And of course, it can't be done.

That little exercise illustrates perfectly how it is for me to try to sit and relax: I can't do it because I feel at all times as though somewhere there is an elephant I'm not supposed to be thinking of.

People who make the beach a destination, only to hunt down the best chair in the best spot (judging qualities that are opaque to me), recline the back, close their eyes . . . and then lie there, are as mystifying to me as those people who put stacks of quarters up their noses or bend their thumbs back and touch them to their forearms. Yes, maybe you can do it—but why? Reclining with one's eyes closed is a perfectly enjoyable activity when practiced in bed, and at night. But during the day? And at a sunny beach? When there are things to be done, things like standing next to reclining people, tossing some small object up in the air and catching it over and over again, and asking those reclining if they're done lying there yet? (That's what I enjoy when I'm at the beach.)

I don't mean to imply that at all times one should be contributing to some industry or other. There are times when it is perfectly appropriate to unwind, relax the mind, lose oneself in thought. But these moments are best enjoyed while in a state of readiness, with one eye on the clock and pot of coffee on the stove.

While on a lovely drive through California's wine country, my wife suggested that we stop and enjoy a few hours at one of their world-famous spas, featuring their world-famous-er mud baths. Of course I pretended not to hear her, which was plausible enough, given that our car was a convertible. But because the top was up at the time, she easily saw through the ruse and asked again. I contemplated pointing at something behind her and then leaping in the backseat to hide while she looked for it, but I was driving, so that was out. I tried simply confusing her by saying that we could go to the Wine Country spas anytime we wanted once we were back in Minnesota, we should just enjoy our time here. She countered by telling in me in no uncertain, yet very loving, terms that we would be stopping at a spa and that I would enjoy it and I would relax. "Capisce?" was how she ended her loving request.

That is how I came to experience my first, and very, very last spa treatment.

For those of you have never been to a spa (men), the first thing you'll notice is how powerfully it stinks. (Anyway, it smells like lotions. Some people find that appealing, I suppose.) You'll also notice that whoever is there to greet you appears for a time to be painfully shy. I thought there was something wrong with the woman who greeted us, until my wife informed me that they speak very softly to ease you into a calmer state of mind. (When I try to get information from a person whose voice is so low that it requires every bit of my concentration to make out her words, I personally am less relaxed at the end of such a transaction than I was before it began.)

We were offered several different "packages," all of them anchored by their famous mud baths. I asked if perhaps they

couldn't check on their "to go" packages, but my wife signed me up for a relaxing couples package including a relaxing massage, followed by a relaxing mud bath, and then the relaxing liberation of more than a hundred dollars from my credit card account.

My wife and I parted for our massages and I gave her a tender kiss just in case I was relaxed to death and was never able to see her again.

I was ushered softly into a room and told by my relaxation technician to undress as much as I felt comfortable. I thought momentarily about taking her literally and putting more clothes on, but I decided not to be difficult. I took her advice, disrobed, put on a towel, and proceeded to look over the many relaxing music choices available. I am told that if one gets there early enough, it's a very impressive sight to watch the huge trucks roll in and unload the great shipments of Enya music at the loading dock.

My music choices were CDs with names like *Pure Moods, Purer Moods, 100% Extra-Virgin Moods, Turgid Soundscapes, Oxygene, Nitrogene, Carbone Monoxide, Soft Spring Rain, Thunderstorm, Straight Line Winds and Damaging Hail, One Slightly Wavering Keyboard Tone*, and so forth. I picked at random, slipped out of my clothes, mummified myself in a towel, and lay down on the massage table.

I must say I was not impressed. Having to stick my face through that face hole was disconcerting. It made me feel as though I were stuck in a well. The massage person crept back in, nearly scaring the life out of me, and then proceeded to shake up a bottle of some sort of liquid out of my view. (Of course, when you're lying on your stomach with your face through a small hole, everything but a small patch of the floor is out of your view.) I couldn't help but think of the scene in *Marathon Man* when Laurence Olivier drills into Dustin Hoffman's healthy tooth and then gives him oil of clove to show him how simple relief could be, if only he would talk. I assumed she was shaking up the oil of clove.

Finally she got down to the business of touching me in an inap-

propriate manner. I know this is the part where one is supposed to let go, give in to the feeling, breathe deep . . . ahhhh. But all I could think was, "Yep. That is my back. You have found my back. You are touching my back. Indeed. That is still my back. That qualifies as my lower back that you are touching now. When do you think you'll be done with that? Hmm. Where are you headed now? Careful. Okay, easy with that. You realize that that is my thigh? I'll need that back when you're done. How much time did we pay for?"

I tried listening to the music, but that, too, filled me with tension. "What are those voices in the background singing? What are they saying? When are they going to switch chords?"

Many, many hours later, after the perimeter of my face had permanently bonded with the edges of the face hole, she crept out of the room. As soon as the door clicked shut, I leaped off the table and did some laps to work off the tension.

Then I met my wife out in the hall, and saw the look of transcendental bliss on her face.

We were ushered into the mud-bath rooms. Unfortunately, the mud baths are pretty much precisely what the name implies. It's not just some quaint colloquialism for *steam bath* or *bubble bath*. You actually get into a vast bathtub filled with gooey, grainy, somewhat smelly mud.[1] Unfortunately the similarities to a true bath don't end there: you are asked to get into the gargantuan tub of reeking goo with no clothes on your personage, anywhere.

Indeed, as I began to lower myself into the grime, I quickly realized just how dire the situation was, for the mud is *very* hot. Much hotter than I am comfortable lowering my naked body into. My wife assured me that I would quickly get used to it. (She'd never been to a mud bath before—how did she know this? I thought.)

"Oh, this is heaven," said my wife as I sat thinking how much body runoff was in the mud with me. Just imagine, I thought, the

1. The mud baths, I'm told, are renowned for their health benefits because of the minerals in the mud (which are also what give it its distinctive odor). If this is so, surely the minerals could be extracted using modern processing techniques and applied in a vastly cleaner environment. Say, in a bathtub using water with 99.99 percent less mud in it.

hundreds of people who have parboiled their nakedness in the very mud in which I now stew. Just what percentage of this mud is actually dander, sloughed-off skin, and sebaceous discharge? Do you think they change this stuff, ever? And why should they—it's mud. If it gets dirtier, great!

I shivered, even though my body temperature was in the low three hundreds.

I believe it was about then that my legs began to take on the delicious texture of perfectly prepared roast pork tenderloin, when it is done all the way through, but there is just the faintest trace of pink in the very center. The meat is juicy and not tough at all. Mmm. Though we still had another twenty minutes on our mudbath time, I sucked my body out with great effort. While my wife drifted away on great fluffy clouds of relaxation, I began the arduous task of hosing off my mud-drenched body. It was no picnic. Little grainy bits of earth adhered with incredible surface tension to every part of my body. The soap they provide at those places is packed with botanicals, sure, but wholly without the desired detergent properties present in even the most inexpensive bar soap. While I was busy removing my top layer of skin, a gentle alarm sounded and my wife floated out of her mud, drifted over to a shower, and reappeared a moment later looking lovely and relaxed in a fetching pink robe. I was mud-speckled, sore, and savagely tense—though I was as pink as her robe from all the scrubbing.

When my wife had finished sighing deeply, I asked if we could perhaps shove off. Wine Country rush hour and all, I reminded her.

"We still have to get our foot massages," she said.

My internal scream was very loud and lasted quite a long time.

"Great," I said, snapping one of the shower controls off the wall.

This is a message to the poor woman assigned to massage the things at the ends of my legs (we'll call them "feet" just because that's what most people have there). I am sorry. If there's anything I can do—money for therapy, pictures of nice feet sent to you daily for the rest of your life—I will. And please know, dear woman, that

the foot massage you administered that day was at least in some measure as uncomfortable for me as it was for you.

You see, my own feet have suffered greatly for many years of having to take the lion's share of contact with the earth as I move myself from here to there. It's not easy, and I haven't always been sensitive to their needs. Consequently, I have broken a few toes, sprained an ankle badly, and generally been thoughtless toward them. They have reacted by transforming themselves from the soft pink squirmy little tootsies of my babyhood into the horny, hairy monstrosities that now live at the same address.

The look of horror on the woman's face when she got a good look at the business end of my legs filled me with pity. She dug gamely in, and with the liberal application of floral-scented oils and, I'm sure, a measure of personal willpower I will never be able to fully comprehend, she made it through my foot massage.

I tipped the woman up to the limit of my credit card, poured my wife into the convertible, and we sped away.

"Wasn't that divine?" asked my wife.

"I can honestly say it is the best spa experience I have ever had," I answered.

PART
SEVEN

COUPON — — — — — COUPON

CLIP & SAVE — — — — COUPON — — — — CLIP & SAVE

Food & Stuff

A PANEGYRIC TO MEAT

As a staple of the Western diet, it looks as though small pieces of flesh nipped off large ruminants or flightless birds are on the way out.

You will be missed, meat.

Ever since the introduction of the animal hundreds of years ago, mankind has enjoyed ending their lives as animate beings and giving them new lives as steaks, chops, chopped steak, cutlets, shish kebabs, luncheon meats, various loafs, jerkies, and roasts. Even meatlike sticks such as Slim Jims acknowledge meat as an important influence. Meat has been served to the most exalted kings and queens and the lowliest kings and queens as well, like the King of Bohemia in the 1400s, who almost no one liked. Still, he had meat. Everybody at one time or another has had his life touched by meat. (And wouldn't that be a lovely title for an autobiography, *Touched by Meat?*)

Meat has been used extensively in medicine—cold steaks are essential to the proper treatment of black eyes—as well as finance, fashion (the skirt steak), politics, and the barbecue arts.

But meat consumption is in danger. Cattle diseases and the relentless competition from non-flesh-based foods are beginning to assail the once-unassailable position of meat as the nation's number one fry-able product.

A recent problem that has definitely affected the way people think about meat is the necessity for restaurants to use an annealing furnace to raise the internal temperature of their hamburgers to 1200 degrees Kelvin and keep it there for forty-three hours in order to kill foodborne illnesses. The resulting disk of singed flesh is absolutely indistinguishable in texture and flavor from a piece cut from a rubber mouse pad. McDonald's is aware of the problem and has taken steps to improve flavor by putting in more Playlands. Wendy's has gone a different direction and come out with their new Smoky B'con, Honey Mustard (Pasteurized Processed Mustard Food), and Mushroom and Swiss™ Mouse Pads and 'Rist Protectors crafted from the durable meat product. (They can be bought separately or as desk sets, which are very popular as graduation gifts.)

So far the steak industry seems to be immune to the problem, as the specific meat-borne toxins appear to stay on the surface of steak, where they are easily killed by a combination of heat and A.1. And they have weathered the storm at other times, too. In the sixties, ignorance concerning the dangers of aspirating throat-sized chunks of steak led to choking deaths that were the ruination of many a business dinner. But Consumer Steak Board research pioneer Dr. Henry Heimlich devised a method for extracting the chunks that involved grabbing the steak lover from behind, just as if you were congratulating him on a soccer win, and thrusting your fist into his abdomen. The quid of steak would dislodge and could, in many cases, still be enjoyed, if Heinz 57 was liberally applied.

Consumers seem to be put off also by the widely circulated bulletin warning them that whatever surface their uncooked meat has touched must be stripped, sanded, irradiated, and resealed before any other food product can safely come in contact with it. If this is

difficult, and most people find it hard to do a full kitchen remodel when they have guests, then the surface should be flushed with bleach for twenty minutes, the cabinets covered in plastic sealant, and a bug bomb discharged. The meat itself must be checked with a meat thermometer (not by touch, or throwing against the wall to see if it sticks), and once it has reached the proper temperature, handled only with rubber gloves, sealed in a plastic bag, and thrown away at once.

Bacon advocates are concerned that lowered consumption levels of the cold-smoked fat will cause breakfast crises as well as a worldwide shortage of bacon grease. Especially at risk is the national restaurant chain Denny's, whose Grand Slam Breakfast has always been two buttermilk hotcakes with two eggs, two sausages, and two strips of bacon. With meat and nonpasteurized egg emergencies being announced daily, the Grand Slam Breakfast will soon have to be downgraded to the Weak, Broken-Bat Single and include two eggless hotcakes, two more eggless hotcakes, two pieces of flatware, and a hearty napkin.

How will the world at large fill the meat-shaped void that remains?

The great white hope is tofu, the congealed, pressed lumps of coagulated soy milk[1] introduced by the Japanese and now found nearly everywhere. Tofu is extremely versatile: it can be spit up, scraped off the plate before anyone notices, left in the back of the refrigerator for a year until it expires, or simply ignored. It has very little flavor on its own but does take on the flavor of foods it is cooked with. For this reason, it needs to nestle up to gigantic quantities of meat before it is even edible, which defeats the purpose.

Miso is another possibility. It is made by mixing soybeans and grain with salt and mold and then aging it in cedar barrels for up to three years. (It was invented when someone wisely threw his moldy soybeans into his cedar garbage can and went on vacation

1. Once soybeans are fully mature, they begin to lactate. At that point they are hooked up to tiny suction-powered milking machines.

for three years.) Miso is a condiment only, though, so presenting a mushy lump of it to a large man, knife and fork in hand, mouth set for a nice portion of meat, is bound to lead to violence.

And what of fish? Well, sadly, though 71 percent of our planet is ocean and home to millions of diverse species of edible animals, we've managed, in our relatively brief stay here on earth, to eat every one of them, and now they're gone. Besides, despite some confusing menu listings to the contrary, fish is a meat. Early experiments in planting them seemed hopeful, as vegetation did sprout up in the soil above them. However, when they came to full flower, no fish were produced, so the leaves were mixed with salt and mold, aged for three years, and thrown away.

Seaweed is another potential source of food. Rich in protein, nutrients, and slime, seaweed is also a source of the thickener alginic, which is used for ice cream, hearty meat soups, and rich puddings. Only, soon we won't have milk, cream, or, obviously, meat, so forget I said anything. Seaweed is a sustainable food source with the drawback that since most people don't have backyard oceans in which to grow it, it must be done commercially.

Obviously, we will find a solution, and in the end we will eat some horrible vegetable product that we will convince ourselves is a perfectly fine substitute for meat. It will be slimy and flavorless and full of amino acids and omega things and good cholesterol and animals will be happier that they aren't being killed and eaten, and we'll all be happy and slim and run a lot and our coats will be shiny . . . But we will be eating whatever it is with a tear in our eyes.

Good-bye, dear, dear meat. You will be missed.

VAN GOUDA: WHEN DID CHEESE BECOME ARTISANAL?

Imagine this scene: you're sitting in your kitchen eating a lovely ham sandwich with a side of Sun Chips, a very nice lunch, the kind where you put away everything and wipe the counter before you even have a single bite of food, when suddenly I walk in and say, "Mmm, are those thin slices of prosciutto de Parma disossato on artisanal Pugliese bread with a rich, peppery aioli accompanied by chayote squash fritters? Wouldn't that go good with a bit of Peruvian purple potato salad on the side?"

What would you do? I imagine that, be you man, woman, or child, you'd rush me full out and body-tackle me right onto your kitchen floor. You'd demand to know who I was and what I was doing in your kitchen. Once I'd established that, after no small amount of cuffing from you, you'd probably ask me something along the lines of "Now what was all that mumbo jumbo about prosciutto and purple Peruvian potatoes? You a food snob?"

"No," I'd explain. "I just accidentally read one of those gourmet food magazines and I guess I got carried away." You'd nod, let me

go, help me up, and then have me arrested and prosecuted to the full extent of the law. For the breaking and entering, sure, but my use of the words *artisanal Pugliese bread* is what would continue to drive you on through the lengthy court battle and uncomfortable cross-examination.

And that, at long last, is my point: no one likes a food snob. You take any given situation—be it a dinner party or a police action—and throw a food snob in the midst of it, and things get noticeably worse.

Food snobbery is on the rise, encouraged, no doubt, by a thriving economy and the powerful balsamic vinegar lobby. Also, those Kentucky Fried Chicken commercials featuring a rapping animated Colonel Sanders have caused millions of people to question whether buying any kind of food by the "bucket" is really such a wise idea. Start experimenting with non-pail-based foods and you can find yourself vulnerable to food snobbery.

Its basic premise is sound: that food is good, and worth eating. But where the food snob makes her mistake is by assuming that knowing about exotic and expensive dishes makes her a superior person. If that were true, the common gray wolf, which regularly feasts on pricey caribou flesh, would be a superior being, and anyone who's spent five minutes with one knows that's just not true. Bad manners, horrible breath, a propensity for one wolf to drag you down by your nose while others nip at your hamstrings—no thank you.

Food snobs also believe that anything created in Europe is inherently superior to the American-made equivalent. Allow me to explode that fallacy with these words: the 1983 Renault Alliance. Food snobs would also do well to remember that Europeans don't believe in refrigeration (they believe it exists, just not to chill their food or freeze water), so when you buy a wedge of Parmesan Reggiano or a big log of Citterio Abruzzese, know that in all probability it sat on a shelf in someone's hot garage for at least eight weeks.

Food snobs appear to communicate their strange ideas to each

other by using glossy magazines like *Food & Wine, Gourmet,* and *Saveur,* or by handing each other caramelized onion tartlets. It's tough to know what the purpose of the magazines is, because the several times I tried opening one to read it, I was nearly buried in a blizzard of subscription cards and spent weeks in the hospital recovering from multiple paper cuts. From what I understand, these magazines are recording one long ongoing debate over which is the "fruitiest" olive oil, with an occasional column inch or two extolling the virtues of broccoli rabe.

Since food snobs are under a kind of grilled-panini-of-San-Daniele-prosciutto-with-fig-conserve hypnosis, they don't answer yes to questionnaires asking, "Are you a food snob?" If so, they could easily be rounded up in great herds and fed those unnaturally red Dolly Madison Zingers until they softened enough to respond to treatment with a goal toward rehabilitation.

I suggest that the buttery snares of food snobbery would be easier to avoid if we just observed a few commonsense rules. First, ban the use of the word *artisanal* to describe any kind of food product. Though technically it may even apply, in actual usage we've always been perfectly happy with its fine arts connotation. You start applying it willy-nilly to food and other things and you're likely to end up with "artisanal arch supports" and "artisanal breathable cotton panels."

Secondly, and perhaps a touch more drastically, make the possession of wine a felony. For whatever reason, people behave like lunatics around wine, hoarding it in basements, referring to it as having a "chocolate nose" or "flavors of flint and smoke." These are the words of a madman, clearly. If you have flavors of flint and smoke in your mouth, it's because you or someone near you just fired off a Kentucky long rifle. The fact that you can't distinguish between drinking a glass of wine and being part of a Civil War reenactment just proves that drinking wine is as dangerous to the brain as huffing gasoline. Wine also seems to make one more susceptible to artisanal food products.

Similarly, bar the sale or possession of polenta. This is for selfish reasons: I simply don't ever want to be put through having to eat polenta again. *Food & Wine* has devoted several hundred pages over the years to what is, as I understand it, cornmeal mush.

Take extreme care not to refer to green beans as *haricots verts*.

Finally, we must do something about Tuscany. Like Vegas to gamblers, Hartford to insurance salesmen, or the upper peninsula of Michigan to antigovernment groups, Tuscany seems to the be the spiritual home of the insufferable food snob. (There are polenta makers as thick as flies there.) It would be unwise to put restrictions on travel or prohibit the importation of Tuscan goods, because that would only create a situation similar to the Cuban embargo, wherein the cigar snobs imbue average-quality Cuban cigars with mythical properties. We do not want the same thing to happen with creamy Tuscan solfini beans. I suggest we pool some funds to send a pallet load of seed-corn hats, tacky windbreakers, Zubaz, and sweatshirts with off-color trucker sayings on them to the people of Toscana and bribe them to wear the items during the height of tourist season. The place won't be nearly as enchanting what with the charming creamy Tuscan solfini bean farmers wearing animal-print Zubaz and shirts that say I'M HAVING TROUBLE REMEMBERING NAMES. CAN I JUST CALL YOU DUMB ASS? on the front.

It can work. I know a great artisanal dirty-T-shirt maker.

TEA, YOU SHOULD BE LEAVING NOW

What do you want from us, tea? What are you and why are you here? When will you be going? Because I for one, tea, would like to give you your hat and send you on your way at once.

I would propose that tea has been getting a free ride for too long. Someone either needs to speak up for tea or it should all be thrown away, as our wise forefathers were attempting to do one glorious night in 1773. Unfortunately, their noble work was able to destroy only several hundred pounds of the cursed stuff, leaving 234,069,564,453,345,279 trillion pounds of it intact. (If they had stayed another few hours, perhaps they could have finished the job. I don't want to accuse our forefathers of being lazy, because I'm sure they all had jobs to go to in the morning printing inflammatory pamphlets or preparing for their Freemason mixers.)

I don't wish to see the plant that produces tea destroyed, though if it could be spayed or something so that it could no longer produce whatever it keeps producing that people keep pouring hot water onto and trying to serve me, that would be fine.

According to legend, tea was discovered in 2737 B.C. when some leaves accidentally blew into the pot of boiling water belonging to a Chinese emperor. (I guess he had harvested and prepared tea leaves just as pets or something.) He tasted the resulting beverage and said to his servants, "This is absolutely the most horrible, flavorless crap I have ever tasted. Take this and see if you can make it better." They tried, but could not do it, and people around the world have been trying the very same thing for nearly five thousand years without even a tiny hint of success.

Tea comes in three basic varieties: watery, vaguely unpleasant, and fully emetic. In Japan, it is often served in highly ritualistic tea ceremonies designed to make it harder for people to excuse themselves from drinking it. The British adopted tea fully into their culture in the 1800s and have found it to be a stubborn parasite ever since.

The problem for tea, and one that tea and friends of tea never mention, is while it sits weakly steaming in its thin-walled little cup, its reedy voice calling out for a little more milk, please, and another lump of sugar, coffee strides about the globe like a colossus, conquering kingdoms. People actually like coffee. It completely obviates the need for tea, so the fact that tea even exists is slightly embarrassing. Much like a talentless child who can't hold down a job, some people try to mother tea, having parties where it is served, attempting to introduce others to its good points. Of course there are none.

I suspect that everyone has been too busy to notice that tea is still around, and I can certainly understand that. But can we all just agree to stop growing it now? Then we can either use our extant tea as pet bedding for chinchillas and ferrets or what have you, or else as ballast for ships or railroad beds. Perhaps we could also sell it in big bags at the hardware store and people could use it to increase traction on ice and snow.

Thanks. And I just want to remind you not to introduce hot water to it and pour the resulting infusion into a cup, or you'll end up with "tea."

LUNCH ON THE SERENGETI

Lunch is a good meal. I don't think I'm extending myself too far by saying that. There are only two other widely recognized meals it has to compete with, and it acquits itself pretty well, I think. Especially compared to breakfast, a most evil, bullying meal. It is breakfast's *necessary-ness* that makes it so smug and uninventive. In fact, go to hell, breakfast.

But lunch is humble, pure, and patient. Lunch pursues you gently, like a lover, and it is hard to speak of lunch without weeping.

Yet there are those who try to appropriate lunch and bend it to their desire by creating forced theme restaurants. Yes, their folly is always exposed in the end, but their recklessness and cruelty are hurtful to those of us who love lunch.

For instance, is there is anything enjoyable about eating a turkey club while living in fear that at any moment, a Serengeti leopard will leap from the tall plains grass, sink its teeth into the back of your neck, and as you thrash and scream, drag you up and into a nearby shade tree, where it consumes you slowly? No matter

how moist the turkey, I can't imagine that being desirable.

A lunch at the gigantic Café Odyssey restaurant (there's one in Denver and one in Bloomington, Minnesota) in the Serengeti Room promises exactly that experience. If, however, you happen to get seated in their Machu Picchu Room, you get the authentic experience of being a Machu Picchu-an, which—since no one knows for sure just what that experience was like—here involves being served gummy chicken wings and iced tea from a soda gun. Overwhelmingly, people prefer being torn apart by African cats to being served soda-gun iced tea, which tastes most like used pipe cleaners steeped in lemon-flavored Pam cooking spray.

The odd man out on the triumvirate of Café Odyssey seating areas is the Atlantis Room. It doesn't fit in with the theme. The Serengeti and Machu Picchu are both real places—you can see them both, and I daresay your in-flight meals will compare quite favorably with the food at Odyssey. But there are no regular flights to Atlantis. It was Plato, a little tipsy on retsina, who got so lost one night that he imagined he'd misplaced his whole continent. That event inspired an entertaining story, if you go in for that kind of thing, but Atlantis is no more real than Shangri-la, Funkytown, or Kissimmee, Florida.

No place more defiles the pure ideal of lunch than that venerable old man of theme restaurants, TGI Friday's. Their slogan is "In Here, It's Always Friday." On the surface, this seems nice, if a little vague, but it actually causes more trouble than they realize. For instance, if it's Thursday, the special is a Jack Daniel's Marinated Grilled Cheese sandwich. If you order that, the waiter is bound by his code to point out that "in here, it's always Friday." Well, what if the Friday special is the Fajitapalooza and you don't feel like having your eyelashes singed off by the red-hot platter?

"I know that in here, it's always Friday, but can I be grand-fathered in under some sort of Thursday rule and get the Jack Daniel's Marinated Grilled Cheese anyway? Please?" you plead.

"Listen," says the normally avuncular waiter coldly. "Let me explain it again. In—here—it's—always . . . *Friday!*"

"But why is there even a daily special?"

"We don't deny the existence of other days," the waiter explains. "We just choose not to live under their tyranny."

"Well, can I have the Thursday special today, on this day, which is, quite obviously, Friday?"

"It sold out hundreds of Fridays ago," he says, "when we first opened."

What would usually happen in a case like this is you would be surrounded by waiters holding colorful balloons filled with a gas that makes you very open to suggestion. You would be taken into the back room, pelted with deep-fried broccoli balls, and reprogrammed to their way of thinking.

Go to a Friday's sometime and you're likely to hear a woman say to her husband, "Oh, honey, we've got to get going. Wednesdays are my Pilates nights," only to hear him reply with a chilling deadness in his voice, "In here, it's always Friday. In here, it's always Friday. In here, it's—"

"Honey, are you all right? Roger? Rog, honey?"

"Noo ooo . . . ooo!"

I swear I hear that exact exchange at least once a visit, and I go there every Friday. At least I believe it's Friday.

Allow me to tempt you with this: the Web site of the gigantic franchise Rainforest Café recommends:

> *Order your favorite beverage at the Magic Mushroom Bar. You can get it hot or get it cold, smooth or with pulp, sweet or tart, with or without spirits.*

Sounds tempting, until they make this shocking scatological demand:

Pull up one of the hand-carved animal stools.

Good heavens, no!

I mean, I don't want sound like a prude, but should animal spoor be anywhere near a beverage service area? I assume it has been dried or processed in some manner, but still, it's very off-putting. Not that I even want to enter into a discussion of the matter, but would any animal but an elephant or a large wildebeest produce enough yield to be good raw material for carving?

And of course it begs the question Why? I might have liked to visit your Magic Mushroom Bar for something hot or cold or pulpy or pulpless, but I would very much not like to pull up any animal stools, carved or not. Why do you even offer? If this is a tradition in the rain forests of the world—here's your guava juice and a scrimshaw done in lemur dung—it's one that should be rethought.

I'd be hard-pressed to think of a worse dining idea than that, unless it be at Planet Hollywood, where you can enjoy fried cheese planks while sitting near the jockstrap worn by Stallone in *Over the Top*.

PART
EIGHT

Me, Myself & I

WHO DO I THINK I AM?

I've got enough years behind me now that you could call my time lived a fair "representative sample" of my life, even if I end up living a long time. So what, then, is my deal? Who do I think I am?

When people unknown by the general population are interviewed for TV news, the network usually does us the service of giving them a little graphic under their name: *Patricia DuMontier—saw man steal rabbit,* it might say. Or an actor that people might not know right away will often have the title of her most famous movie as part of her name: *Jesse* (Sisters in Crime) *Applefriar.* Similarly, boxers have their win–loss record to hold out to people, and football players their colleges. Me? What am I?

I could, I suppose, hold out my fight record, which by my tally is now 1–5. There will be those who find my putting the number 1 in the win column somewhat dishonest, but I stand by it.

If you were there, doubtless you remember the fight. The year was 1975. The place, Coultrap Middle School gym, Geneva, Illinois. It was a warm spring day. The opponent, Tom Riensdahl. For rea-

sons I cannot remember or perhaps never knew, there was a period of a few days when he would see me at the start of gym class and begin badgering me to fight, calling me names and threatening to punch me. Once there were enough kids gathered around as witnesses, he would then attack, viciously setting his hand on my chest and making a pushing flourish. I would then do the same to him. He would then put me in a headlock and kind of slap at my face here and there, which is what he tried to do on this particular day. Only this time I was able to wrestle him to the ground before the slapping began.

I will concede several of the disputed points relating to my decision in that bout: yes, when the action stopped, Tom Riensdahl was atop me raining a hail of slaps to my facial area. Yes, my takedown was unanticipated and unorthodox. Yes, my control over him, once I had taken him down, was short-lived.

But! When the fight was *called,* officially, by Mr. Baustien,[1] I was in control *at that point.*

He had won the three previous bouts, and the one the following day as well, bringing my total to 1–4 in bouts against Tom Riensdahl.

My other loss is completely uncontested by me. It was a clean win, by knockout.

The place: the wedding reception of a friend of a friend. The opponent: I don't know. Reason for the fight: I don't know. I was craning to see over a crowd of people, as there was a ruckus nearby. Suddenly I caught the eye of a person I did not recognize, and for some reason, he looked at me oddly. He approached me through the parting crowd, and after a curious second of silence, I spoke to him.

"D—"

And he punched me solidly in the face, knocking me fully unconscious.

I awoke perhaps half a minute later and was asked to leave by the bride's mother. Apparently my opponent was a treasured family

1. "All right, all right, all right, that's enough!" I believe, were Mr. Baustien's words.

friend who had anger management problems. I had come with friends, so I was forced to stand outside for several hours while they finished celebrating the union alongside the man who punched me in the face. Worse, as I stood outside, I suddenly realized that I was not wearing my glasses. They had been punched off in the incident and I had been too unconscious to notice. I had to knock on the window and ask somebody to look for them. After a minute or two, a hand reached outside the door and gave me all the pieces that my glasses were now divided into.

There were no rematches.

Since then I have managed to avoid fisticuffs, and so, my record remains 1–5.

As I look at my record again, it seems less impressive to me. If I stir in my high school wrestling record, the win total shoots up 400 percent to, well, four. However, it will not be worth it in terms of the damage it does to the loss column, driving it up as it does 980 percent to 49.

I suppose I could go with the larger totals and asterisk them with an explanation like this:

Mike Nelson (4–49)

*Many of the losses represent high school wrestling defeats in the heavyweight division, while Mr. Nelson was not an actual heavyweight himself. Since there were no heavyweights on his high school wrestling team, Nelson, who could not win the 185-pound position, was moved up into heavyweight simply so the team would not forfeit that weight class. He was, for the most part, fallen on by very, very large high school seniors. Mr. Nelson stands behind the decision to include the controversial Tom Riensdahl win and will not answer any more questions pertaining to it.

That, however, would seem to defeat the purpose of the capsule description.

If I resort instead to the evening-news type descriptions of myself, I am hard-pressed to come up with succinct and interesting enough facts.

Mike Nelson *visited Grand Canyon when young*, does not offer much, nor does *worked nights at cheese factory*. Of course, it pays to keep in mind that if Patricia DuMontier happened to be interviewed on-camera again on an unrelated matter—say, if she was breaking ground on the new hospital—it wouldn't make much sense to describe her as *Patricia DuMontier—saw man steal rabbit*. I don't doubt that there would be more than one phone call to the station asking if allowing her to break ground on the hospital was a reward for witnessing a rabbit theft, or was it punishment? Did she have to work on it for not doing more to stop the theft of the rabbit? people would ask. Am I at risk if I don't do everything in my power to prevent rodent pilferage?

The point being, she would get a new description to fit the situation. So perhaps I, too, should attempt to make quick summaries of how I fit in the lives of the people I run across. When, for instance, I'm slumming around the incredibly snooty little boutique mall adjacent to the music store where my son has piano lessons, I can hand a card to the guy at the eyeglass shop: *Mike Nelson—will not be buying $700 glasses*. And when I return home, I can hand a card to my wife reading: *Mike Nelson—brought son to piano lesson*.

Later, when we attend a house party for a friend in the neighborhood, I can have a stack of cards reading: *Mike Nelson—is attending same party*. Self-evident perhaps, but it will help to place me somewhere in the grand, sweeping vistas of their lives. Then, several hours into the party, I can update them by handing them a card reading: *Mike Nelson—handed you card earlier*.

Stock will be a problem, I can't kid myself about that. I will have to have a very good relationship with a printer, as I'll have them on a pretty tight leash. I'll need to call them at a moment's notice saying, "John? I need forty-eight thousand cards in one hour. Are you ready? They should read 'Mi'—exactly. 'Mike Nelson.' And then an em dash. Yup. And then, 'Is at Vikings game with you.' No, certainly I won't use them all, but I can't take the risk of running out either."

COUCH MOVER: RETIRED

There was a time in my early twenties when no fewer than eighteen energetic guys a week called me to ask if I could help each of them move a couch. I have no idea why that total is so much higher than the national average of .01 energetic guys per week. Perhaps, yes, I was living my life in such a fashion as to be susceptible to such requests. (At any rate, I have made life changes that have whittled the total down to .0 guys a week.)

Having extra apparent energy gives energetic guys no advantage in the area of furniture transport. Not one of them seems ever to have been able to accomplish this task without my help.

Typically, my phone would ring about noon, and when I answered I could hear only the pressure-wave-type sound of a hand covering the mouthpiece and the low vocal tones of someone speaking.

"Hello?" I would say. Then the sound of the phone being dropped, a chair being moved, the clicking sound of a dog's claws on cheap linoleum, and then a voice.

"Watch it, Sarah," says a male voice.

"Up yours," says, presumably, Sarah.

"Hello?" say I.

"Hey, hello?" says the male voice.

"Hello?" I say for the third time, but I want my point to be clear.

"Hey, man, Mike, this is Bone Man. You gotta help me move a couch tomorrow, man. It'll take twenty minutes. I'll pick you up at one."

"Will Larry be there?" I ask. I always needed a buffer between myself and energetic guys. Someone to down-convert their energy and help them fit into my admittedly energetic guy-unfriendly view of the world. Bone Man assures me Larry will. I decline. He insists that Larry wanted him to call me or he wouldn't have even asked. "Well, if Larry's helping . . ." I say, and reluctantly agree.

Energetic guys often have myriad obligations that prevent them from getting anywhere until at least three hours after they tell you they will. Bone Man shows up at 5:00 P.M, but unfortunately, I'm still home.

"Hey man, sorry," says Bone Man as he tosses broken radios, half-finished bags of circus peanuts, and endless White Castle hamburger boxes off his passenger seat to clear a place for me. He then offers a lengthy explanation about his tardiness that involves the selling of a used phone system that his stepfather gave him. It is frighteningly complex yet spectacularly uninteresting.

He pauses momentarily to throw a hyperactive glance over his shoulder. "Hey, you think a pretty-good-size couch will fit in here?" he asks. I give his AMC Gremlin a cursory look.

"No," I say.

"Shoot. Man, we'll have to rent a van," he says. I take note of the not-so-subtle introduction of the word *we* into his sentence about van rentals.

"Let's get Larry first," I suggest.

"Oh. He's not gonna make it," he says. "He had to get some deal for this thing that he was doing."

Soon we are driving past many clean, well-lit van rental establishments on the way across town to his cousin's friend who he claims owes him a van rental. I challenge him on this and point out the obvious fact that it is wholly implausible that one human being could ever owe another human being "a van rental."

"No, really," he says, and launches into an explanation that ties back to the used phone system given him by his stepfather. Soon we pull up to a pleasant-looking house with a well-groomed yard. There are quite a few cars parked out front.

"Your cousin's friend?" I ask.

"No, this is my sister's place. She had a baby and I just wanted to stop in and congratulate her." Energetic guys always assume that everyone they know is somehow part of their great big loving, energetic-guy family.

After seeing Bone Man's nephew and eating a piece of sheet cake with several old people who are justifiably suspicious of me, we head off to cash in on the free van rental that is owed "us."

We pass a Sears store and he makes a quick, dangerous move to veer into the parking lot. "I just have to get some pants. You coming in?"

I decide to wait in the car and listen to the radio. After forty minutes or so, he comes out the back with a guy who is carrying two cases of motor oil. He puts them in the trunk, shakes hands with the other guy, and gets back in. "They didn't have my size, so I got some oil," he explains.

You are perhaps getting an idea of the level they work on, these energetic guys who called me to help them move furniture. Shady backroom deals, concealed under a smoke screen of pant buying, that ended up paying off in two cases of motor oil.

The free van rental turns out to have some provisions. We must give Bone Man's cousin's friend the two cases of motor oil and

twenty dollars, and we have to "swing by" his sister's house to see his new niece.

Of course the couch turns out to be one of the only six iron-framed couches ever made, and the new apartment is in the fifth-floor spire of a Victorian home. When it's over, and I'm weak and soaked with sweat, he says, "Hey, thanks, man. You okay going home with my aunt?"

The calls tapered off in my mid-twenties and I don't think I've received one in eight years or so. Of course I haven't answered the phone in eight years, so who knows?

HOORAY, I'M DANISH

Take a thousand Americans of every different type of national origin (don't go off and do this right now) and tell them to begin celebrating their heritage, and it's my guess that after the crowd disperses, you'll find seven or eight Danish people standing around with their hands in their pockets wondering what to do.

"Wanna go cream some fish?" one of them might hesitantly say, unsure whether it's Swedes or Danes who are known for their fish-creaming habits.

"Um, sure," another will say, and the small knot of them will begin shuffling away, every one of them hoping someone else will take the reins.

"Shall we go get our fishing poles?" a third might ask.

"I think we use canned herring."

"Um, yeah, but I mean, we'll need the fishing poles to knock the cans off the shelf if they're up too high, right?" Everyone will nod in solemn Danish agreement.

It's no way to live. I know because I am of Danish extraction.

And being Danish, I'm naturally . . . what, exactly? See, no one knows.

Yes, I am part Irish and German as well, but those are showy nationalities, and outlets for celebration are easy to find. Furthermore, I spent a bit of time in Ireland and was never once mistaken for an Irishman or a German. I was often pegged for exactly what I was, a big clumsy American, but more than once I was misidentified as a Danish farmer. Upon returning home, I was seized with a desire to find out more about my people—yet my desire was tempered by a feeling that I should proceed cautiously and not rush into anything. Was that, itself, a Danish trait? I don't know, but I would find out in due time—provided the coast was clear and I wasn't asked to extend myself too far.

The first thing I did, I had a Danish. The pastry, that is—don't get any ideas. It was nice but nothing to inspire me to start a Danish cultural movement. Then I moved on to Danish ham. Frankly, here I was even more disappointed. It was water-cured and bland and its lack of smokiness made me wonder if my people even knew about fire or if they just cooked with hot tap water.

Next, I listened to a few things by legendary Danish composer Carl Nielsen. I ended up replacing two CD players before realizing they were functioning properly and he just wanted his music to sound like it did. If there was anything inherently Danish about it, I would say it was "irritability"—it sounded like the kind of music that might be written by the neighbor who wouldn't give a kid his ball back if it went over the fence. I then moved onto the albums of A-Ha, poring over their work, listening for some clue as to what it meant to be Danish. On the third marathon day of A-Ha, I mentioned to a friend what I was up to.

"A-Ha is actually a Norwegian band," he informed me.

"What's the difference?" I asked.

"Hmm. I don't know." Clearly, I had more work to do.

I got right down to it by renting the 1952 film *Hans Christian Andersen,* a biopic of the Danish children's author, and also getting a pack of sour Gummi Worms and some Raisinets. The Gummi

Worms and Raisinets turned out to be a big fat dead end, not Danish in the least. The film was extremely helpful: whether it could be attributed to his Danishness or not, Andersen seemed to be existentially challenged, and would occasionally reassure himself of his place in the world by singing to anyone who would listen, "I'm Hans Christian Andersen! Andersen, that's me!" No values or judgments attached, just a simple, almost Cartesian statement of existence. A spare philosophy, to be sure; not at all unlike their ham. The Danish picture was beginning to come into focus. I returned the movie and got more Raisinets, to make certain they had nothing to contribute to my quest.

It was time to tackle the most famous and legendary Dane in all of history. So I waited until after his concert and ran full out at Victor Borge, knocking him into a snowbank. I was promptly arrested and spent that time in jail rereading the story of yet another famous Dane, Hamlet, the Prince of Denmark. (Something about the way it's phrased—"the Prince of Denmark"—always makes me think of a pale version of the *Purple Rain* star. You know, like "the Elvis of Japan.")

The first thing that strikes you about Hamlet, "the Prince of Denmark" (as opposed to "the Boy George of West Texas"), is how easy it would be to play Voltemand. He's got just a handful of lines, he doesn't have to learn a sword fight, and there are no towering Voltemand performances to live in the shadow of. In comparison, even Osric seems a brutally complex part.

Next, you are struck perhaps, by how—like all those before and after—the clowns in Hamlet are simply not funny. They both have absolutely tin ears for comedy. Listen to this joke from Act V, Scene 1:

> ***CLOWN:*** What is he that build stronger than either the
> mason, the shipwright, or the carpenter?

Kind of a promising setup, if you look at it through the lens of seventeenth-century Europe and the Black Death and all . . . but then . . .

> **OTHER:** The gallows-maker, for that frame outlives a thousand tenants.

Now, the first time I read that, I didn't even pause on the Second Clown's response. I just assumed the First Clown was going to dismiss it and come back with the real answer, something like, "Nope. A something something something, because he's a something something something." And whatever that response would have been, it'd be funny, because they're both clowns after all. But that's the *whole joke*, and believe me when I say, that's their *best* joke. It's all downhill from there, even as clowns go.

The First Clown, believe it or not, gets a big kick out of it, though, and when he's done laughing a hearty Ed McMahon laugh, says, "Ooooh, I like thy wit well." The exchange has the feeling of one of those wedding toasts that the groom's old fraternity brother might make. "I wish Beth luck with the Todd-Monster. I just hope she knows a good place to get baby spinach at two in the morning on a Sunday!" And then three guys at one table laugh uproariously. "Dude, I like thy wit well!" yells one of them.

As they are clowns under the employ of the royal court of Denmark, at first blush this doesn't seem to speak well of the Danish. But if one allows for the fact that these are obviously low-ranking clowns, with government jobs no less, things look brighter. They're not selling out shows at the Copenhagen Hippodrome, after all: they're on grave-digging duty. You might even argue that these clowns are being perfectly utilized.

For his part, Hamlet—even if he is nuttier than a cheese log—really goes 'round the bend when he stabs Polonius behind the curtain. After all his tortured introspection, does he throw himself into his studies or redirect himself into service of his fellowman? Does he seek the comfort of faith? No, he decides to apply himself to thrusting rapiers behind all the window coverings. What kind of world would it be if we all went around stabbing indiscriminately

behind curtains? Think how many young actors, trying to get a
peek at the size of the house, would be run through just before
their first performance as Will in *Oklahoma!* Puppeteers would
especially suffer. Trying to get a guy in to steam-clean your drapes
would be impossible.

If the dramatis personae in *Hamlet* are at all representative of
the Danish people, I'd prefer to stay mum about my ancestry. Hair-
trigger, stab-happy depressives; incestuous lunkheads; addlepated,
babbling old men dispensing sage advice one second, hiding behind
the drapes like a naughty child the next; disloyal friends covering
nearly every imaginable object and surface with deadly poison—
with all due respect to the Danish, what the hell?

It's not easy being Danish. Watery meats, unfunny clowns, the
whole Hamlet mess. Thanks goodness for Carlsberg. And Tuborg.
And Old Gambrinus Dark. You Danes are great! You are my people.
I love you guys, man.

FRIEND GOOD

Our tallest, wisest, wartiest president once said, " 'Tis better to keep one's mouth closed and be thought a fool, than to open it and remove all doubt." It's not one of his best sayings, really, which is why it ends up on those puffy, foam-and-mesh baseball hats. Rarely do the aphorisms reprinted on puffy, foam-and-mesh baseball hats offer any true wisdom (except for Lincoln's other classic old saw, "My wife tells me if I go fishing again, she's gonna leave me. Lord, I'm gonna miss that woman"). Perhaps Lincoln wrote it while sitting on a bench in the ladies' department at Penney's, waiting for Mary Todd as she bought another couple hundred bonnets.

But there is a lesson there: be silent and maybe everyone will only *suspect* you of being a hopeless, drooling idiot. It can be a very effective tool, unless, while getting up to leave after impressing them with your blank, mute nature, you pitch forward directly into a bear trap, then stumble and fall into a manure spreader, only to get out and attempt to wipe yourself off with a porcupine. That combination effectively removes all doubt.

One problem with remaining quiet, however, is that in certain situations, you tend to project an aura of menace. As a sometimes quiet fellow, I can attest to this firsthand. When the chatty people are carrying the conversation along, I'm perfectly happy to give it over to them without a fight. I go quiet, and the result is the people who don't know me assume I have a knife and that I probably hold the rank of colonel in some extremist militia group. I have the look about me of someone who might own night-vision goggles.

Part of it, I would guess, has to do with my size. At six-two and 195 pounds, I'm certainly not Man Mountain, but I'm larger than most people, and just about the national average for guys who hang around in alleys after 2:00 A.M. It's not just that I'm large, it's that, unlike jolly large guys, I haven't expressly laid out my plans for what I intend to do with my mass. Jolly large guys implicitly let you know up front that their physical stature will only be used for good: tossing the occasional delighted child up in the air and catching her, getting glassware down from high shelves, moving couches. Because they omit this step, quiet guys leave open the possibility that they will be rending you limb from limb, tipping over hutches and screaming, or tossing you around like a rag doll.

Images propagated by the popular culture have portrayed large, quiet men in a pretty unflattering light. Frankenstein's monster, for instance. Almost no one has anything good to say about him. Oh, you could ask the kind old man who invited him into his home for food, music, and a decent cigar . . . except he's *dead*! Killed by Frankenstein's monster. Nicely done, large quiet man. You are a really great ambassador for your kind. *To Kill a Mockingbird*'s Boo Radley? His first excursion out as a member of society *and* . . . he kills a man with his bare hands! Again, thank you, Boo, you've done enough for us. Lenny, from *Of Mice and Men*? Quiet, simple, gentle as a lamb. On his first date, does he do us quiet guys proud, get her a corsage, get her talking about herself, let her lead the way as far as holding hands, and offering, perhaps, if she's clearly

willing, a chaste kiss? Or, does he choke the life out of her and hide her body? Lenny, why don't you go down to that spot George told you about, we other large guys need to talk to you.

Large quiet guys are often burdened with baritone or basso profundo voices as well. Consequently, the laws of acoustics dictate that in the average room, the large, quiet man's voice can only get about three inches out of his mouth before dropping to the floor, unheard by anyone who isn't currently crouching under the table. If the large quiet man is to be heard at all over the clear, bell-like voices of the normal-sized people, he must yell, something he's not comfortable doing. But if he's feeling especially awakward and quiet, he may give it a shot anyway, usually with disastrous results. "You know, he poisoned his mistress *and* his dog with cyanide," the large man shouts.

Unfortunately, in the time it had taken for him to get his nerve up to yell it, the conversation had shifted from Hitler to the congregation's newly instated priest.

At this point, the only option really open to the man is to fulfill his destiny by turning the table over and tossing people like rag dolls.

The most uncomfortable situation is when, at a social gathering, everyone known to the large quiet guy leaves the room at the same time on different missions, leaving him alone with a very small female he has only just met. There is every reason in the world for the small female to think that the large man is on the verge of doing her great harm, and every reason in the world for the large man to be aware that she feels that way. Consequently, conversation is labored and stilted.

"So, Karen tells me you're going to crush the life out of me?" she opens.

"What's that?" says the large man.

"The life. You're going to crush the life out of me." she repeats.

"Oh, right. Life. I may, if provoked." Long pause. "Ahem. Hard to say really."

"Hmm?" she says.

"I say it's hard to say if I'm going to crush the life out of you yet. It depends on whether or not I see fire. Fire bad."

" 'Fire Brad,' you say?" she says, a little irritated now.

"No, I was just referring to the fact that friend good—fire *bad*."

"Well, I don't know about that," she says sharply. "That fire-roasted salsa the Pattersons brought was just delicious."

"Oh, yes, yes, very good. Fire sometimes good. I guess I should have said, 'Friend good. Fire bad, except when used to roast poblano chilis,' " the large man says, and then laughs self-consciously.

"I don't know what you mean," she replies.

And it goes on like that until the large man feels provoked enough to pick up the woman, carry her to the attic, bust out a window, and crawl up on the roof, holding on to her limp body and grunting at the other guests who've come outside to see what all the ruckus is about.

The other hazard faced by us large quiet men is that we are often given slightly unflattering handles by the other, slightly smaller men of the world. "Hey, big fellah," they say cheerfully, which would be just fine if I were a draft horse or if my name were Biggintine Aloysius Fellah.

They have mistaken me for a large, jolly guy. Any large, jolly guy worth his salt would know that the correct reply is "How you doin' there, sports fan?" accompanied by a affectionate clap on the back. The exchange would then blossom, the affection between the two deepen as the regular-sized guy continued with "Can't complain. Treating you okay there, Paul Bunyan?" To which the large jolly guy would reply, "Like a mushroom. Keeping me in the dark and feedin' me bullshit." And it would continue from there, the two becoming golfing buddies and, eventually, friends for life.

We large quiet men usually bungle these good-natured exchanges right at the top—to the opening volley, "Hey, big fellah,"

we usually say something like, "Hello, then," in a halting baritone, which sucks all the energy out of the room. The regular guy's shoulders slump and he looks disappointed. For all he cares, you might as well be a regular-sized guy like him now. Or a woman. Or a kid.

You can try to rally, win him back.

"Um, fire bad," you could say, clapping him on the back.

"Hmm, I don't know. Fire good, as far I'm concerned," he'd say.

Which means, of course, that you'd have to pick him up and toss him into a lake, ending any chance at a meaningful friendship.

YES, I HAVE NEVER
BEEN MELLOW

Do you have any idea how damaging it was to a fragile, newly formed personality to hear England Dan and John Ford Coley singing, "There's a warm wind blowin' the stars around, and I'd really love to see you tonight?" Where were my parents to stop my hand from switching on the radio when that song was in heavy rotation on WLS AM? It, and so many other similarly mellow songs, was entirely too laid-back for a child who needed a great deal more structure than even Seals & Crofts or Olivia Newton-John could provide.

As children raised in the seventies, my friends and I could not escape the relentless, crushing pressure to have a peaceful easy feeling. How? we wondered. We were happy the way we were and didn't want to get mellow. So our response was to adopt an attitude that said, in essence, "I don't know what you people are all about with this seventies thing, but we'll just be over here whenever you're done."

It was creepy to me to imagine Minnie Riperton felt that "lovin'

you," and I assumed she meant some creepy guy with greasy hair and thigh-high suede boots, had made her feel "every time that we, ooo, I'm more in love with you," meaning, again, the unemployed guy in the rusty conversion van who smelled like pot. Ooo, indeed. That song in particular was so suffocatingly mellow, it seemed to actually leach calcium from your bones until you were rubbery and couldn't stand.

Finally, Olivia Newton-John got very direct and aggressive. "Have you *never* been mellow?" she demanded of me. I wanted to say, "I'm nine! I have nothing to be mellow *from*." Until the moment everyone started telling me to mellow out, I had never been tense for a single moment in my life. Now I found myself wanting to beat the stuffing out of the guy who sings "Chevy Van."

Besides, it should be pointed out that the mellowness of which they spoke was very difficult to achieve without smoking at least half a joint. They were certainly easy to come by—they rolled off the seats and out through the holes in the rusty floors of the afore-mentioned conversion vans all the time—but again, I was nine. I was more concerned with being able to ride my bike with no hands, and was not ready to meet Sister Golden Hair in the middle or in the air or anyplace, really.

I think my lifelong aversion to marijuana has something to do with the time, twelve years old, I wandered into a record store look-ing for a recording of the Spanish pianist Alicia de Larrocha play-ing Schumann's *Carnaval* not knowing that it doubled as a head shop. Now, the fact that I was searching for a recording of *Car-naval,* and a *specific* recording of it at that, certainly qualified me for a good schoolyard thrashing. But I did not deserve the Eagles and thick pot smoke, no matter how severe my crime. Lava lamps on every flat surface, those flickering black lights, Pink Floyd posters by the bale, and a few spectacularly mellow clerks with red-rimmed eyes watching—kind of—over the inventory of specially designed tubes, pipes, fittings, and flanges. And "Witchy Woman" playing very loudly on the sound system.

BOY, 12, DIES OF SEVERE MELLOWNESS, the headline might have read. "WHOA," SAY EMPLOYEES.

In the late stages of our countrywide attempt to be mellow, even kids my age began to use the word, but as a reproach, not an invitation. Say, if a friend was in the Mobil station's bathroom trying to kick the pipe from the urinal's water supply off, and you said, "Hey, man, c'mon. Let's book." His response, as he gave it another kick, would most likely be, "Mellow out, man." It implies of course that you are a highly strung, harshly judgmental person who goes about oppressing others with your unreasonable moral strictures. Besides, not all the facts are in in this case. Perhaps the kicking off of the urinal pipe will yield good fruit for all involved. So just *mellow out*. Stop freaking, man.

Perhaps it was the constant remonstrations to be mellow that caused it, but I spent the seventies feeling certain I had been born into the wrong world, that there must be another, better one, somewhere. One without crocheted, beer-can-reinforced hats; where it was never midnight at the oasis and no one was sending his camel to bed, ever. I was sure it was a mistake. But until I could grab a bus and get there, it was a funhouse mirror of horrors, and it smelled vaguely funky.

These days, what with the seventies gone, the nostalgia for it, far from bringing me down, is simply a reminder to me that it's over, it's cool, man. I'm quite mellow, thank you. No need on your part to freak whatsoever, though I thank you for your pains.

PROFESSOR GOOD-NATURED

When I was in high school, I always imagined I'd end up as a professor of music at a small Ivy League school somewhere in Wisconsin. (I didn't know what an Ivy League school was at the time. In fact, I'm still a little foggy on it.)

I'd cycle through the quad on my way to class, my homemade recumbent bike a welcome sight to the older students, a source of amusement and wonder to the freshmen!

"Hello, Mr. Nelson," my students would shout as I pedaled by.

"Hello, Sarah. Hello, James. Finish that analysis of the Brahms sonata yet?"

"Um, not yet," they'd reply in unison.

"I'm wrestling with it myself," I'd say good-naturedly. "We'd all better have another day with it!"

"Thanks, Mr. Nelson," they'd shout, again in unison.

"Believe me, it is my pleasure," I'd reply as I pedaled on.

(I realize my fantasy biking would have to be done at an unnaturally slow pace in order to accommodate the amount of dialogue

here, and to avoid crashing into an ivy-covered wall or a stately oak. I've allowed for that.)

I'd hurry to my class, nodding and smiling at students, perhaps ducking into a practice room quickly to correct the fingering of a student I'd overheard having a hard time with a passage from Chopin's "Black Key" étude. Then I'd bustle into my classroom just after the bell. (Being in high school at the time the fantasy was constructed, I just assumed that bells signaled official start times for everything from then on.)

"I presume you are all chattering about the unique chord changes in Beethoven's Opus 121," I'd say to quiet the class.

Laughter.

(I knew there were chord changes in Opus 121, and I took it for granted that they are unique . . . They are, aren't they?)

"Okay, a little ear training—who can tell me what this chord is?"

I'd play a chord on the Bosendorfer. No reply. Eventually a student tentatively raises his hand.

"Is that an A-diminished?"

"Yes, James."

(I had forgotten that the kid out on the quad was named James, and since he wouldn't have had enough time to get to class before me, let's just say it's a different James.)

"Yes, James," I'd say archly, "it's an A-augmented—provided we all agreed sometime this morning to shift the entire notation of our tonal system down one whole tone and call a diminished chord an augmented chord."

(Huge laughs here.)

"But since we did not agree to that, I'm afraid you are wrong and that that was a G-diminished."

(You may think me flip, but James responds well to a little bit of rough treatment. The quad-James, nothing can reach him.)

The students scribble down a note to that effect.

"Before we begin today," I'd say, "how about I play a little Ravel to get the blood flowing?"

Enthusiastic approval and some light applause. I rip off a muscular interpretation of Ravel's *Gaspard de la nuit*. (It's considered by many to be the most technically challenging piano piece there is. At the time the fantasy was constructed, I thought that was supposed to mean something.)

After what seems like a minute of awed silence, as the last faint reverberations of the piano's overtones are fading into nothingness, the cheering begins. It goes on for a while with no diminution of its energy. I make a gesture to quiet them, and eventually the ovation subsides, turning into muttered words of awe.

A student raises her hand.

"Mr. Nelson? Why did you never marry?" she asks, her face open, yet searching.

I knew this moment would come. It comes every year. There is a poignancy to the fact that it is always a young woman asking that I can't even express.

"Now, Amanda, we're here to talk about six/four inversions, not my personal life," I'd say calmly.

"Sorry, Mr. Nelson."

I'd wave off the apology, stop, look off into the distance, and sigh.

"No, it's all right," I'd say. "I was married once. To a wonderful woman, with a tinkling laugh and hair the color of ripe kiwi."

(I didn't realize at the time that ripe kiwi is a pretty dull, ugly brown-green color, not at all appropriate to use when describing human hair.)

"Di-did she die?" Amanda would ask.

"I think so, yes. Well . . . maybe she left me, I don't know. Let me get back to you on that," I'd have to say vaguely, because I didn't have that part of it worked out yet. It seemed too shocking to have her die and perhaps a little bland just to have her leave me for a concert pianist, so in my fantasy, I remained noncommittal.

I was also unsure as to how to end it. Was it more ennobling that I should teach for fifty years and retire, a towering and legendary figure at the university? Or would it be better to take the easy way

out and imagine that while cycling across campus to give a lecture on Mendelssohn, I am hit by a garbage truck? Or shot by a member of an extremist antimusic group? In both cases, ouch. Too dark, anyway. I would just have to knuckle down and work for fifty years. Which means, of course, that I'd still be there, probably playing politics and kissing department-head butt in a sad attempt to muscle in line for tenure. What a dope I am. I'm going down there right now and straighten myself out.

PLEASE TELL ME, DO I LIKE THAT?

Not liking something someone else likes is fraught with danger, almost as much as liking something someone else does not, so be aware and be vigilant!

In conclusion, be careful when not liking something someone else likes, or vice versa.

Whoops. I got ahead of myself there. It usually starts innocently enough, a friend remarking to you that the co-op has a nice new crop of grapefruit. "Hmm, I don't really care for grapefruit myself," you say, entirely without malice. She seems startled. "Really?" she says. If you had a tendency to be sarcastic, you might say, "No. I deliberately misrepresent my taste in citrus to gain the upper hand in conversation." But you are not sarcastic, so you restate your dislike, a little more timidly now. "Yeah. I just don't care for grapefruit. It tastes bitter to me."

"Bitter! How can you think that grapefruit tastes bitter?" she demands.

"I find that difficult to answer—" you say.

"Grapefruit is the single least bitter thing in the world!

Sugar is more bitter than grapefruit!" she continues.

"Sugar is deliberately bitter," you say, trying to calm her. "Sugar is pure white hate."

"You want bitter? Radicchio is bitter. Dandelion greens—they're bitter!"

"I hate them. They're mean," you say as the situation death-rolls out of control.

"I'm going to get you some of that grapefruit right now and show you that it's not bitter," she says, marching to the refrigerator. You have apparently run afoul of a committed grapefruit apologist. Soon you are eating extremely bitter chunks of a fruit you loathe.

"Tell me, is that bitter? Is it?" she asks, leaving no wiggle room.

"Unbelievably not-bitter. Sweet, sure. Sour, you bet. Salty, powerfully so—but bitter? No and again, no. All bitterness has vanished from existence. Even the concept of bitterness has been conquered and bows down before this grapefruit," you say, nearly gagging from the bitterness.

My point is you never know in what thing people have invested themselves, and consequently, the world of conversation is a minefield, navigated only with extreme caution and loads of heart-stopping fear. That is why small talk is best kept extremely small. The weather is the only thing human beings have in common. Stray from that topic at your peril.

"Wow, it's really coming down out there," you offer, as the opening volley of any of a number of small interpersonal relationships people find themselves in.

"It is wet," says the person, agreeably.

"It's been like this for a while," you say, a bit dangerously. Your editorializing has left you vulnerable. But you can still qualify it if it blows up in your face.

"It has rained for a period of time," he says.

"Yep," you agree. You both fiddle with some prop pointlessly for a moment until the silence becomes unbearable. "Best have your umbrella today," you say, wryly.

"Really?"

Uh-oh. What have you done?

He attacks. "I've never liked them myself. They amplify the sound of the rain until it feels like it's raining inside your head. Why do they do that, do you think?"

"I couldn't say."

"And they're dangerous, too! Bits of jagged, surgical steel, covered with high-tension, pressurized nylon and then spring-loaded. You might as well hold a running blender filled with broken water glasses above your head! Umbrellas—I curse them with curses too deep for words," he says, nearly crying. "Still, you seem to love 'em. You can't say enough about them."

"Actually, I hate them. I was just trying to point out that they exist," you say.

"My mother was killed in an umbrella-opening accident on a day very much like this. By a person who strongly resembles you. He was leaping about singing their praises just like you were, opening and closing that stupid umbrella, when she walked right into it. Never knew what hit her." He weeps for a moment and then looks you in the eyes. "Be proud. Go home and try to sleep knowing you prefer your precious umbrellas to the life of a saintly woman!"

Be especially suspicious of people who solicit your opinion. It is almost always a trap.

"Did you read that book *Drink Deeply, Horse?*" asks a friend, too casually.

"Yes, you gave it to me," you respond, your sensors twitching.

"Really?"

"Yes, you insisted I read it, remember?" you say flatly.

"Hm."

"You sat in front of me while I read it and videotaped my reaction," you say.

"Oh, that's right. As I remember, your expression betrayed no hint of what you might have thought of it. I watched the tape a few times and couldn't see any signs of an opinion at all," he says. "So. What *did* you think of it?"

"I have no memory of that particular book," you say.

"So it was so flat it made no impression on you at all?" he asks.

You sigh heavily and prepare for the worst. "I did not care for *Drink Deeply, Horse.*"

"You . . . *SNOB*! That was my favorite book ever! It has formed me as an individual. Any goodness, grace, or mercy I've ever received was the direct result of my having read *Drink Deeply, Horse!*" What was wrong with it, tell me? What horrible sin did it commit that you feel the need to attack it like a rabid jackal?"

I've learned to simply stick to passive Watergate-like conversational phrases such as "At this point in time, my awareness is that people have reviewed the situation and the situation has been found to be in a state that could best be described as neutral."

That is my understanding, anyway, to the best of my knowledge.

A MIDWEST APOLOGIA,
IF THAT'S OKAY?

Should you ever find yourself about to form an opinion about Minnesotans based on the repugnant nature of our hats, please take this into consideration: it's very, very cold here.

There is no acceptable excuse for looking the way we look, I know, but I would like to distract you from that fact by pointing out that the elite Swiss Guard wear some pretty outrageous caps, too. And they can't argue that those huge red feathers protruding from their odd-looking helmets are functional at all, unless the function is to make them look like Secondhand Rose. The pope himself occasionally sports headgear that has him resembling a gilded fountain pen.

We can at least can claim functionality to our headgear, even if the person to whom we're making the claim is too busy laughing at our stupid hats to pay much attention. You see, it regularly reaches temperatures where all molecular movement ceases and freezing solid, falling, and shattering into thousands of shards is a very real danger for us all. A hat can sometimes prevent a person from shattering by cushioning his fall.

As I travel about the country, acquaintances are often curious about Minnesota, and questions abound: "Hey, how's Jesse?"; "How about those Bears?"; and "When are you leaving again?" are the most common, but some just want to know what life is really like in Minnesota, without having to actually go there, for which you can't blame them.

It's interesting to note that Minnesota was admitted into the union in 1858 when Vice President John Breckinridge said to President James Buchanan, "I dare you to put a state where Minnesota is." Buchanan, who, because of his high, frilly collars, was susceptible to even the faintest challenge against his manhood, took the bait. Though he himself made it a state, he was shocked to learn that there were people living there and he and Breckinridge had a hearty laugh when they found out.

The character of Minnesota is revealed by what appears on her state seal: a barefoot farmer plowing a field as an American Indian rides by on a horse. The farmer in this case represents a farmer, of which there are many in Minnesota. His bare feet represent the fact that he has gone foaming, shoe-shedding insane due to the temperature extremes and the isolation. He is plowing his crops under and plans to sit in a corner of his log cabin, weep, and have a long talk with his imaginary friend, "Uncle Mustard." The American Indian, who is Apache, is headed to his to his home in western Texas after visiting an aunt and is waving at the insane settler and telling him to get some help.

Life is hard here, and that leads our cold-ravaged bodies to exhibit quirky behavior. Perhaps the most difficult thing for any non-Minnesotan to understand is our propensity to "ice-fish." It's odd behavior, certainly, but not so much if you factor in the deep love that exists between a man (or woman) and a walleye. A walleye is a freshwater perch so named because its eyes resemble a wall, provided that wall is covered with detailed pictures of fish eyes. Otherwise there is no resemblance at all and the name simply confuses and annoys.

Why are Minnesotans so fond of the walleye? They're not large fish, they're very common, they're decent but not good fighters, and their looks are best described as "offbeat." Is it because the most common bait for walleye are monstrous, black bloodsucking leeches that attach immediately to one's hand and then writhe and twist in grotesque agony when hooked? That's part of the appeal, yes. But the main charm of the walleye is that its cheeks can be deep-fried and served with Brobdingnagian quantities of Grain Belt beer (if unavailable, quality beer can be substituted).

Perhaps, because you are a decent, civilized person, you have not heard of walleye cheeks. You, and many like you, have always thought of cheeks as the pink, fleshy things that make up a cheek-sized portion of the human face. Because they are particularly attractive on infants, you may even make a warm association between babies and cheeks. To the Minnesotan, however, a cheek is a small clump of bloody flesh found behind the gills of a slimy panfish. These cheeks are not to be playfully pinched, but rather cut off with a scalpel-sharp Rapala fishing knife, coated thickly with a beer-enhanced batter, cooked in a two-month-old frying medium, and served in a paper-lined plastic basket at places with names like The Rendezvous, Andy's Bar, or Players.

Here is a quick lesson on how to ice-fish for walleye. First, wait for a body of water to freeze (very important!). Next, buy a small quantity of peppermint schnapps to keep yourself warm out on the ice. Now buy six more. Then add some Stroh's beer (a thirty-pack should do), peach schnapps, Rumple Minze schnapps, root beer schnapps, cinnamon schnapps, and Watermelon Pucker brand schnapps. Then some Wild Turkey in case you lose your taste for the schnapps family of spirits. Load it all into the back of your truck, ignore the thin ice warnings, and head out onto the lake (note: you will probably fall through the ice, so keep a window cracked).

If by some miracle you don't fall through the ice, pick a spot, drill a small hole, drop a line in, and begin drinking. No matter

what happens with the fish, ignore them and pay special attention to your limbs, as the liquor will make you feel warm even while you are losing precious tissue to the cold. At regular intervals, climb back into the truck to warm yourself and listen to people call in and complain about Vikings coach Dennis Green on one of the many hundreds of AM call-in shows. Once your core temperature drops to about eighty-seven degrees, climb into the truck and head home, stopping at Dick's Red Owl Market for some frozen pollock.

Another popular winter pastime is deer hunting, the only known sport where participants regularly douse themselves with animal urine and fire on one another.

The urine, or "buck scent," is from a mature doe and is meant to be a sexual lure to mature male whitetails. This does not speak well of the mature whitetail buck, and reflects even more poorly on the person who would wear it for such a purpose. The advertisements for buck scents often trumpet the fact that they're 100% HIGHLY POTENT DOE URINE!! or that they USE ONLY HIGH-QUALITY PURE DOE ESTRUS SCENT!! What the fancy language, uppercase letters, and redundant exclamation points are saying, in effect, is, "Splash on great handfuls of sallow, musky deer pee." Everything in our beings rebels against this, of course, but the long, cold winters in Minnesota cause us to lose perspective on just what it means to be human. We forget basic codes like, "Human beings should not, under any circumstances, cover themselves with the waste products of lower ruminants."

Once befouled, the deer hunter takes his rifle, climbs a tree, and sits without moving for up to three weeks waiting for a buck. Deer, however, have not only a fine sense of smell but decent vision as well. Though they can't fully understand the motivation, they gaze up into the trees and see that the woods are suddenly swarming with men looking for a strong, sensitive buck to make love to them. Naturally confused and repulsed, they run. After several weeks, the hunters climb down and begin organizing into small, angry mobs that chase around the woods firing on anything that moves,

blaze orange or not, for the remainder of the season. At the end of any given day, the hunter returns to base camp, towels off as much of the urine as he can, replaces it with a midprice pheromone cologne such as GoGetSum, and heads off to Players for some wall-eye cheeks and a little companionship.

I don't want to convey the impression that Minnesota is nothing more than smelly, insane people and subzero temperatures, far from it. We boast some of the most gorgeous summers in the tri-state area, and many of them last upward of two weeks. During that time, as beautiful as it is, it's not terribly safe to venture out of doors, as one of our hundreds of species of bloodsucking insects is bound to fully desiccate you within minutes.

Ticks, mosquitoes, bedbugs, chiggers, gnats, deerflies, blackflies, and horseflies are just a few of the insects one may encounter on the way out to the car. Go near anything even resembling the woods—even the most fragrant of copses—and you're simply begging to lose blood meal and be injected with bacteria-laden saliva.

It takes a special kind of person to survive our harsh winters and give up so many platelets during the summer. The conditions harden a person. Truly, one's skin becomes horny and armored from all the chapping in the winter and the thousands of bite bumps in the summer. We are, therefore, literally guarded. We could "come out of our shells," but that would mean we'd have to molt.

Because of this, some say we lack passion and verve, that we've collectively taken on the staid character of the Germans, Norwegians, and Swedes who settled this land, but to have that notion dispelled, one needs only to drive our highways and see the many middle fingers shooting passionately up, or witness the purple majesty of the many chunky, bare-chested men, their bodies painted in Vikings colors, screaming and spilling 3.2 Old Style at the Metrodome.

And our most famous exports only prove my point. Look at Prince: is that a staid or reserved person you see, shirtless, wear-

ing little satin pants and high-heeled cowboy booties, dry-humping that pink guitar? And Garrison Keillor, while he seldom dry-humps his podium, has true passion behind that sleepy, staid, and reserved exterior. I'm almost certain of it.

The 3M corporation is based in Minnesota, and while it's actually a pretty conservative company, that Scotch mascot who hawks their tape and their clear plastic shrink-to-fit window coverings has got a fire in his belly, you just know it. I can't imagine he doesn't sound his mighty yawp, toss a few cabers, have a few Scotch ales, film a Scotch tape commercial, sound his mighty yawp again, and then hit the hay, a day well spent.

SPAM, the meat by-product, is constructed right here in Minnesota. Snap the key off and open a can: is that a smell you'd classify as reserved? Taste. Are you getting a flavor you'd call passive and stoic, or are you tasting forward notes of aggressive salt, the tang of cartilage, the passion of boiled swine head?

Minnesota is so much more than babyish governors and blaze-orange hats with earflaps. Not tons more, but enough to be noticeable, anyway.

PART
NINE

The Whole Famn Damily

PAINFUL BLESSINGS

It has been said that nothing can change your life so much as a child ... hitting you in the groin with one of those pull-along toy phones with the googly eyes and the little bell that rings. The ones with the machine-tooled iron chassis and hardwood bodies attached to the yellow plastic strings. When spun with just a few ounces of force by a toddler, they can reach speeds of Mach .3, which is roughly 330 feet per second in average air density. I've taken many body shots from that particular model, including once when I lost twenty-five seconds of consciousness from a particularly solid blow to the head delivered by a two-year-old girl. Sadly, I never recovered those twenty-five seconds.

There is a direct and provable correlation between just how much stimulation a toy provides for the child and how badly it can hurt a human shin. For instance, I know that a Tonka fire truck is good for small-muscle coordination, stimulating imagination, and promoting healthy role-playing—because it is capable of delivering a very deep bone contusion.

Yes, children are a joy, a blessing to your life, an unimaginably

rich gift—but make no mistake: given half a chance, they will take you down, man.

It starts when they're young. Very young, like seconds old. They have those tiny, incredibly adorable half-moon fingernails that are fifty-eight times sharper than a scalpel. A quick, not-very-well-coordinated movement of the baby's arm (which is all any baby I've ever met has been able to muster) and you've got thirteen stitches. That's why the AMA recommends you have your baby in a hospital: so that any fingernail-inflicted wounds can be dressed quickly before there's too much blood loss. Yes, sometimes babies will administer self-inflicted fingernail wounds, but that's only so there is verisimilitude for their claim that, "I'm only a baby—I don't know what I'm doing. Waa, by the way."

Women, wear a brand-new pair of hoop earrings around a newborn and what happens? Does he offer a sincere compliment, tell you how they set off the color of your eyes, like the majority of men do? Or does he immediately swing on them like Bart Conner? Or try to pull them out, putting one hand on the side of your head for extra leverage? The fact that they can do something like that and still look you in the eyes is chilling.

Babies bide their time till the toddler years when mobility and tool use combine into a lethal combination. That is when they begin wielding their toy phones like medieval maces, but they can club you with pretty much anything that fits in the hand. Often their attacks are ambushes. They'll sit quietly tapping brightly colored pegs into a wooden brightly colored peg receptacle (what can I say—this seems to make them happy), humming and cooing to draw you in. Gently approach to offer encouragement and love and all that, and in an instant they're on you, the little plastic hammer a blur as it connects again and again with the tender parts of your face; and the face seems to have an abundance of tender parts, or at least many that would best be left unhammered upon. "Da, da, da, da, da, da, da, da, da, da," they say, with roughly one *da* per blow. Then, as quick as it came, the attack is over and they go back to their pegs while you go off to take a short "So You Think You

Have a Concussion" questionnaire in your home medical book.

Younger children, famous for their sleep deprivation techniques, begin to grow in skill as they mature. One method a three-year-old might use is to wait until the father has reached a deep state of REM sleep, checking carefully for the telltale movement of the cornea under the surface of the lid, before positioning his own face a centimeter or two away and saying in a clear, full voice, "Dad?!" Following his scream of unbridled terror, the parent's pericardium swells, life expectancy is significantly reduced, and he usually begins to suffer night terrors. Sleep in general becomes shallow and unsatisfying as the victim twists in endless anxiety in anticipation of another attack. Dementia takes hold and the tormented parent begins to enjoy the calming trips to Chuck E. Cheese's, where he is calmed by the gentle counsel of the eight-foot singing rodent.

As the children grow, their knees harden and become more pointy. Their accuracy is unerring; they can find the father's groin and sternum, respectively, underneath layers of bedclothes on the first try. The second try is just as accurate, and the father is obviously more vulnerable having been pretenderized for the follow-up attack.

Some injuries can only be blamed on the parent. I once squared off with my seven-year-old, each of us wielding a very light Nerf ball loaded into a sock. Good fun, until my younger son joined in, creating his own makeshift weapon by stuffing some high-impact plastic LEGO men into a large-capacity tube sock. That my jaw was only wired shut for twenty-eight months is a testament to how far modern surgical techniques have advanced.

Most other injuries are Super Ball related.

Of course any rational parent would respond to these attacks by positioning himself in the rafters and, face painted in camouflage, wait until the child came home from school, all flushed with excitement and bursting with news of his day. He would then swoop down with a savage war whoop, sounding an air-pressure horn and throwing handfuls of realistic rubber tarantulas and cobras, then square off for battle. My wife, however, has forbade this approach in my home.

Probably because she knows that I can't win.

GRUMPY FLOPPY
AND THE FLO-FLO

Perhaps you have been set back on your heels by something similar: you're talking to a mature, adult friend who has up to that point displayed no signs of dementia when suddenly—

"I have to go," he says. "I have to pick up Num-Num and Pee-Paw at the airport."

Your first instinct is to subdue your friend and hold him until the proper prescription medications can be administered by a team of professionals in white scrubs, but before you commit to anything, you spit out a great mist of coffee and say, "What? What is a Num-Num and a Pee-Paw?"

He explains, "Oh, it's my great-aunt and -uncle. I've called them that since I was two."

You want to tell him, "Yes, but so much has changed since then. You've gained more than a hundred pounds and very many teeth, you've stopped going Num-Num and Pee-Paw in your diapers, why hang on to this thing?"

I kept my ears opened and discovered that these little pockets of

baby talk can be found *everywhere*—if only you're petty enough to look for them.

Most common are the names for elderly relatives. Nana Fluffy, Doo-Dad, Grumps, Tanta Kee-Kee, and Lady Boo are just a few you may run across. Less dignified names might be Shoe-Ma, Sadie Pree, or Wrinkle Johnny.

I wonder about the grandparents who are complicit—they have to be—in this name-calling. Surely there was a point when they thought very seriously about putting a stop to it. I would guess a chart of the name's progress would look something like this:

- AGE 2: Adorable.
- AGE 2½: So cute.
- AGE 3: "Uh-huh."
- AGE 4: Wearing thin.
- AGE 5: That's enough now.
- AGE 6: "Just call me Grandpa, honey."
- AGE 7: "Have you had him tested?"
- AGE 8: "We won't be able to make it this year."
- AGE 9: "It's getting so hard for us to call."
- AGE 10: "I just have to shut down when I'm with him."
- AGE 15: "I hope they get help."
- AGE 20: "I nearly punched him back there."
- AGE 25: "You want to call The Freak or should I?"
- AGE 30: "He'll never get through our caller ID."

Then there are those words that people adorably mangled when then were kids, got attention for, and so have kept them in the vocabulary in the mistaken belief that people will still be charmed.

"Could you hand me a spoon and some of that flo-flo?" they say. And noticing your look of contemptuous horror, add, "At a big party when I was three, my Grumpa Ploppy was pouring some sugar into his coffee and I said, really loudly, 'Lookie Grumpa Ploppy pour the flo-flo,' and everybody laughed and

from then on I've just always referred to it as flo-flo."

This example serves to illustrate how little talent children have for naming things. They tend to make a grab for the most obvious surface element. If you sat a child down and gave him some new pieces of laboratory glassware that you could really use a hand naming, the odds are good that, first of all, he'd throw every single one of them down on the floor, and after all that come up with only one name, "Crashie-bye-bye," for every single broken piece, regardless of its function.

And the mistake people who hang on to their babyish names make is thinking that they were being admired when they originally minted them. No. I'm sorry to have to tell you this, but you were being laughed at. In the relatively safe environment of friends and family, sure, but they were laughing at you. If you doubt that, think back: your mistake. Big laughs. You, the only one not laughing. I'm an expert on this—you were being laughed at.

Once on a plane, I saw a grown woman hugging a baby-blue flannel-covered pillow depicting little happy bears wearing flannel pajamas themselves, floating around a fluffy cloud-dotted sky. She caught my eye.

"This is my boo-boo. I take it everywhere," she said, hugging it. She was right in thinking my look implied a question. However, she was mistaken about the question itself. It wasn't "What do you call that adorable pillow and do you travel with that lovely, fluffy, stuffy little thing everywhere?" It was "Good gracious, woman, will you please get some help?"

As the country gets more casual, I suppose these things will begin to enter that last bastion of formality, the business meeting.

"All right, that completes our work on Article One. Why don't we break here so that everyone can either go grumps or sprinkle, maybe grab a little hot-hot—I have to phone my Granny Gray-Toes and we'll meet back here in ten, 'kay?"

If I ever heard that, I would chuckle-muckle till I pee-pawed.

THE KIDS TODAY,
THEY CAN'T GET ENOUGH OF ME

Because my wife works with youth on a regular basis, the poor kids are occasionally forced to speak to me. They're fine, polite young people, it's me who has the problem. I can't seem to manage not to look like an idiot. Somehow, though I don't own one, a pipe ends up in my hands, my hair automatically Brylcreems itself into place, I look down to find slippers on my feet, and I'm wearing a robe.

A group of three or four will walk into my house, in no particular hurry.

"Ho, ho, ho, ho, hold on there! Where are we all running off to in such a big hurry, kids?" I'll ask, puffing my Borkum Riff with an amused expression.

"Just headed in to see your wife," says one of them.

"You kids are always running this way or that, some scheme or another afoot. What is it today?" I laugh.

"Just headed in to see your wife," he repeats.

"Is that what you kids are all about today? 'Going in to see my wife?'" I laugh.

"It's not what we're all about," he says.

"Are you okay?" asks the girl next to him.

"Hey, hey, hey, now—let's not back-sass the old man!" I say, with enough humor to get out of the situation gracefully should they turn on me.

"Sorry. Can we go see your wife now?" they ask desperately.

"Just one second, everything doesn't have to be a big headlong rush. You act like a bunch of kids running after a freshly made batch of shake-a-puddin'!" I say, knowing that shake-a-puddin' is something old, but so lost now that I have no idea what it might have been. "Have a seat. You're not too old to talk to Old Mr. Nelson, are you?"

They look at the door longingly and then sit down.

"So what's the bulletin? What kind of music you kids listening to these days? The Tone-Loc, your Eve's Plumb, Percy Grainger, the Bill Evanses? What about Rudy Vallee?" I ask. "Are kids still into bearbaiting? You guys, you keeping up on your parlor tricks, I hope? Why, in my day, we used to build ring forts to protect us from Nordic invaders—do you kids still do that, or is everything about 'finding a direct path to the Orient'?" I laugh in a convivially mocking fashion. "What about tool use? Is that still big? *Kids?* Please tell me tool use didn't go out the window when the great vowel shift came along? Well, I should hope not. You know one of the things I hope never goes out of fashion is the brand of Deism espoused by Thomas Paine. Constantine still around? What about the Visigoths? Oh well, everyone take a handful of posies before we all get the Black Death, for crying out loud."

They get up to go in search of my wife without saying a word.

"Ha-ha-ha, nice talking to you kids. Oh, I know it's not the thrill of the ages to talk to an old wheezer like me, but I really had a nice chat with you," I say as they run away at full speed.

"Don't forget, you're helping me with that burial mound on Sunday," I say.

Oh, they love me.

UNCLE SOLOMON

Is there anything wiser than an old uncle? What I mean is, I'd actually like some solid suggestions, because I'm ready to move on from the wisdom of uncles.

When you think about it, it would be pretty amazing if someone lived more than sixty-five years on this earth and didn't accumulate any wisdom worth sharing with their fellow human beings. And yet plenty of old uncles not only have nothing to share, what you manage to pry out of them is advice that would be painful or deadly were you to actually heed it.

Perhaps, like VCRs or tomato mills, human beings eventually just wear out. We know it's true with human knees, it's probably the case with the part of your brain in charge of "things that are worth saying." If someone's "been around the block a few times," it might mean he didn't have the good sense to give up and park in the lot.

Take my uncle Wally. Nice enough guy, but the stuff that comes out of his mouth! At its best, it's pretty thin gruel. At its worst, well, run. Run and don't look back.

If you happen to stop by his small crumbling house in a Chicago suburb, he'll enthuse for hours on the AMC Hornet. He'll take as much time as you've got to spend, so keep one eye on the clock and be ready with an excuse. Fake an aneurysm if you need to, or actually go ahead and have one, because it's got to be better than another hour suffering under the yoke of his passionate Hornet chauvinism.

"Great, great cars, your Hornets. Oh, I've got a couple of Gremlins, too, but I keep coming back to the Hornet," he says to me once, while trying to get his Hornet started.

"Walter! He is not ehn-terested in your cairs," his girlfriend Yuliya shouts from the doorway. (*Girlfriend* is a word that doesn't quite stick to a seventy-year-old woman of indeterminate ethnic origin with long hair dyed the color of a top hat, but I don't know what else to use.)

"Baaaahhhh! You listen to me—put your money in Hornets and you can't go wrong. You buy 'em, I'll do the restoring, and we'll split the money."

Put Your Money in AMC Hornets and You Can't Go Wrong—my uncle's advice. Now sit for a second and see if you can think of worse. Extremely difficult, if not impossible.

Later, we drive off to a locked junkyard and he stalks ahead of me like Holmes on the scent, looking for a spot to crawl over the fence. He finds a place where the chain-link sags.

"Step on that while I crawl over," he says. Soon we are inside. He picks through a pile of old starters looking for something Hornet-compatible.

"Are you sure we should be doing this?" I ask.

"Bahhh, they want you to take this stuff. It saves them the trouble of getting rid of it."

Right there you have some more wisdom—*Jump the Fences at Junkyards and Steal Starters. The Owners Encourage It Because It Saves Them the Trouble of Having to Dispose of Them.*

This advice would seem to run counter to the whole system in

place at junkyards. The fences, the killer junkyard dogs, the own-
ers with loaded shotguns yelling, "Get the hell out o' here, you
damn looters!" And the economic structure, wherein the junkyard
owner gets paid for his old starters. Still, my uncle, who is old,
must know something I don't.

Later, he suggests a bike ride, which I accept. He gives me a gold
ten-speed bike that weighs more than a Hornet.

"Bought that for my trek through Europe in fifty-three," he says
in answer to my implied question, "Where does one get a bike this
old and heavy?"

About the bike he's riding he says, "Bought this with the insur-
ance money when that one was stolen out of the garage. Only it
was never stolen out of the garage." He laughs.

"Insurance fraud," I say.

"What the hell should I care?" he says, and cackles a high-
pitched cackle.

The message is clear: *Acts of Petty Insurance Fraud Are Morally
Okay, Because "What the Hell Do You Care?"*

Later that summer, I stop by his house but he is mowing the
lawn, so I talk to Yuliya.

"He is mao-ing the lawn rait now," she says. He is ten feet away
from me mowing the lawn when she offers this report.

As I wait, Uncle Wally rolls the mower over some landscaping
rock. One of them shoots out and hits Yuliya in the head, cutting
her scalp just above the forehead. He is oblivious, so I run over to
tell him.

"Just let me finish this," he shouts.

So there's some more advice distilled from the rich life of Uncle
Wally: *Above All Else, Including Treating the Head Wounds of
Loved Ones, FINISH MOWING THE LAWN!*

He must have thought this one very important, because he
mowed to the exclusion of all other household chores, including
throwing away the copies of the *Chicago Tribune* from the day of
his birth on, all of which sat in stacks in his basement; vacuuming

up sowbug husks from the corners; and generally keeping the house from smelling old and sour.

It was inside that house later that he began dressing for his folk-dancing club meeting.

"Folk dancing is the best exercise there is," he announced as he strapped on the leiderhosen.

Another jewel: *Folk Dancing is the Best Exercise There Is*. By definition, there can be no better. The President's Council for Physical Fitness suggested training regimen: schottische for fifteen minutes, polka for fifteen, then alternate between morris dancing and Southern Mountain big circle dancing for the remainder of the hour. And don't forget to wear thick leather shorts with toddlerlike over-the-shoulder straps. It's the best exercise there is!

Bahhh, is my response to that, and all his advice. Bahhh, I tell you.

DO AS I SAY...

I slip up every now and then in front of my children, revealing small details of my recklessly lived youth.

"Don't go too near that birthday candle or you'll get burned like the time when I was nine and squirted lighter fluid on my brother's arm just as he was lighting a match and his arm burned like a blue torch for about ten seconds before he put it out in the creek and then ran after me and wailed on me till I cried."

Accidents like that were common, as my brothers, neighborhood kids, and I spent most of our time building and maintaining a massive armory of homemade tennis-ball cannons. I will not let my children know this, nor will I tell them that immediately upon completion of a particularly good tennis-ball cannon, my older brother and a friend looked at my friend Jon Barrett and said, "Start running." And that he did start running as they counted down from ten, and was just scrambling up onto the low limb of a huge elm tree when, after setting range and trajectory and adjusting for windage, they lit the tennis ball aflame and fired off the cannon,

scoring a direct hit on Jon's left thigh. It struck with a whack and a slight whoosh of flame, he gave a small "caw" like an injured crow, and fell from the tree.

I laughed every bit as hard as my brother and his friend, until I remembered that Jon might be dead. But in a second, he got up moaning and rubbing his leg, meaning that I was free to laugh again.

Because I know the danger out there for young boys, I plan on issuing my sons chunks of cut-up foam rubber—in various sizes and shapes, so they don't get bored—and decreeing that they shall play exclusively with the chunks until they are twenty-one and on their own. I will, of course, regularly maintain them by trimming any sharp edges that may develop through normal use. They will have to sign them out, too. And only play with them in their large, custom-built playpens.

My children will not be allowed, under any circumstances, to jump up and down on the domed plastic skylights of their elementary school as a friend and I did when I was eleven. They are forbidden to crash through those skylights and plunge down onto the floor of the elementary school, lying there dazed until the police come. No matter how much their friends pressure them to do this, I will not allow it.

The odds are against it anyway, as kids are aware in a more general sense that the jumping on or shooting off of or hitting and breaking of things not explicitly designed to function that way can be dangerous. They would know, for instance, that the thin, milky plastic of the skylight has a very small load limit, and a low tolerance to repeated impacts, having learned it in school from Sammy the Skylight Tolerance Squirrel. There are so many other choices for their entertainment, too, that jumping on skylights would naturally be low on their lists anyway. But to my friends and me, the implied mission was at all times to seek out vulnerable fences, unlocked windows, open sheds, discarded cans of petroleum distillates, and retail clerks with relaxed attitudes about the sale of

butane to minors, and see if there wasn't something in the neigh-
borhood of fun to be had out of them. If not, no loss, but if there
was, then we were duty bound to tell other kids about it, and would
be appointed official ministers of whatever fun we'd discovered.

Like the time a rabid, hairless squirrel kept up a nearly one-
hour assault against Tim Fischer. The squirrel hissed and barked
in a very unsquirrellike and fairly nightmarish fashion as Tim
kept it off him with a stick, afraid to turn and run for fear of being
overtaken. We felt compelled to go and get everyone in the neigh-
borhood out to see. It made for good sport, as Tim's confidence was
growing and he was able to give us a kind of play-by-play on the
squirrel's attacks.

"When he hisses like that, it means he's about to run at me,"
said my friend authoritatively. "Okay, he's gonna spin around now,
kind of crazy like."

After a little while of this, a squad car pulled up, an officer
yanked my friend out of the way, shot the squirrel unceremoni-
ously with a rifle, picked him up with plastic gloves, threw him in
a garbage bag, and was gone.

One day we discovered a use for cable spools—the large, wood-
en variety that are often turned on end and used as tables by
first-time renters—that didn't involve storing cable. Two of the
inner slats can be removed and a smallish person can be tucked
inside, the slats put back in, and the kid rolled around in a
makeshift carnival ride by his friends. That same kid-filled spool
can be intercepted by bigger, less safety-conscious kids and rolled
down the steep hill of Jefferson Street toward busy Bennett
Avenue and, ultimately, the Fox River. And yes, it can gain speed
tremendously as it goes down the hill, crosses busy Bennett
Avenue without incident, crashes into the curb, leaps into the air,
and lands on a car, wrecking it, and stops just short of the Fox
River. The kid, sick and bruised but okay, no doubt had the ride of
his life! Kids today just don't remove slats from cable spools and
roll kids down steep hills like they used to. Nor shall they, as

the security guards I hire to watch my kids full-time will ensure.

My kids will not be inclined to light firecrackers and hold on to them until the last second, as my brothers and I often did. Nor will they build a gigantic box kite, tie it to a wagon on a windy day, and put a kid in it, sending him down the street at thirty miles per hour, as my brother's friends did. Most importantly, they will not put D-size Estes rocket engines into every imaginable small item they can get their hands on and light them off to see what happens, as I, and virtually everyone I know, did.

They will have their foam rubber chunks and that shall be dangerous enough.

OH, LOOK AT ME, I HAVE FRIENDS!

Friendly, energetic people, with big, expansive personalities and a kind word for everyone! How do they do it, and why?

My wife is one of them, a friendly person—to the point that she herself has enormous mounds of friends. When I'm with her, wherever we go people greet her, smiling even, speaking openly with her. If they wonder who the silent hulk next to her is, they're kind enough not to ask. Because they're nice, friendly people, too.

How does she work it? What's her angle? I meet many of the same people she meets, yet they seem to call to talk to her. When, at any given social event, people see me before they see her, an overwhelming number of them say to me, "Oh, goodie. Bridget's here!" Why? I don't know. I've been married to her for twelve years and I'll be damned if I know.

But one day, not too long ago, I decided to find out.

Let me be clear about my motivations. I simply wanted to share in the richness that having many friends seems to add to her life and stuff. This is not to say that I don't have friends. I have a num-

ber of top-quality, all-purpose friends. We share things, they're there for me in a pinch, we don't steal money from one another's wallets when one goes to the bathroom. (I want to make that clear, Bob. I did not steal money from your wallet when you went to the bathroom!) It's just that my wife has friends in huge numbers. Great Cecil-B.-DeMille-crowd-scenes' worth of friends. She was using some bit of chicanery to pull it off, I just knew it.

Was I jealous of her having so many hundreds of friends? NO, I WAS NOT JEALOUS! I, a somewhat less expansive person, simply wanted to find out how she did it. I decided the most open and honest way to do that would be to observe her secretly for a few weeks. I, being her husband, and living in the same house with her, was in a good position to do this.

The following are reports from the field.

DAY 1: Set my alarm for 6:00 A.M, an hour before hers is scheduled to go off, so that I can do a little planning. Sleep through the alarm, but she gets up early. Makes me coffee and breakfast. Trying to throw me off the trail perhaps, *dear?*

Later that morning, she gets her first phone call. I interrupt her to excuse myself so that I can go listen in on the extension (I didn't tell her that last part). When I pick up the extension, she and whomever she was talking to immediately stop (aha!). She says, "Mike, I'm on the phone," a little too brightly, I thought. While she talks I steal away with her day planner and take it into my office, checking her appointments, seeing if perhaps she isn't keeping people's phone numbers from me, hoarding friends, as it were. While I'm pawing through it, she walks in, still talking to her secret pal on the phone, takes the book from my hands, and walks out without saying a word to me. The fact that she has so many friends becomes even more mystifying to me, given this rude behavior.

That afternoon she leaves to do some "volunteer work." I follow our van on my bike, keeping a safe distance behind her. She loses me two blocks from our home.

DAY 2: This time I get the jump on her, waking at six. Since she

is sleeping and not actively "making friends," there is little for me to do. I decide to see what our paper delivery person looks like, so I stare out our front window. The delivery person, a young woman, screams when she sees my face and runs to the next house without delivering our paper.

Since there is no paper, I go back to bed. Bridget gets up, and leaves before I wake.

DAY 3: Saturday. Not much activity. I again try to listen in on a phone call, this time, as it turns out, with our friend Sally. As soon as I pick up, Bridget says, "Oh, good, Mike picked up. Mike, who was that actor we're trying to think of?" I provide them with the name Victor Buono, hang up the phone, and vacuum our basement steps.

That night, we go out with yet more friends. I am able to observe her closely without her suspecting a thing, but because I'm trying to concentrate on her, I come off as perhaps a bit sullen to our friends and the evening ends early, before I've made any progress at all.

DAY 4: Sunday. Church. I fake an illness, and when she leaves with our children, I follow several minutes later and position myself in the pew behind her. The perspective is very illuminating. Unfortunately, I had forgotten about the sign of peace, where everybody greets his neighbor, and when she turns to the person next to me, she gets a pretty good glimpse of me. When she says, "Mike?" and gives me an odd look, I know I've been made.

It takes a great deal of explaining back at home but I'm able to learn a lot about how she interacts with people. I'd call it a very successful day.

DAY 5: She goes to meet a friend for coffee, and uncharacteristically, I must admit, I ask to accompany her. She says, "No. Don't be weird." As if attempting to share your wife's happiness by secretly observing her is "weird," I think to myself.

Of course I do accompany her, though she doesn't know that. From my secret observation post behind a free weekly paper called

Lavender, I'm able to see how good she is with people, drawing them out, getting them to talk about themselves. I try that myself later that day, calling my friend Chris at work. He is in a meeting, so I leave a message on his voice mail, attempting to draw him out. I get a very disturbing E-mail from him later that day wherein he refers to me as a "freak." His problems are deeper than I originally thought.

DAY 6: Today is the day! She is planning to go to a movie with friends, so I come up with a, may I say, brilliant scheme that involves hiding in the back of our van and eavesdropping. It's almost too good. As cover, I buy six bags of guinea-pig bedding and tell her very casually that while driving by the pet store I noticed a banner trumpeting their GUINEA PIG BEDDING SUPER SALE! and picked up nine bags of bedding at a substantial savings. The discrepancy, as I'm sure you've noticed, allows me to burrow under the six bags disguising my mass, but making it appear as though there were approximately three more bags (I actually have about a 3.4 guinea-pig bedding bag-displacement factor, but I figure she'd be too busy currying favor with friends to do a terribly critical bag-to-volume assessment!).

Unfortunately, overcome by cedar fumes, I pass out and wake up screaming an hour later when a bag shifts, cutting off my air. I am dragged out of the cargo area of the van by my wife and her friends, who stare at me strangely. (Yes, it's an awkward situation, but it's not like it's something they've never seen before.)

That evening, my wife and I have a serious talk. She is very understanding and sympathetic. She suggests that I get out more and make some friends.

STORY TIME

As story time settles cozily on my house, the only clue that there is any activity at all is the scream of my seven-year-old as he absorbs a few blows to the spine from his younger brother, who ends his attack by poking him in the stomach with a toothbrush. Soon his wounds are salved and dressed and the three of us scuttle into bed for a story, my seven-year-old taking care to drive his knee into the chest of his younger brother. Forty-eight minutes of crying and bitter recrimination ensues.

The two of them have picked away at their hard eight o'clock bedtime with cunning so that it is now just past two in the morning. I try to get away with a very short tale called "Puppy Gets a Bike," but they're onto me and deride it as "babyish." The seven-year-old throws the book across the room, and I scold him. He cries. I comfort him. It is now 2:45. I ask them what we should read, and my five-year-old produces a book as large and ambitious in scope as Brian Boyd's two-volume biography of Nabokov. It is called *The Littlest Toad.*

I begin.

"Th—"

"Ouch, you punk!" Five-year-old has just hit seven-year-old.

"Stop it, guys," I say, and begin again. *"The Littlest Toad,"* I announce.

"What's a toad?" asks five-year-old.

"It's like a frog," seven-year-old answers, and immediately receives a punch in the spine.

"I'm—asking—Dad!" froths five-year-old.

"It's like a frog," I say. *"The Littlest Toad,"* I announce.

" 'Jesse brought a frog to school Mrs. Blanding said he had to let it go but he cried so she called his mom and she came to pick it up but then she stayed and told us about frogs 'cause she works for this place where she has to know about animals—' " [Note: I omit here a continuous thirty-four-minute story about Jesse's frog that, were it published, would contain not a single comma or period.]

"Okay," I say, having nothing to add, as I really don't understand the kids today with their stream-of-conscious storytelling style. It is 3:24 in the morning.

"The Littlest Toad," I announce. " 'Toad awoke one day and called his —' "

"You skipped some," seven-year-old observes.

"No, this is the first sentence."

"Before that," he says. I flip back to an introduction page that has a lengthy note to parents.

"Read it, please," he asks.

"No, it's only for parents," I say.

"Please."

"No."

"Please."

"No."

"Please."

"N—oh, all right. 'Parents. *The Littlest Toad* has been written with the new reader in mind and utilizes word patterns and starting consonants that stimulate—' "

"Okay, skip it," he says.

"The Littlest Toad," I begin. " 'Toad awoke one day and called his—' "

"Who's that?" asks five-year-old.

"Who?" I say.

"There," he says, pointing to something in the picture.

"That's a rock," I say. Seven-year-old laughs tauntingly.

"Be—quiet! It's not FUNNY!" yells five-year-old, punching his brother and heading off to retrieve his toothbrush. I stop him and settle them both down again.

"Okay, guys. 'Toad awoke one day—' "

Five-year-old sneezes on seven-year-old's head.

"Grrrrossssss," says seven-year-old.

"Go clean up in the bathroom," I say. As we wait, he goes in, fills the basin, and soaks his entire head in it, not bothering to dry his hair. He returns and lies back down again. There is a disturbance, set off by the wetness of his hair. He goes off to dry it and returns. We settle.

" 'Frog awoke one day and called his friend Jay the Blue Jay.' " I have completed a sentence. There are only 756 pages of ten-point Arial typeface left.

" 'Jay the B—' "

"Who's that?" asks five-year-old.

"Where?" I say.

"There," he says, pointing to a tiny picture of a farmer on Jay the Blue Jay's wall.

"I don't know," I say though I know that's the exact wrong thing to say. I'm off my game because it's four o'clock in the morning.

"Why is he there?" he asks.

"It's just a picture," I say.

"Who is he?" he pleads.

"It's Eddie Albert the Funtime Farmer," I say.

"Not him. *Him*," he says, pointing very carefully to a dot next to the farmer in the picture on Jay the Blue Jay's wall.

"That's nothing," I say.

"No, there's a guy there," says seven-year-old.

"It's just a spot," I insist.

"No, it's a picture on Eddie Albert the Funtime Farmer's wall," he says. I look very closely, and sure enough, the farmer in the picture on the wall of the picture of Jay the Blue Jay's place has a picture on his wall and there's a guy in that picture, though he's two microns high, so it's nearly impossible to make him out.

"Who is that?" five-year-old asks again.

"It's Peter . . . Pepper Pants . . . the . . . Longshoreman—look, I don't who it is," I say, and try to continue reading, but I know it is no good. He will not rest until he has a full dossier on the picture inside the picture inside the picture.

Luckily, the publishers of *The Littlest Toad* have offices in New York, London, and Sydney, so I call the office in London, where it is 10:00 A.M., and ask to speak to a father. I explain my situation and soon he is faxing me page after page of "frequently asked questions" and their corresponding detailed answers. We resume reading an hour later.

" 'Jay the Blue Jay . . .' " I begin confidently.

"Who is it, Dad?" asks five-year-old.

"Aha," I say, turning to Article 14, paragraph iv of "*The Littlest Toad* Abstract," and begin reading. " 'In Sector H-4 (this corresponds to sector 17.003.87 in version 13–9–4531 of this text, and *all* earlier versions, sometimes published under the title "Abstract of *The Littlest Toad*.") readers will find a painting depicting a self-employed agricultural worker. [Please make a note of changes added by author and classified as items HZ5005RX and HZ5005RY.] The author lists the items depicted within this painting in an addendum [revised], but please note that character descriptions, because of their redundancy [see Article 17, paragraph xii] will not be included in . . .' "

I look to either side of me to see my children quite asleep. And I look back and see myself asleep as well.